DAVID HAMILTON
TWENTY FIVE YEARS OF AN ARTIST

First published in Great Britain 1993 by Aurum Press Limited, 25 Bedford Avenue, London WC1B 3AT

Original French text © 1992 Philippe Gautier

Original French text page 149 © 1992 Marc Tagger

Original French texts Philippe Gautier and Marc Tagger
translated by Yanick M. Haywood. Adapted by Liliane James.

Photographs © 1992 David Hamilton

Produced by l'Ariana Pictures Sarl (Paris) and 1B&C (Vienne)

Designed by Gettrude and David Hamilton

© 1992 L'Ariana Pictures Sarl & David Hamilton for the English edition

First published in 1992 by L'Ariana Pictures Sarl, 11 rue Tronchet, Paris 75008.

A catalogue record for this book is available from the British library.

ISBN 1 85410 266 4

2 4 6 8 10 9 7 5 3 1
1998 2000 2002 2001 1999

Printed in Italy by Arti Grafiche Amilcare Pizzi SpA Milano

DAVID HAMILTON
TWENTY FIVE YEARS OF AN ARTIST

AURUM PRESS

THE IDEAL LIFE

David Hamilton has been a photographer for twenty years, during which time he has presented to us his unique images of young girls; his unconcealed obsession. Once acclaimed and favoured, crowned with success for more than fifteen years, it is perhaps because of the vagaries of fashion or the jaded tastes of the public that he is now somewhat disregarded. But such explanations do not provide sufficient answers. Trends are ephemeral and transitory and certainly do not last for fifteen years. The aversion that his work seems to elicit today in those same people who so admired it yesterday, would indicate that the reasons for their changed feelings are, perhaps, more sinister.

Dreams of Young Girls, the first album of his photographs, was published in 1970, in Great Britain, France, Germany and the United States. It is important to recall how many new horizons seemed to open to the civilized world during this decade, to realize that *Dreams of Young Girls* were dreams shared by a freer, more aware, less violent society. Among those new freedoms, which promised to change one's life, there was one which touched us the most deeply: sexual liberty. By depicting the intrinsic eroticism of adolescents, David Hamilton sought to give us a new perspective, free from the constraints within which such a subject had, until then, been imprisoned. His photographs would have had no impact had he used older women as his models. It is youth itself which we find disconcerting. He acknowledges desire, and the right to express it. Look at these images, which seemed so daring in 1969. What do they tell us ? What do they reveal ? Do they shock us ?

What is erotic in Hamilton's photographs is the juxtaposition of two concepts which have always been basically contradictory: sexuality and purity. One of the most fundamental modes of expression, essential to human beings, seems unable to free itself from the shackles of moral condemnation. Yet day-to-day conversation readily accepts references to violence, torture, drugs and racism.

In 1969 and in the early 1970s, Hamilton's pictures were, for many, a breath of fresh air, complementing women's new-found rights with regards to sexual free-

dom and acceptance of their nudity as a perfectly natural state. Here was the Garden of Eden in reality. Sadly these awakenings of yesterday are today threatened by intolerance and a jaundiced eye. When we look at Hamilton's photographs now we may think that we have been deceived and that the vision he offered was a fallacy. But perhaps it is the world which has been false and has not lived up to its brave new tolerance. We once shared, with him, a new perception of our bodies and of our love, yet with the passage of time such perception has come to be condemned and even mocked.

First picture : me at seven, London, 1940

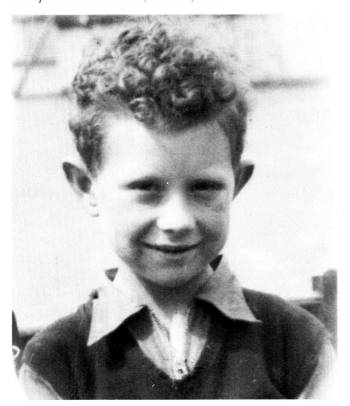

The photographs assembled in this book allow us, for the first time, to distinguish the real works of art from those less serious studies to which Hamilton owes his impressive commercial success. To this day, very litle has been written about him, with the exception of a few impersonal lines printed on the inside covers of his books. Yet this photographer has undeniably added a chapter to the history of erotic art. He was born in London on April 15th 1933. He now lives and works in the South of France. For the first time, this reflective man, for whom the future has no more significance than the past, agreed to talk about himself, his childhood, his profession, his tastes, his motivations and above all, his fascination with young girls. He has always lived only for the moment, the instant of a single click of the camera. Much of the past has escaped his recollection and so several meetings and interviews were needed to help him remember the beginnings.

S itting at a table, I was preparing to write; to assemble some memories. Before me, in a small vase, was a simple yellow rose. Had the flower been a part of a bouquet, I would not have noted its singular perfection. Life has given me one very important gift: the ability to appreciate perfect simplicity, whether of nature or of the human form. The journey which brought me to this awareness of perfection began more than fifty years ago. I have no memories before the age of seven. My first remembrance was the declaration of

the Second World War. The world stopped momentarily when the news came over the wireless. I was transplanted then from dreary, grey London to a new life in the countryside and a boyhood spent climbing trees, birds-nesting, fishing and swimming. My true life therefore began in Dorset; in the Blackmore Vale of Thomas Hardy's novels, just a couple of miles from Marnhull, the "Marlott" of *Tess of the D'Urbervilles*.

The war, and Churchill's plan to evacuate London children to the safety of the countryside, proved to be a blessing, for me at least. In 1939, I found myself at Waterloo Station, with hundreds of other children, each wearing an identification tag around the neck and heading for the West Country. After a long train journey I, and dozens of other youngsters, arrived at Gillingham in Dorset. Families from the town and surrounding villages had come to welcome us. Amongst them was an elegant-looking lady who pointed imperiously at me and said, with some authority, "I want him". This was Lady Talbot and my fair curls must have pleased her. She lived in a grey-stone Georgian mansion in the village of Fifehead Magdalen. I was lodged in a delightful cottage in the grounds, where her cook and butler lived, and given a room of my own. I was well cared for and ate good food. The husband and wife rather spoiled me and I must have been a precocious child for I well remember asking my mother to bring me a pair of 'country' boots and my dismay at being given a fur-trimmed pair, which were totally unsuitable and which I refused to wear. Even in those ear-

ly days my ideas about clothes and shoes were very well defined. I went to school in the nearby village of Stour Provost. I hated it and hated having to eat beetroot, tapioca and wheat cakes. I had to go to church twice on Sundays; once in the morning for catechism and again in the evening for mass, which I found extremely boring. The boredom was alleviated somewhat by my friends and I teasing the girls. Often we would steal apples and cherries from the vicar's orchard but, if my memory serves me correctly, we were never caught. Forty years later I returned to Fifehead Magdalen and this time I was struck by the beauty of the little church of St. Mary Magdalen, a beauty which had, of course, escaped me in my childhood. In the visitors' book I wrote: "What a pity that youth is wasted on the young" – Oscar Wilde.

After more than five happy years spent in Dorset, my return to London at the end of the War was not at all pleasant. I had not missed the city. My home was in Kennington, near the Oval Cricket Ground, that Mecca for cricket-lovers all over the world, but for me, cricket and the Oval held no interest. I can remember a few sirens and the noise of the German V1s. This area of south-east London had suffered considerable bomb damage and houses at either end of our street had been destroyed. My mother lived alone, my father having disappeared shortly after I was born and I had had no news about him. However, soon after my return, a man moved in with us. We had both, in our own way, been destabilised; I by a five year stay in the

country and he by the army and a prisoner of war camp. We arrived at the house within a short time of each other with our few belongings. Soon after, he and my mother were married, and they had a daughter, Mary. I had little contact with my step-father, as even at that early stage in my life, I wanted to preserve my new-found independence and the particular outlook on life I was beginning to develop.

I did not enjoy living in London and still loathed school and so, the second chapter of my life, from the age of twelve to eighteen, was dominated by my passion for cycling. My enthusiasm for the sport knew no bounds and all my time was devoted to it. I managed, by borrowing money, to buy Apo Lazarides' bicycle, the very one on which he had ridden in the Tour de France. It took me a year to pay back the loan. The concept of a man and machine, working together as one, brought me to my first appreciation of the beauty of shape and form: bicycle and rider were as pure in line as horseman and mount. Fortunately the equine shape changes little but racing bikes seem, to me at least, no longer the objects of beauty they once were.

Our cycling heroes were Fausto Coppi and world champion sprinter, Reg Harris. At our local track, the De Laune Racing Club, which my friends and I joined, we saw the world's greatest racing cyclists. All my weekends and holidays were spent on cycling expeditions taking us far from the city. Nothing else mattered to me, neither school nor even girls, who seemed at that time, out of reach anyway. I do remember, however, a bicycle ride through Dulwich Park with some friends. It was a warm day and we had stopped to catch our breath when I saw something, fleetingly, which made a lasting impression upon me. Two boys and a girl were on the grass. One of the boys had pinned the girl down, and the other boy had pulled up her dress and was sliding blades of grass and daisies between her knickers and her skin. The three of them were rolling around, giggling and joking. Without understanding why, the eroticism of this incident affected me profoundly. I made no comment to my friends but the scene and the feelings it aroused remained with me.

During this period of early adolescence, two people came into my life who were, in their own very individual ways, to exert important influences upon me. One was my uncle, William Leat – a portly but immaculately dressed man with an elegant air about him. He was a dealer in antique jewellery. It was William Leat who undoubtely gave me a taste for the good things in life; a desire to aspire only for the best. He wore Savile Row suits, handmade shoes and shirts and in particular, a beautiful rectangular-faced wristwatch which I coveted and eventually adopted as my own style.

William was a great 'character'; a Cockney but an astute businessman with impeccable taste. He could unerringly recognise an item af value, whether it was a piece of jewellery, an old coin or an objet d'art. Once he had owned two Inca funeral gems which the British

Museum wanted to acquire from him. He was a great story-teller and would tell the funniest stories about everyday happenings. At the age of 11 he had gone 'on the stage' in the old-time music halls and had worked in the same troupe of boys as the young Charlie Chaplin, who also, incidentally, came from Kennington. In his own way, William Leat was a great artist and I admired him tremendously.

Terry Round was the other 'character' that entered my life at this time. We were inseparable and became involved in numerous escapades and slightly nefarious activities. We regularly played cards, often in the school lavatories and if we won enough money would place bets with the street-corner bookmakers (betting had not been legalised then). As the police were always on the lookout for these 'bookies', it was a fairly hazardous enterprise. We also went greyhound racing and gambling became our main source of income. My taste for expensive clothes was well-developed, even at the age of fourteen and I would buy everything I could, with my ill-gotten gains, from Moss Bros., who then dealt in second hand clothes of a superior quality, often selling entire wardrobes which had belonged to a member of the aristocracy. Thus I acquired handmade suits and shirts, silk ties and shoes from Lobb. Terry and I had little money but we dressed like millionaires.

I left school at fifteen and became an apprentice in a small firm – Barrats Shopfitters. As I was good at making things I wanted to get some technical training and I also enrolled for evening classes. The fact that I was a school-leaver gave me an advantage over the other workers, most of whom had had little or no schooling, I began by learning, with painstaking care, carpentry and cabinet making. The firm manufactured huge shop counters, made entirely by hand, which were sanded to perfection before being given to the varnishers. Some of the carpenters would come to me if they had technical problems or difficulties in reading a plan. I would explain things to them and this ability soon enabled me to move from the work room to the planning room where I wore a white coat and drew plans. I asked a friend, who was a photographer, to travel around London and photograph the façades of all the fashion stores for me. I collected them in an impressive catalogue which helped me when I came to design shop fronts myself. Because of my enterprise I was respected within the company, and I began to earn a reasonable living. I was barely eighteen years of age.

About this time I had an urge to see Paris and hitch-hiked there with Terry. My first discovery was the crowded Place de Clichy, buzzing with life and activity. For the first time I saw restaurants with people sitting outside, eating and watching the world go by. I remember my first taste of croissants and French coffee. Terry and I shared a room near the Place de Clichy, in a sleazy hotel. One afternoon we were barred from our room and could understand nothing of the concierge's explanation. We waited around and eventually a

(Cont. page 150)

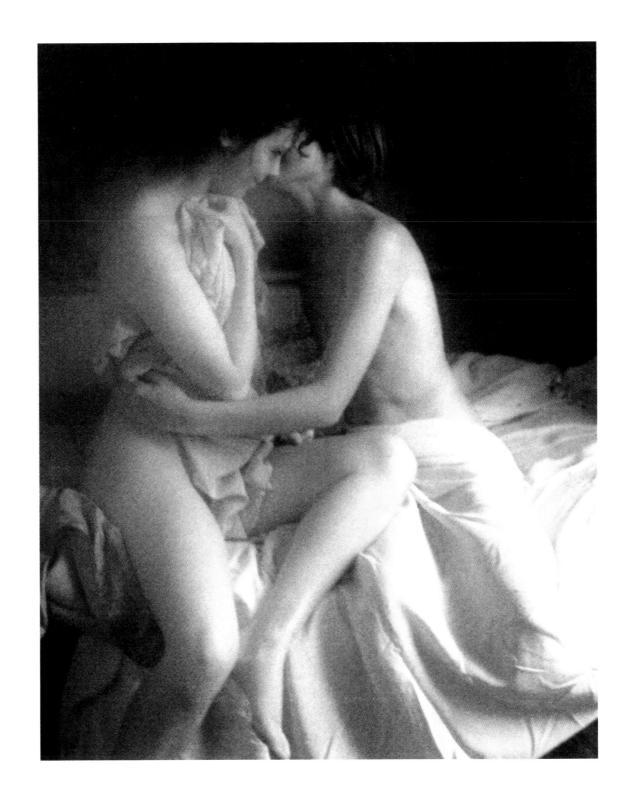

First time, love scene from "Tender Cousins", 1980

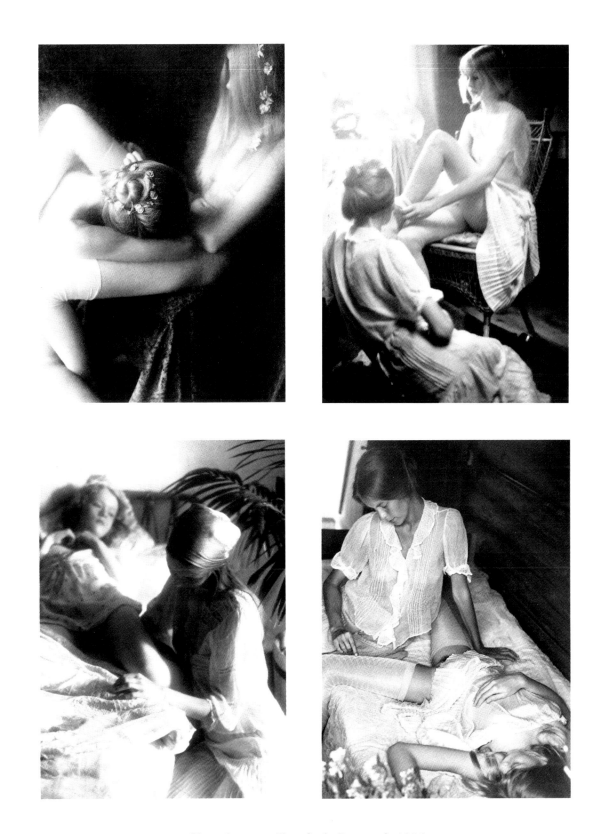

Shared secrets, Hornbeck, Denmark, 1970

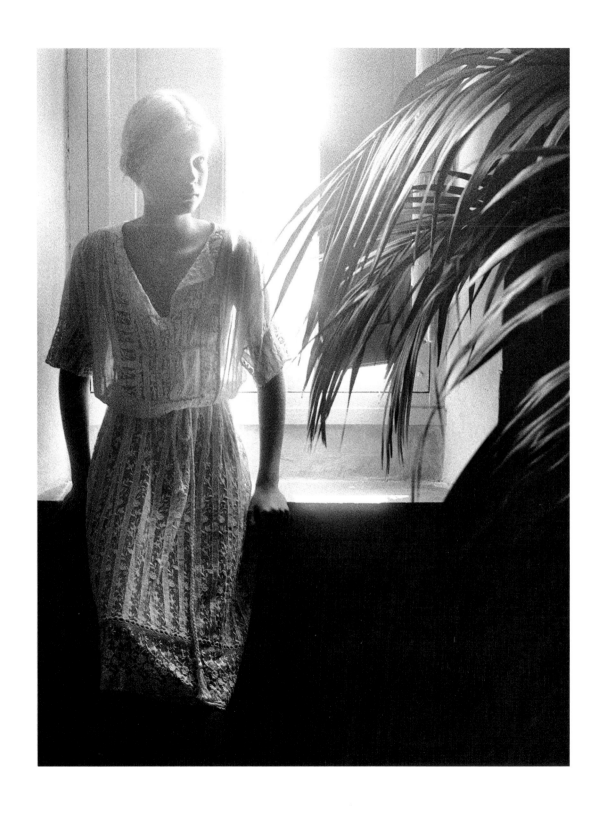

Margot, Ramatuelle, 1974

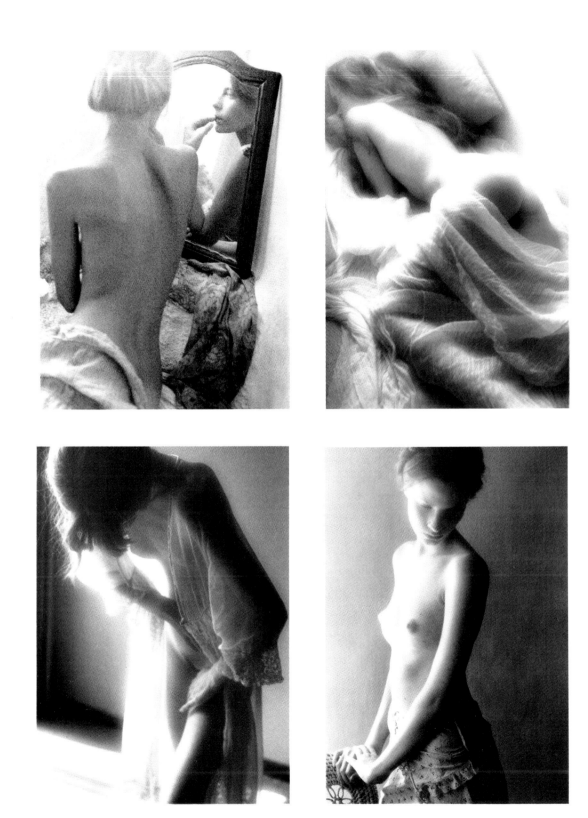

Passing the time away

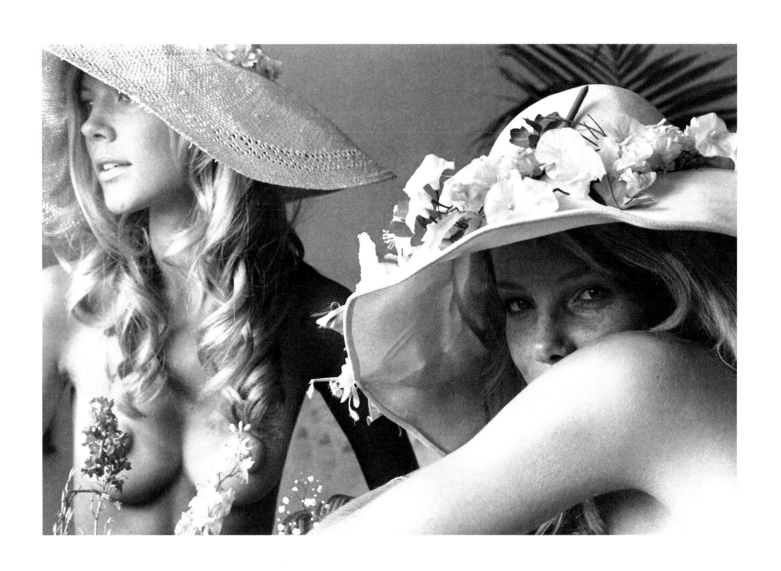

Dressing up, Ramatuelle, 1969

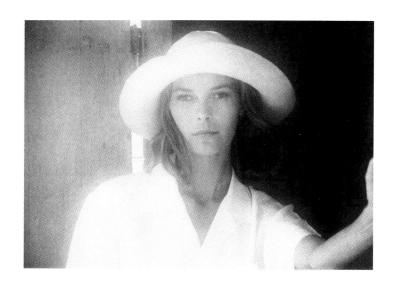
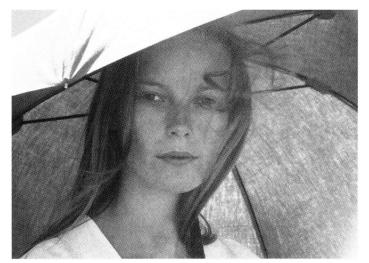
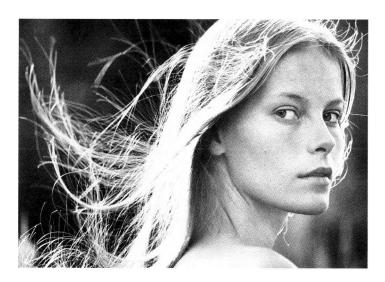
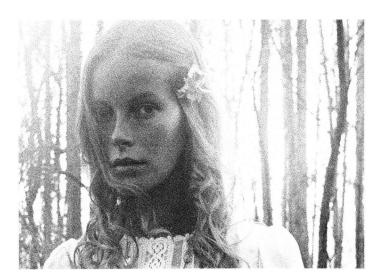

Mona

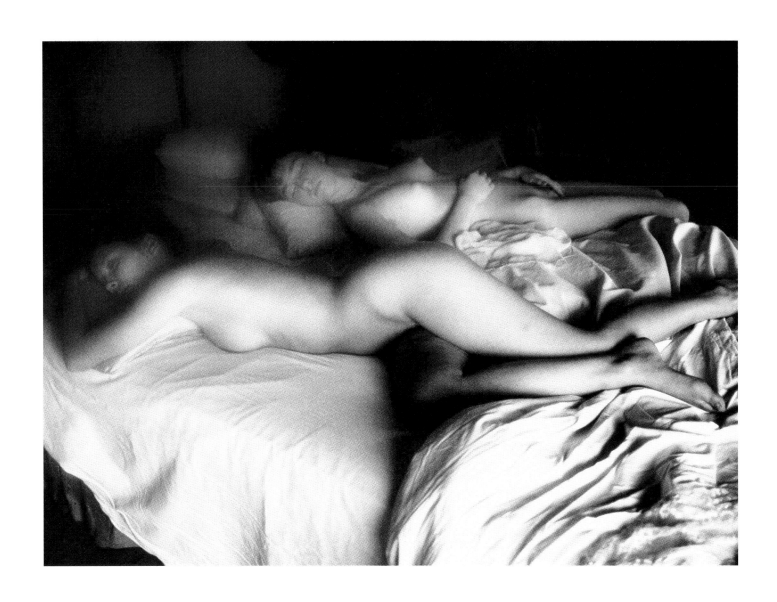

Waking up, Bangkok, 1980

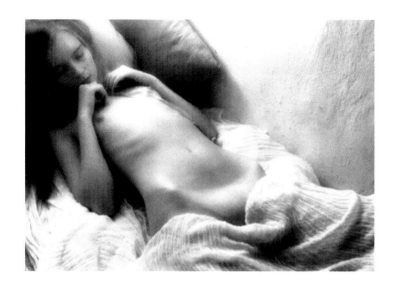
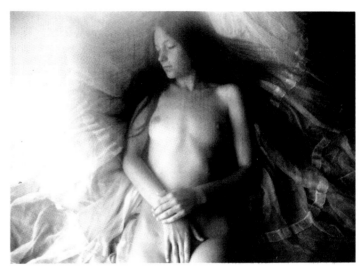
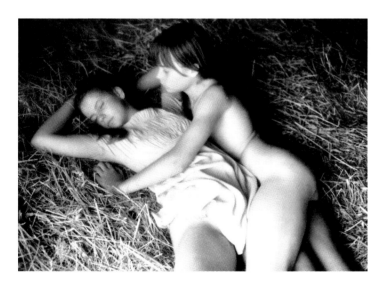
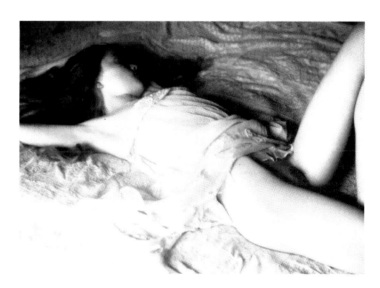

Dreaming and discovering

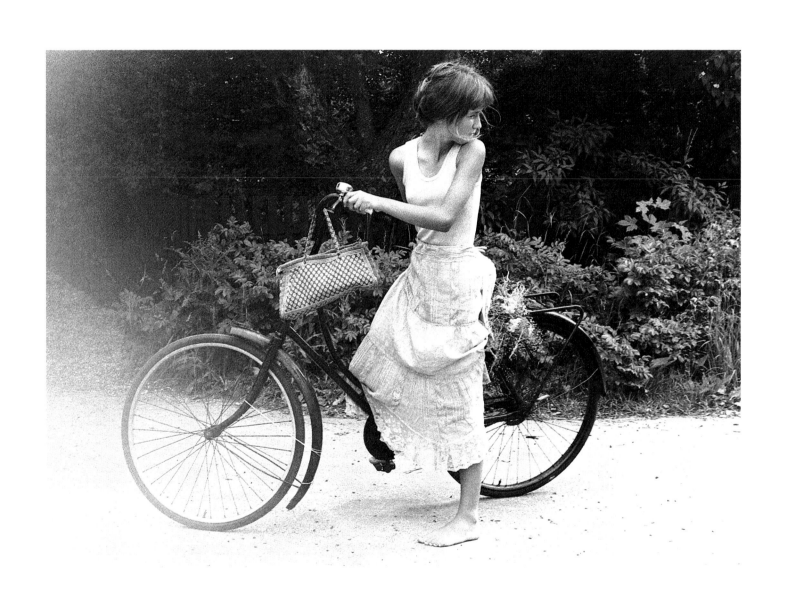

Off to the beach, Hornbeck, Denmark, 1971

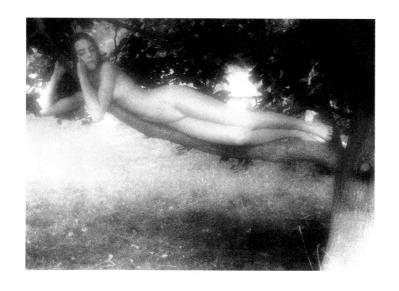
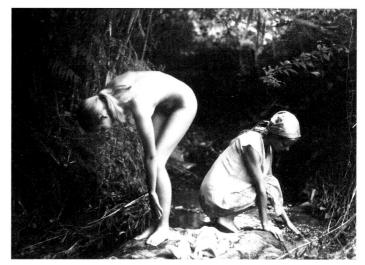
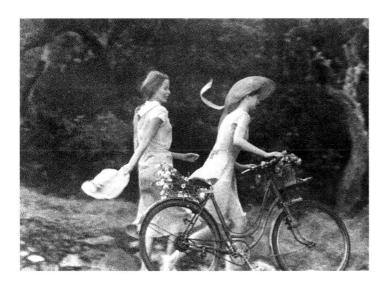
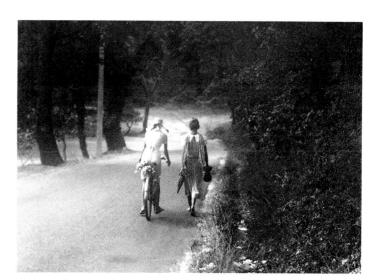

Summer

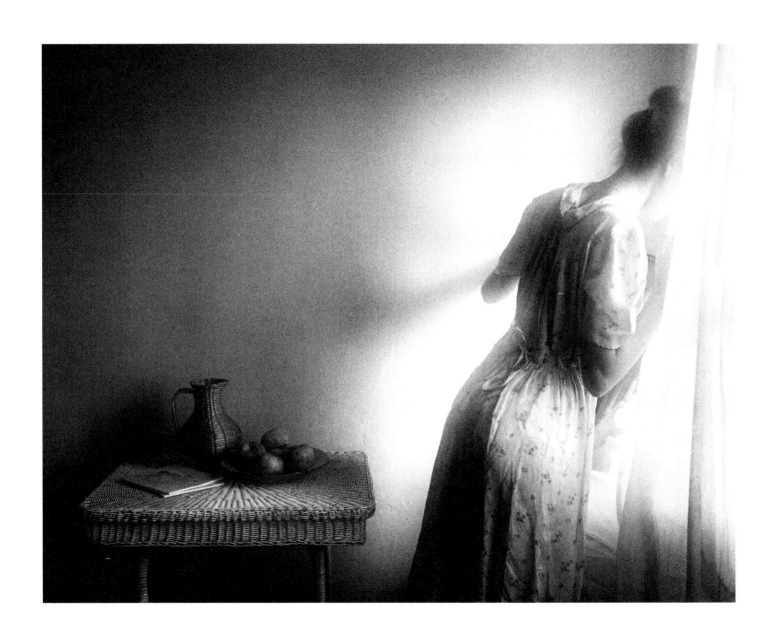

Curiosity, Ramatuelle, 1985

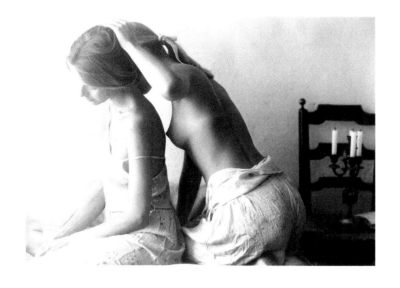

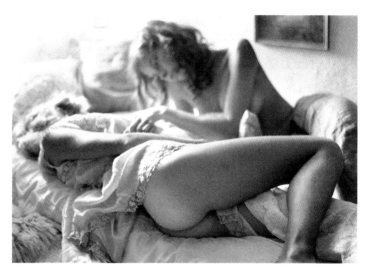

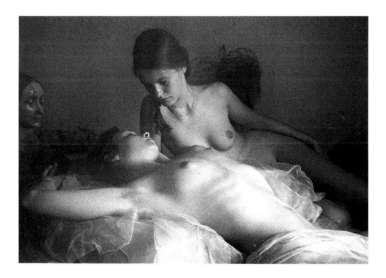

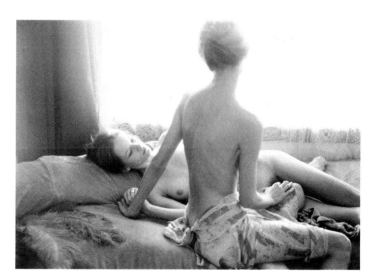

Summer afternoons

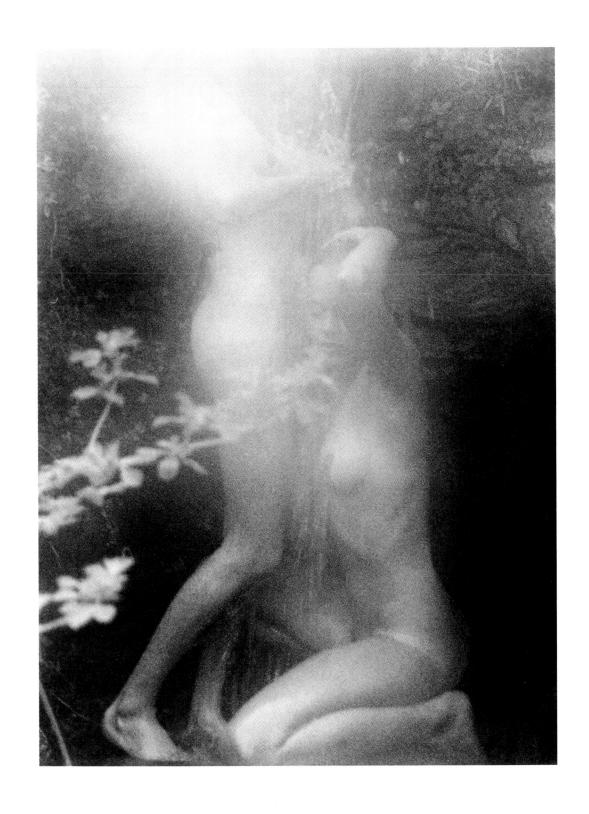

The morning shower, Corsica, 1971

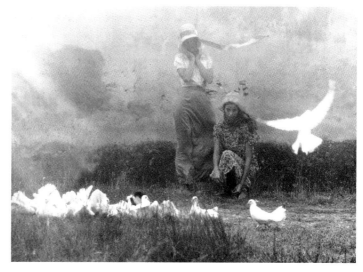
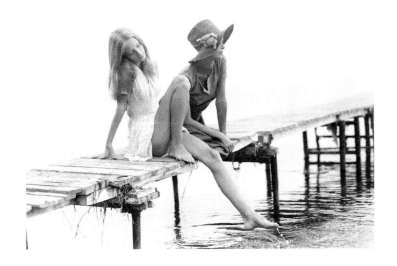
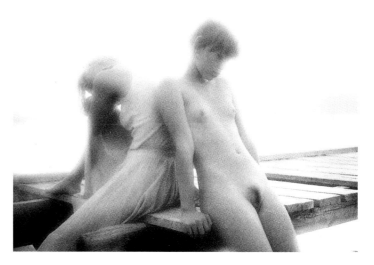

Friends

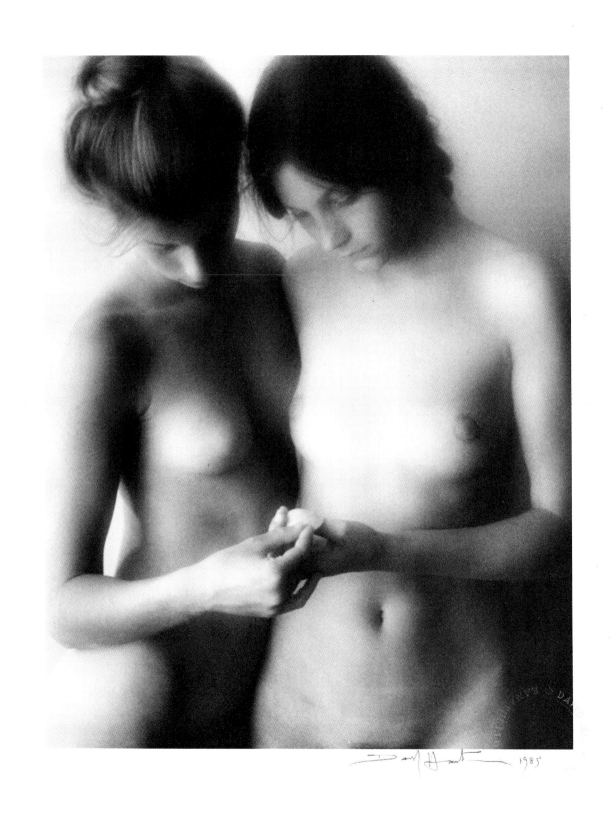

The seashell, South of France, 1982

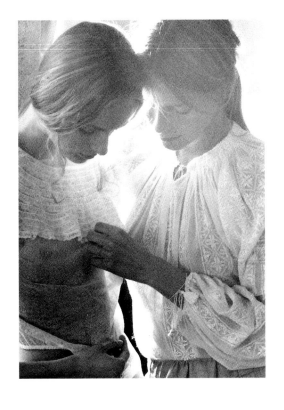
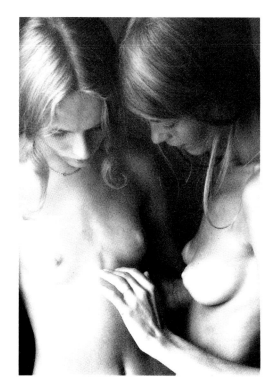
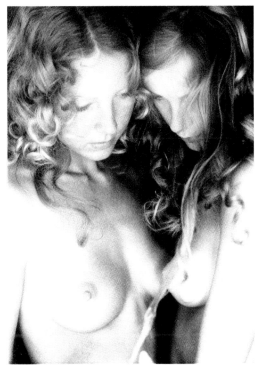
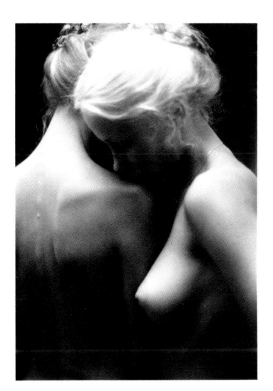

Sisters

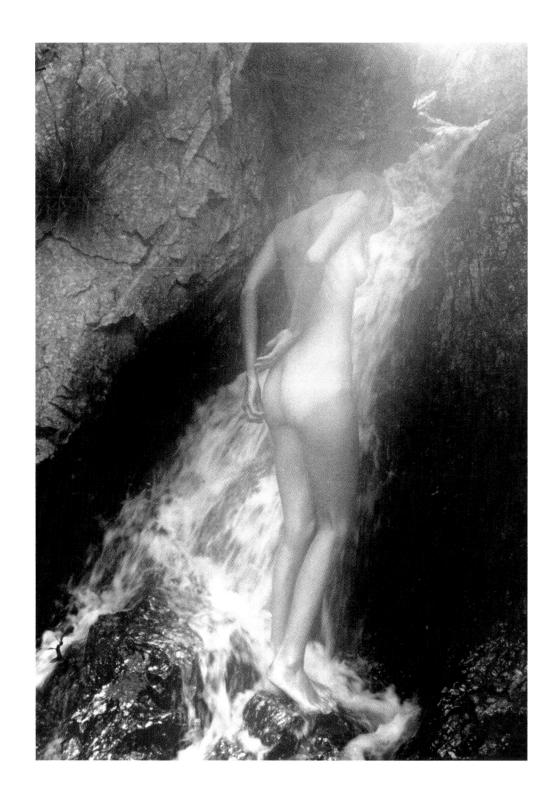

The waterfall, Saint-Tropez, 1971

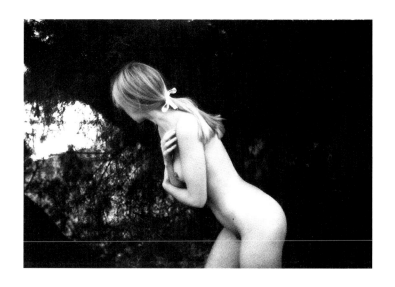 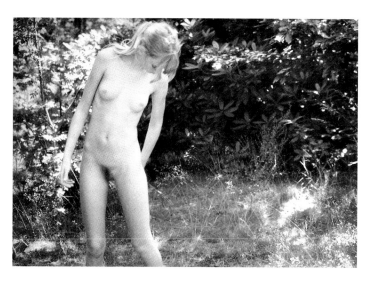

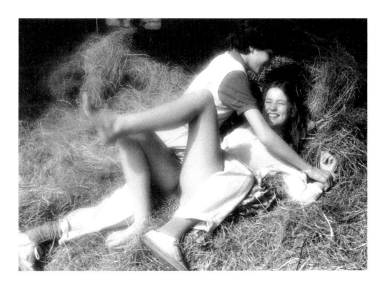 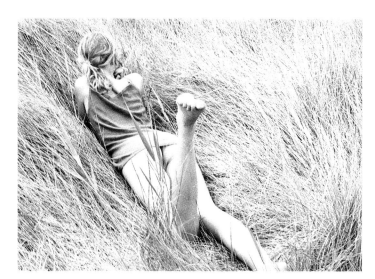

Playing hide and seek

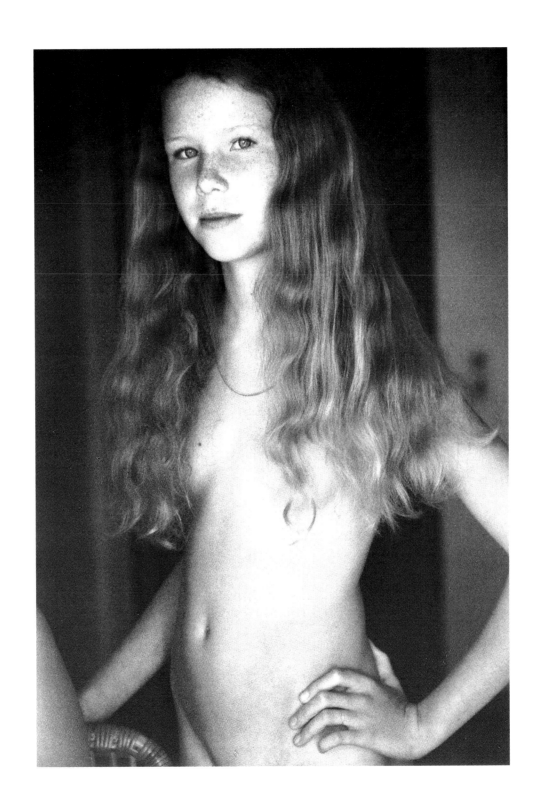

Pia, Saint-Tropez, 1975

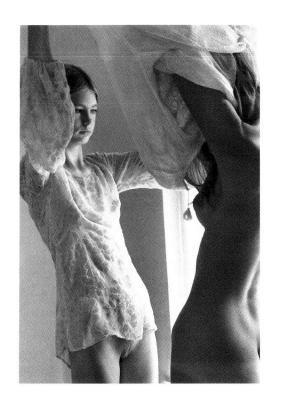

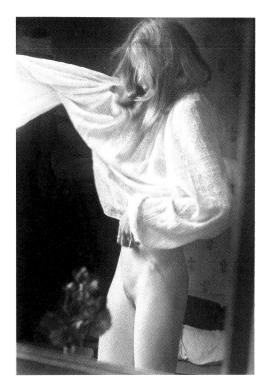

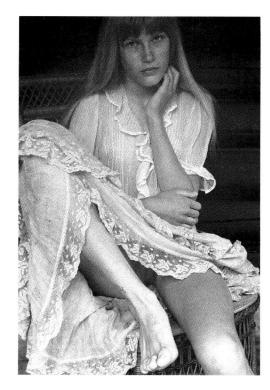

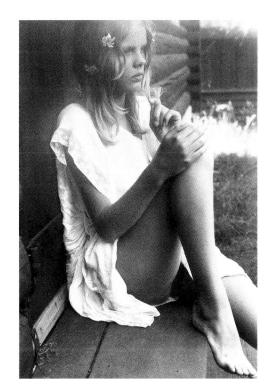

Ulla, Mandy, Anna, Gunilla

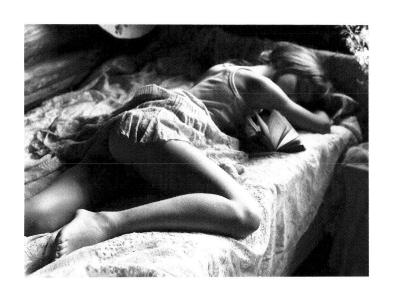

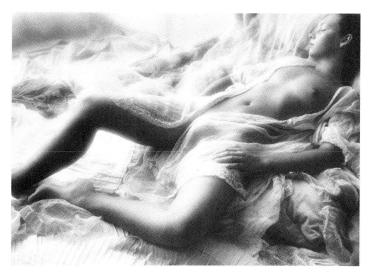

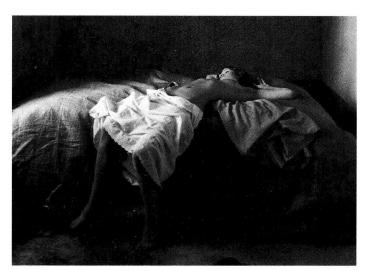

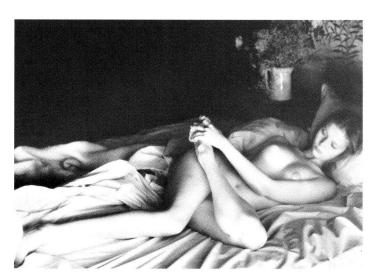

The heat of the night

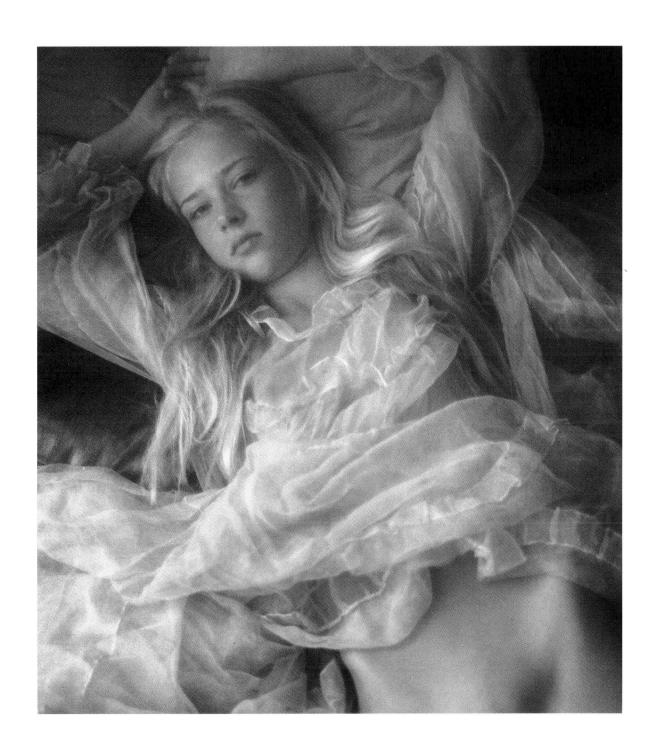

False innocence, South of France, 1986

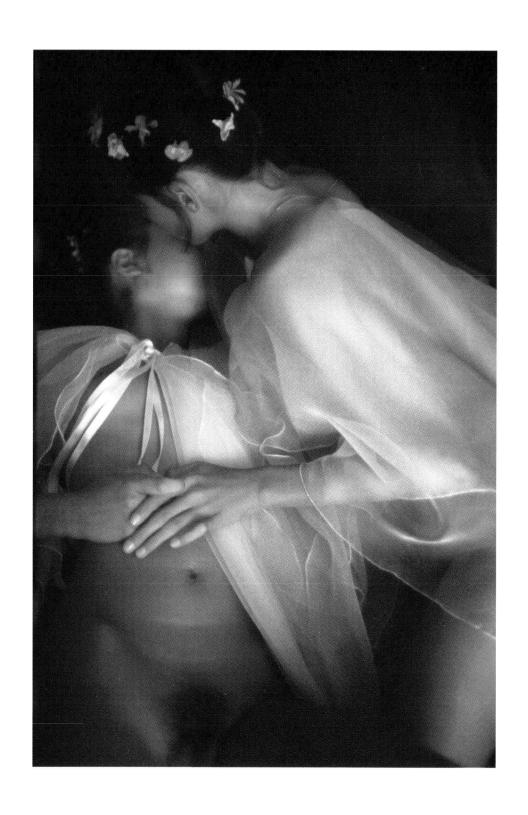

The kiss, Saint-Tropez, 1976

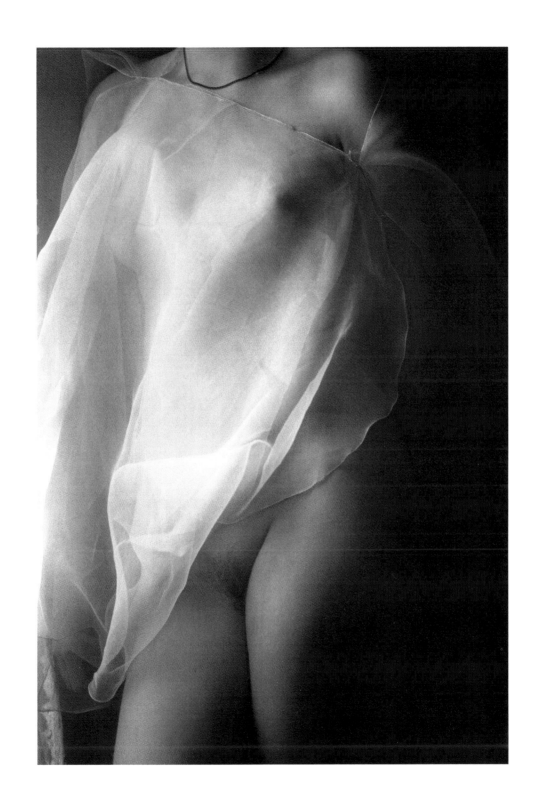

The lilac veil, Saint-Tropez, 1976

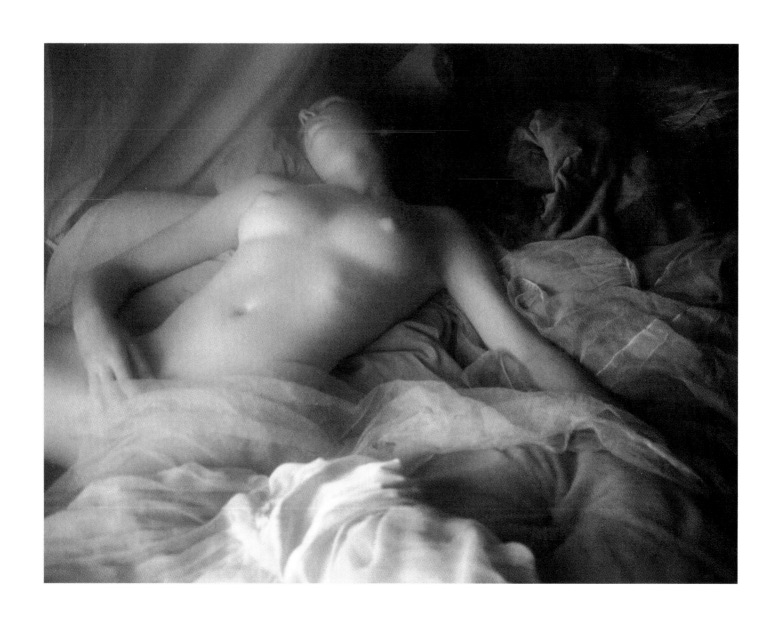

Fantasy, South of France, 1985

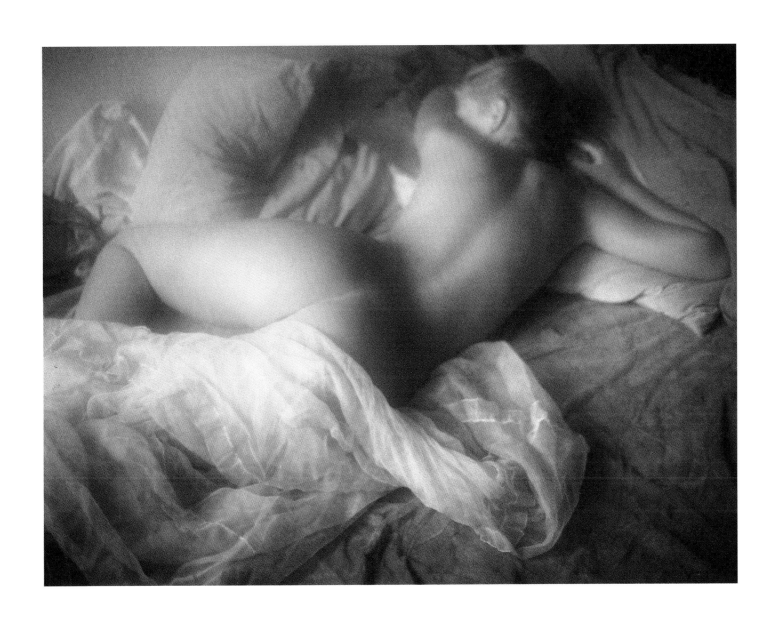

Provocation, South of France, 1985

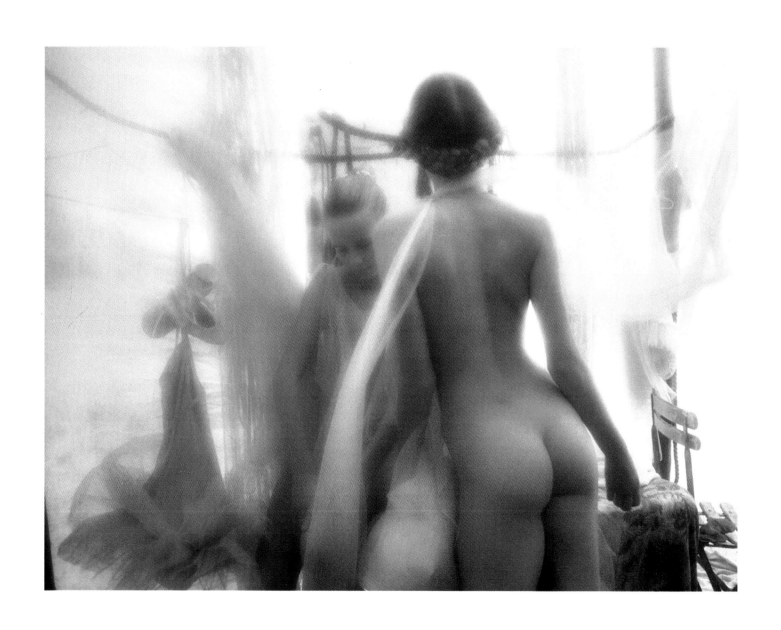

Scene from "Bilitis", Saint-Tropez, 1976

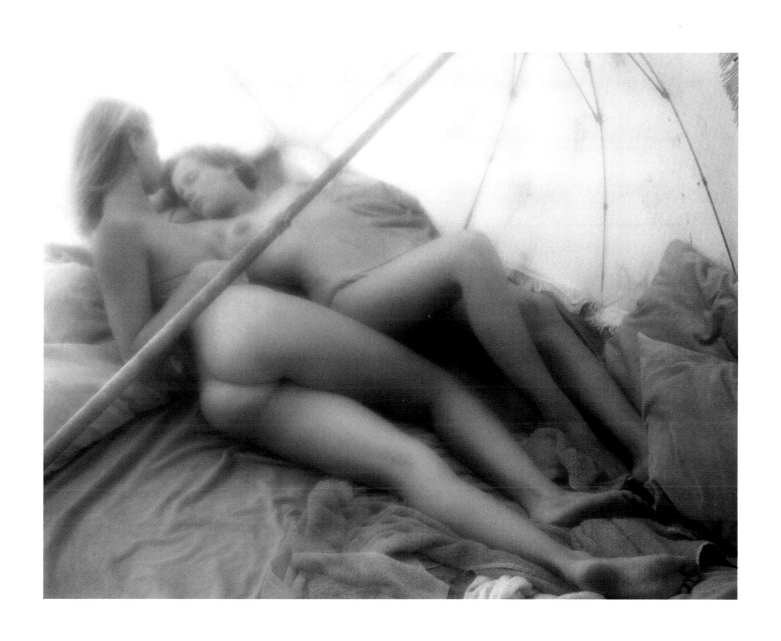

Scene from "Premiers Désirs", Saint-Tropez, 1983

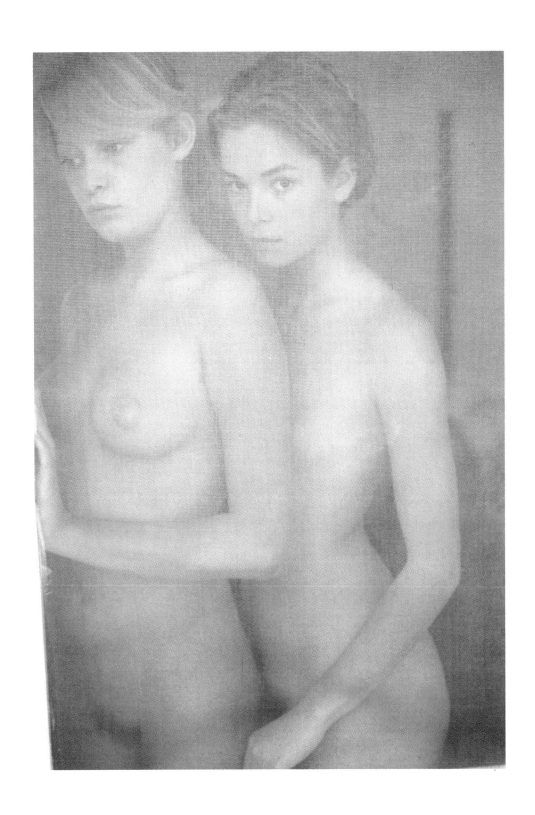

Catherina and Larry, Bahamas, 1978

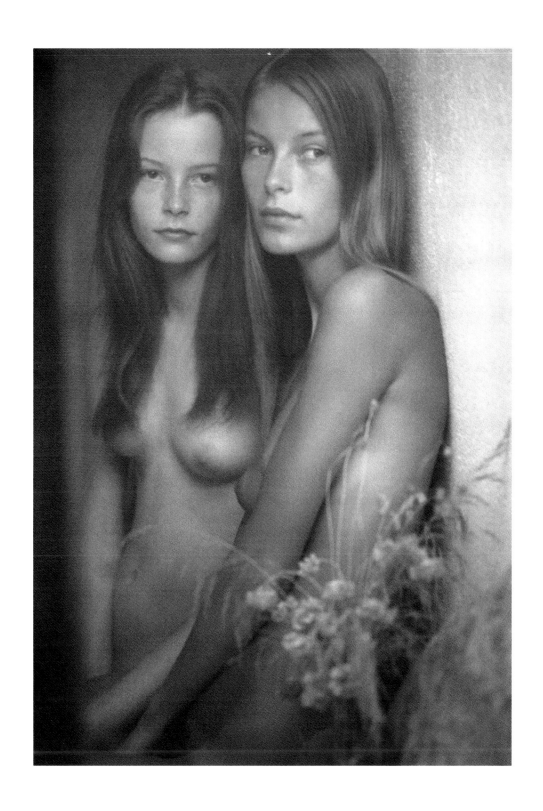

Heidi and Mona, Ramatuelle, 1970

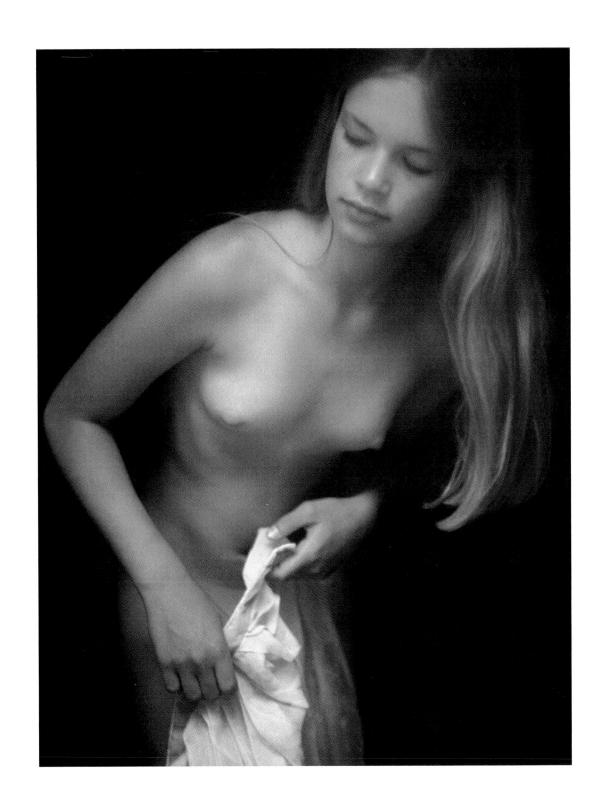

Undressing, Copenhagen, 1972

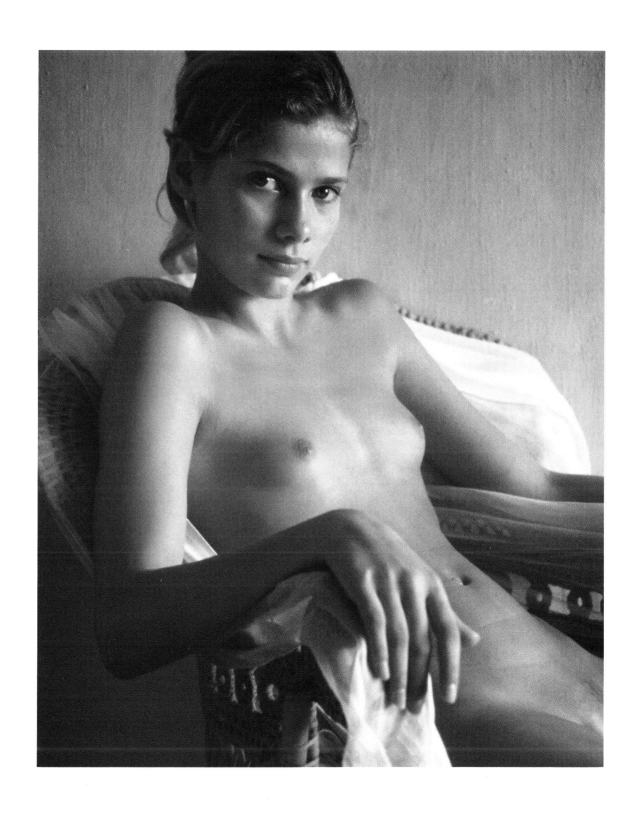

Carine, South of France, 1988

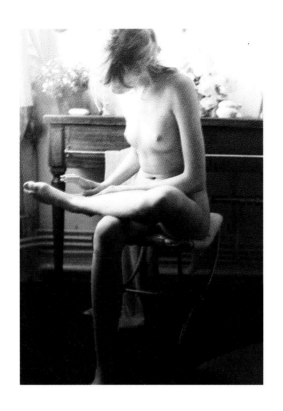
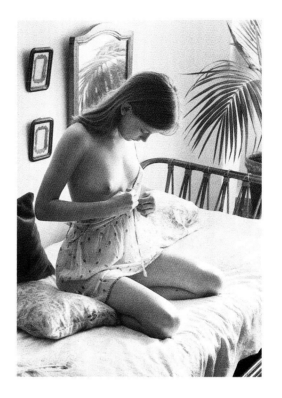
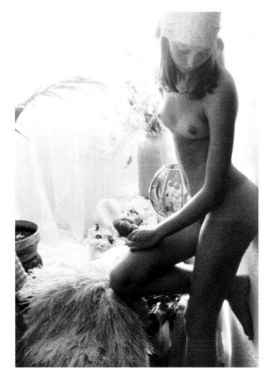
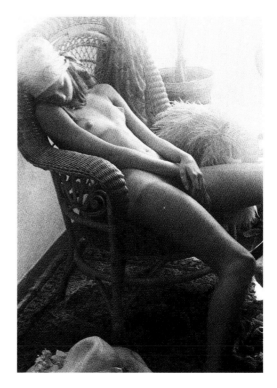

Private moments.

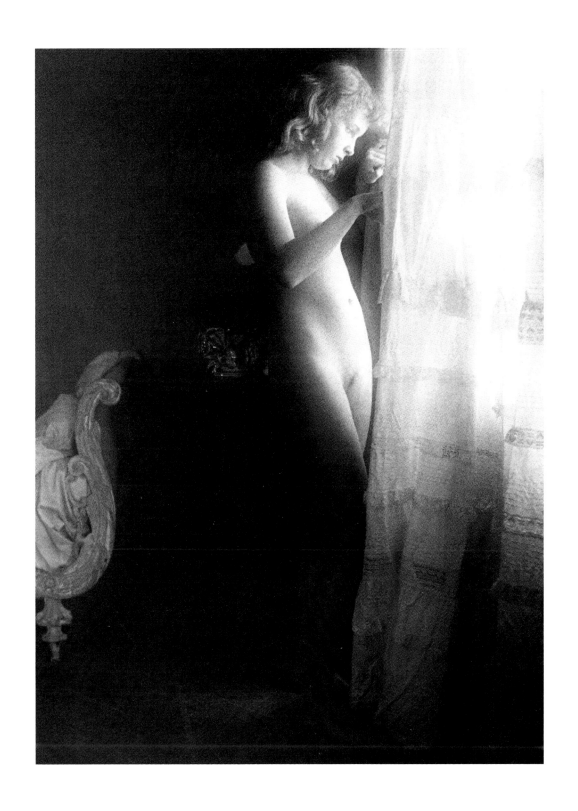

Young girl at the window, Saint-Tropez, 1978

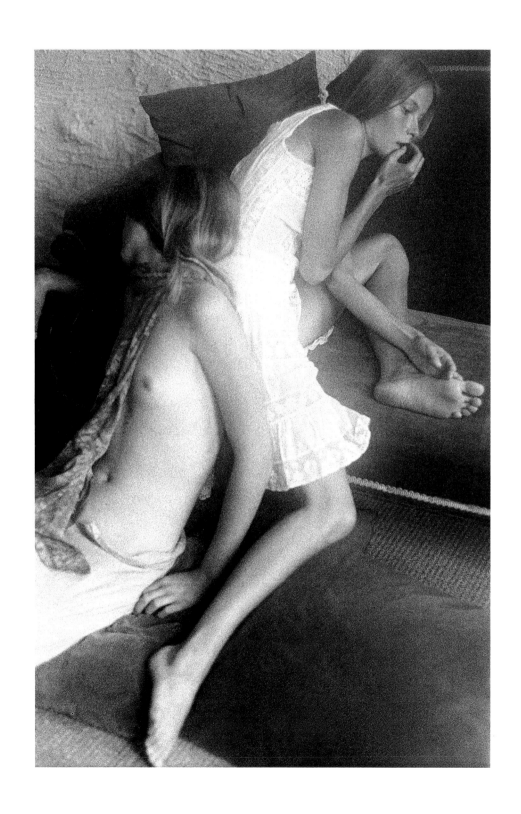

Hesitation, Amsterdam, 1973

46

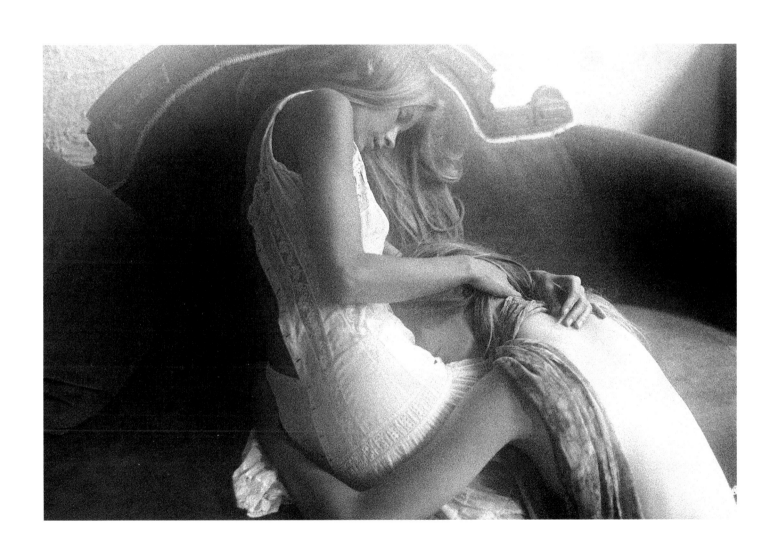

Confession, Amsterdam, 1973

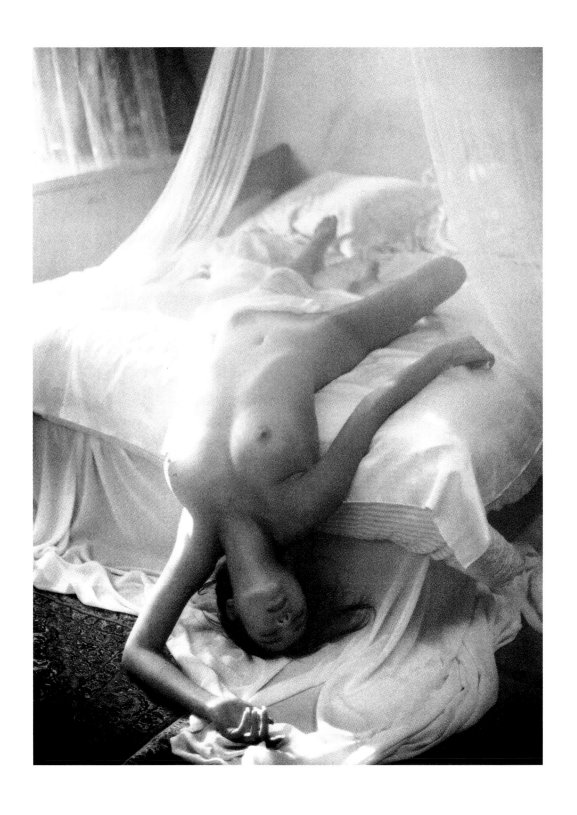

Abandon, Tokyo, 1986

48

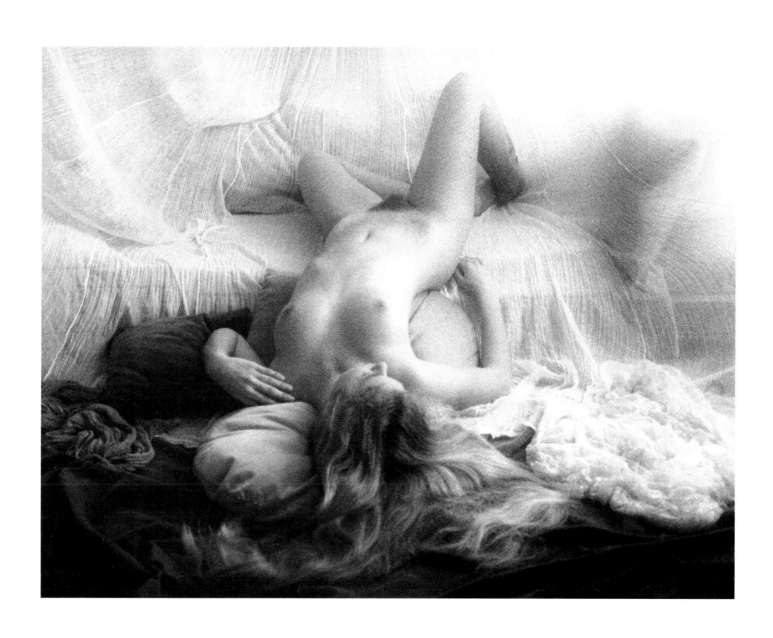

Voluptuous beauty, Ramatuelle, 1985

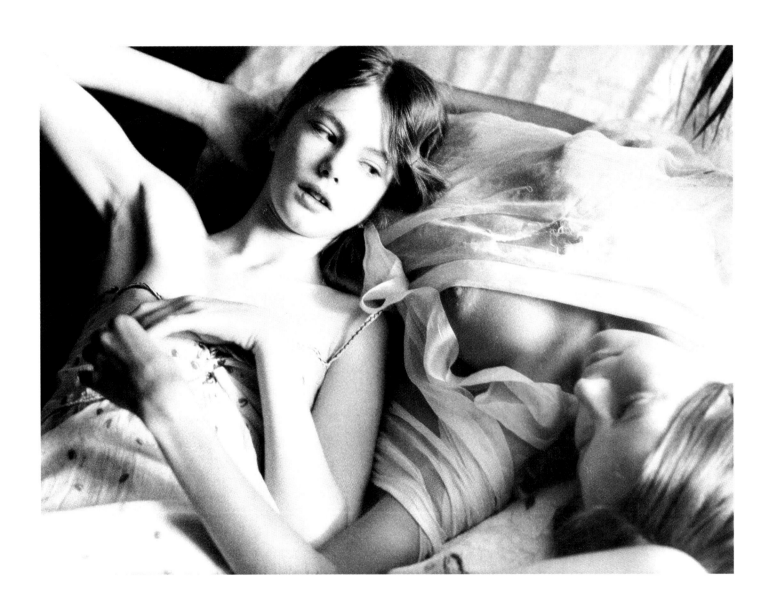

Mandy and Mona, Ramatuelle, 1971

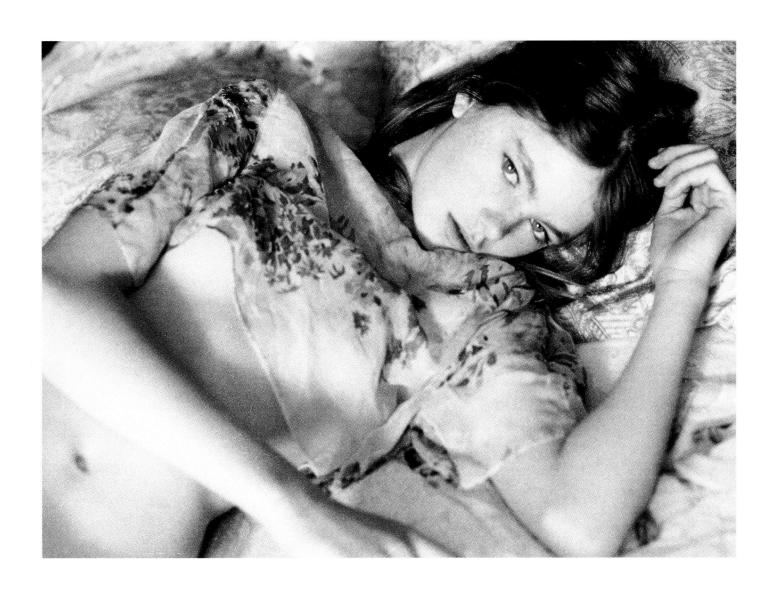

Mandy, Ramatuelle, 1971

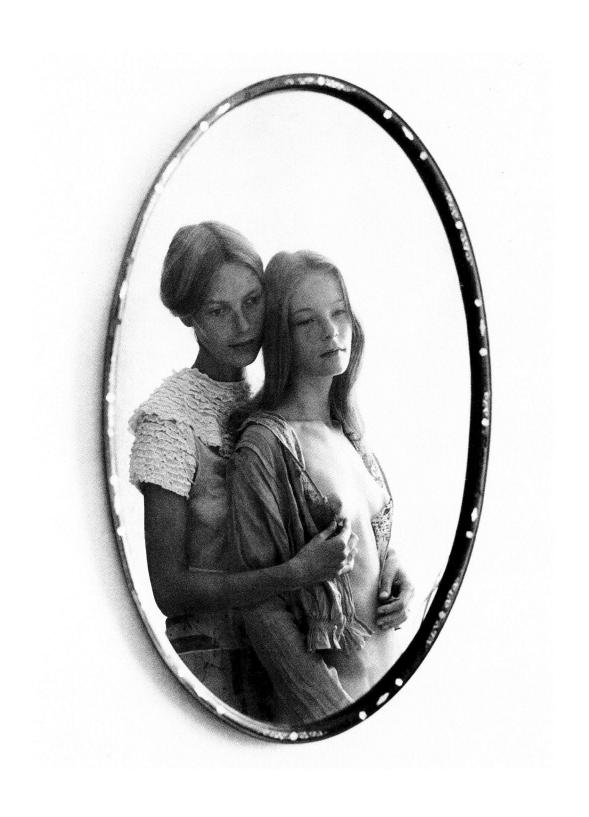

Mirror, mirror on the wall, Ramatuelle, 1970

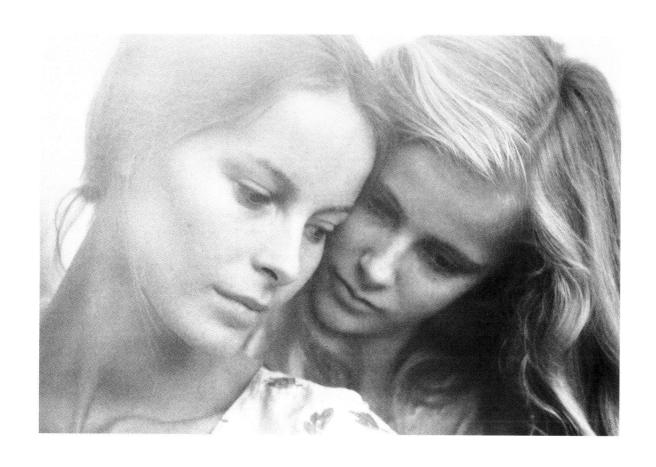

Double beauty, Ramatuelle, 1972

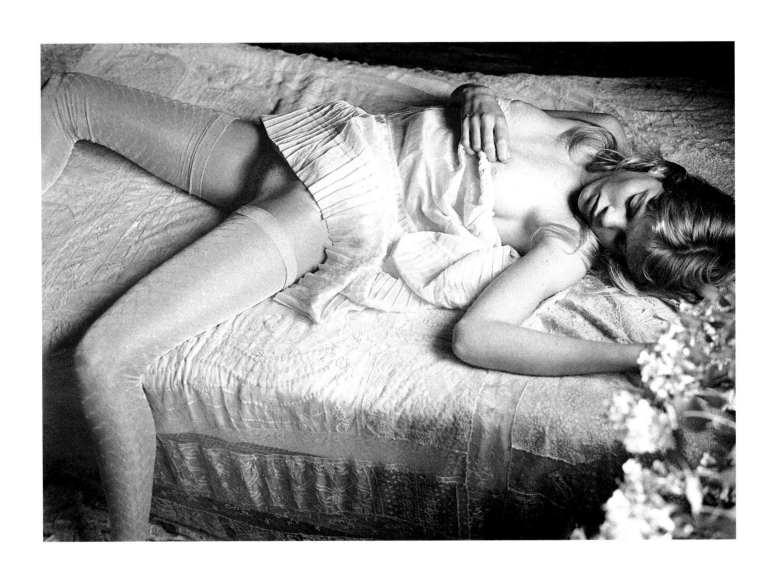

First desires, Hornbeck, Denmark, 1972

54

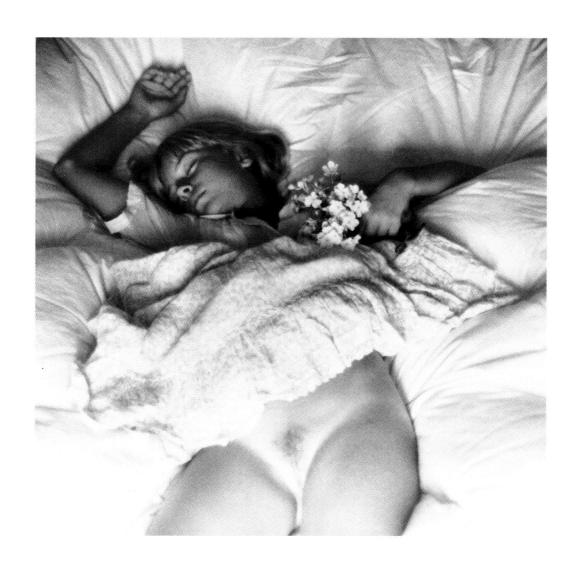

Feigning sleep, Saint-Tropez, 1982

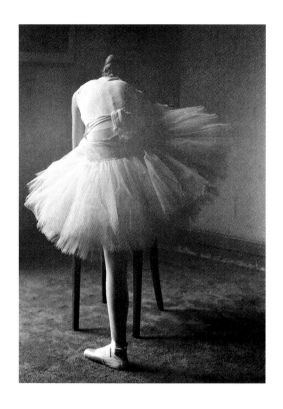
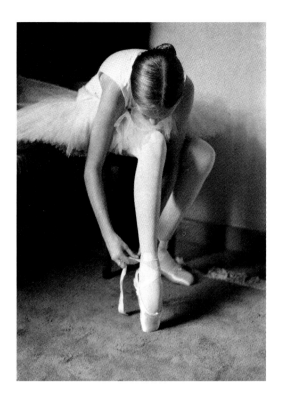
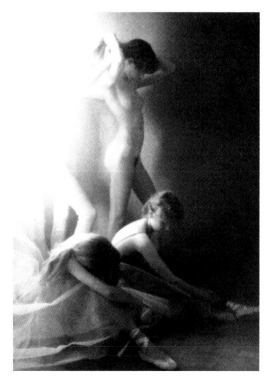
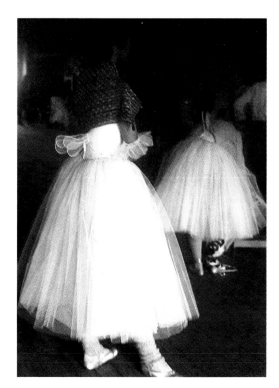

Young dancers

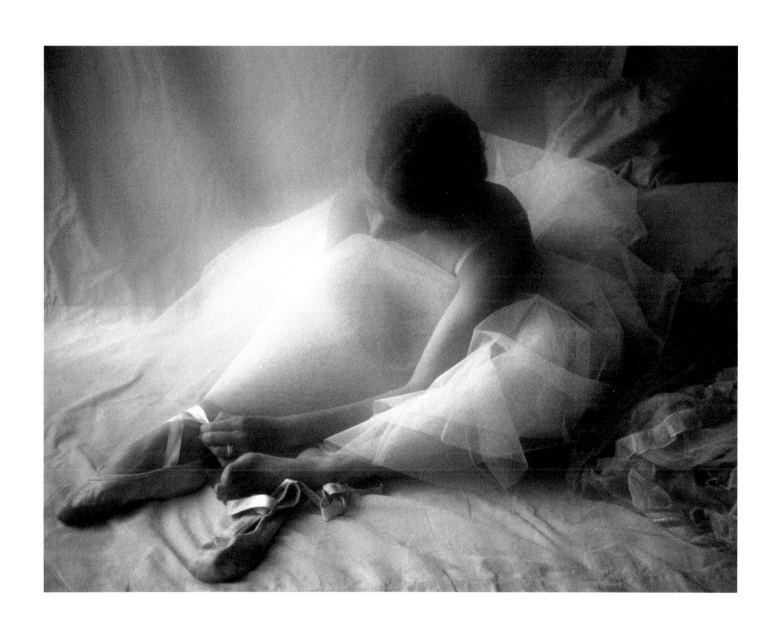

Dreaming of a stardom, South of France, 1979

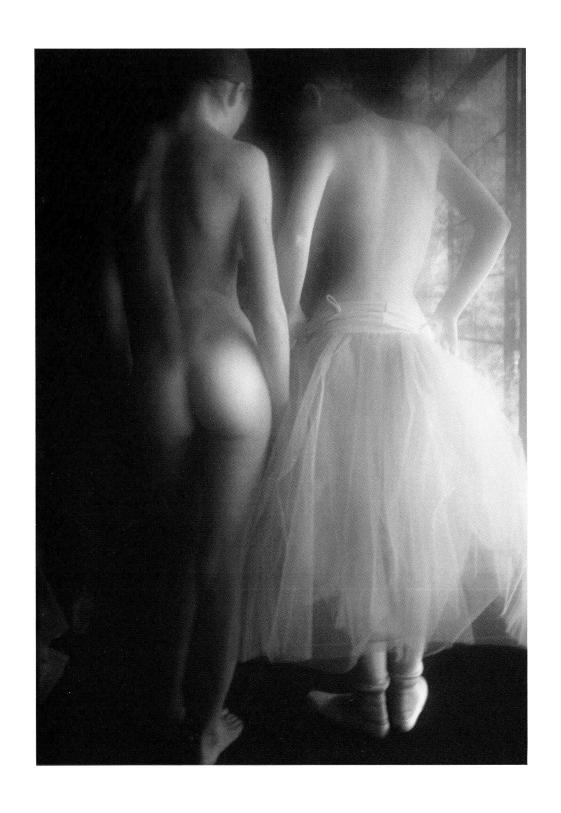

After rehearsal, Ramatuelle, 1985

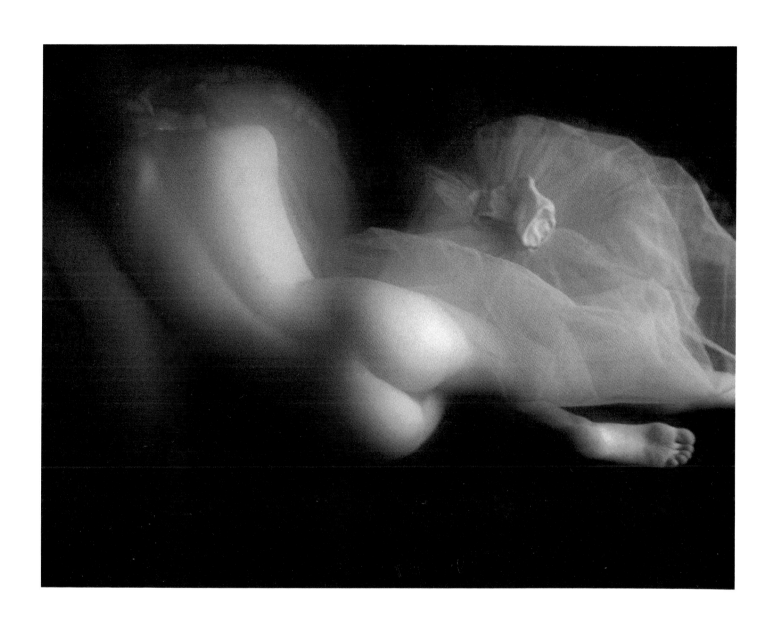

Resting, Ramatuelle, 1985

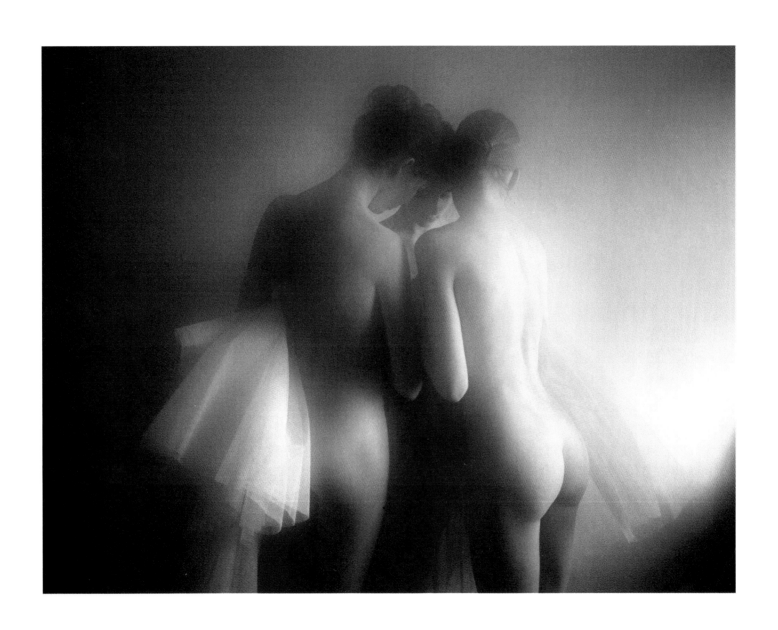

Whispering, Ramatuelle, 1985

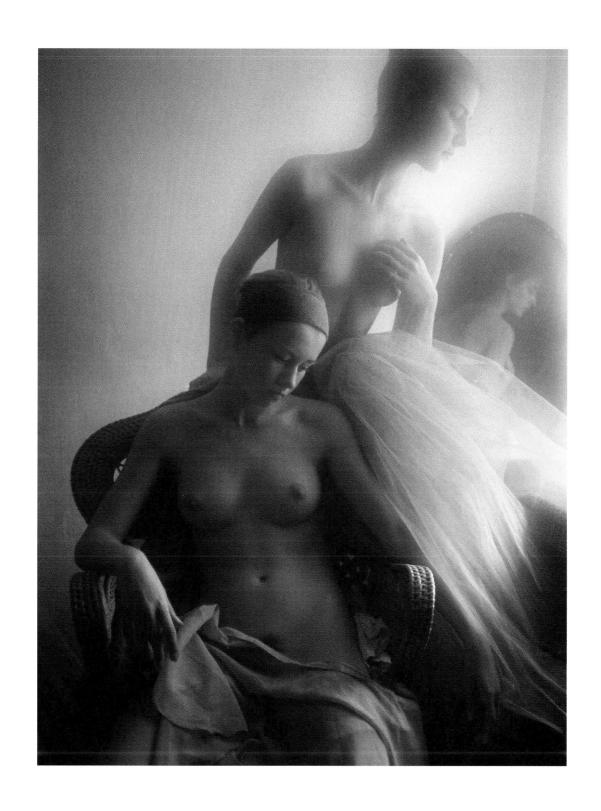

Francesca and Sandrine, Ramatuelle, 1985

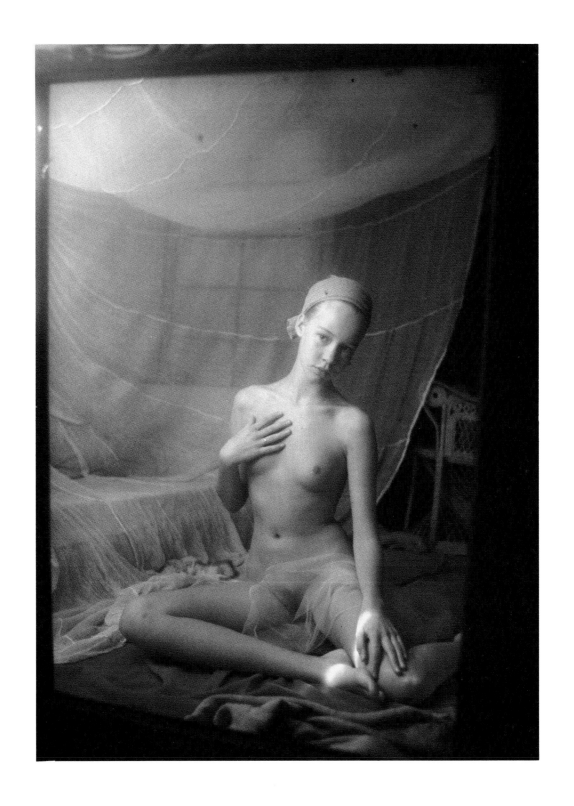

The narcissus, South of France, 1985

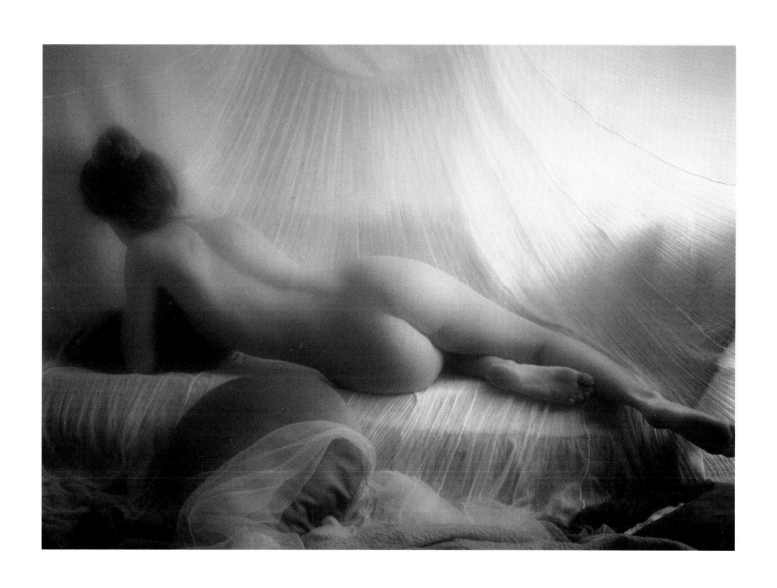

The mosquito net, South of France, 1984

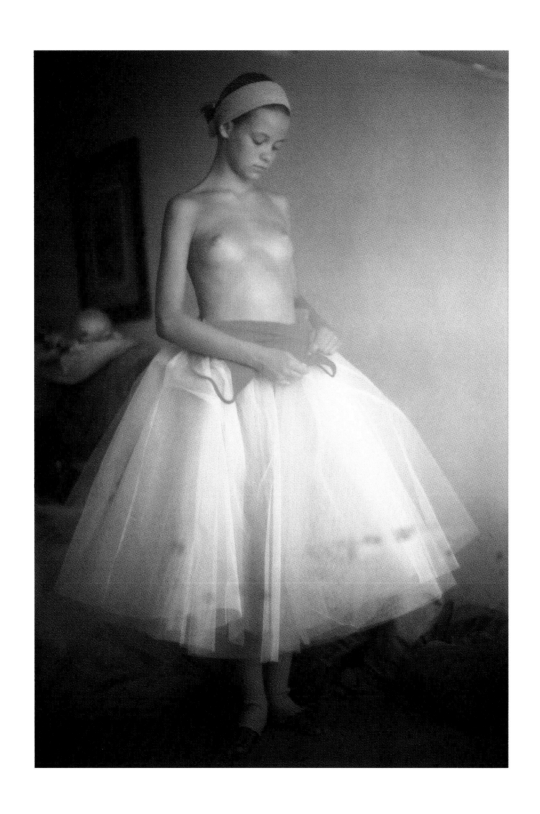

The young dancer, South of France, 1985

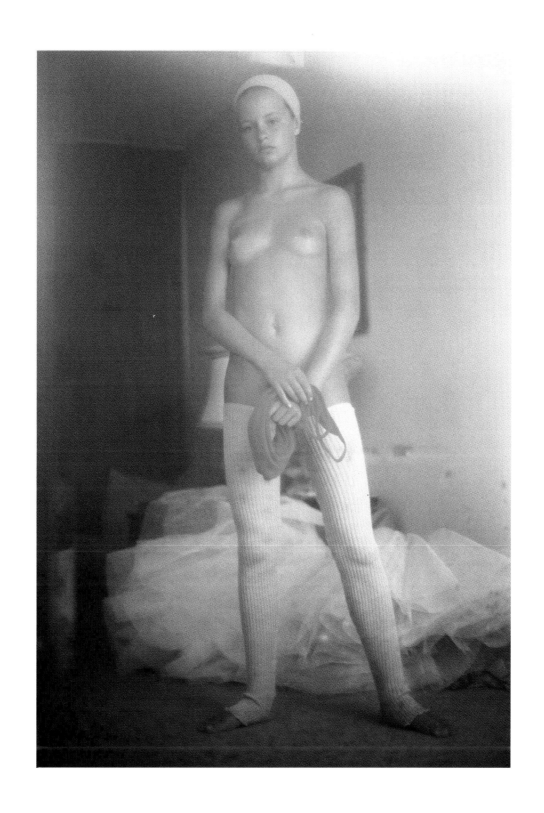

Stephanie, South of France, 1985

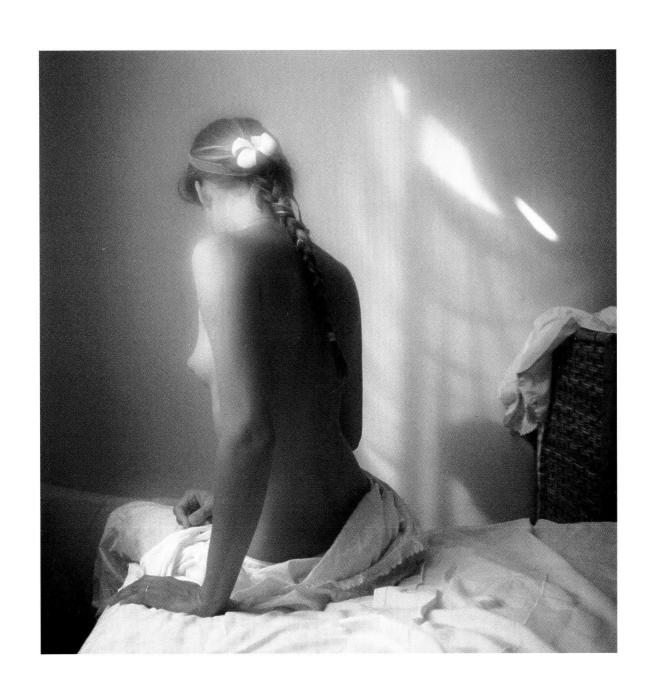

Interior beachhouse, Guam, 1987

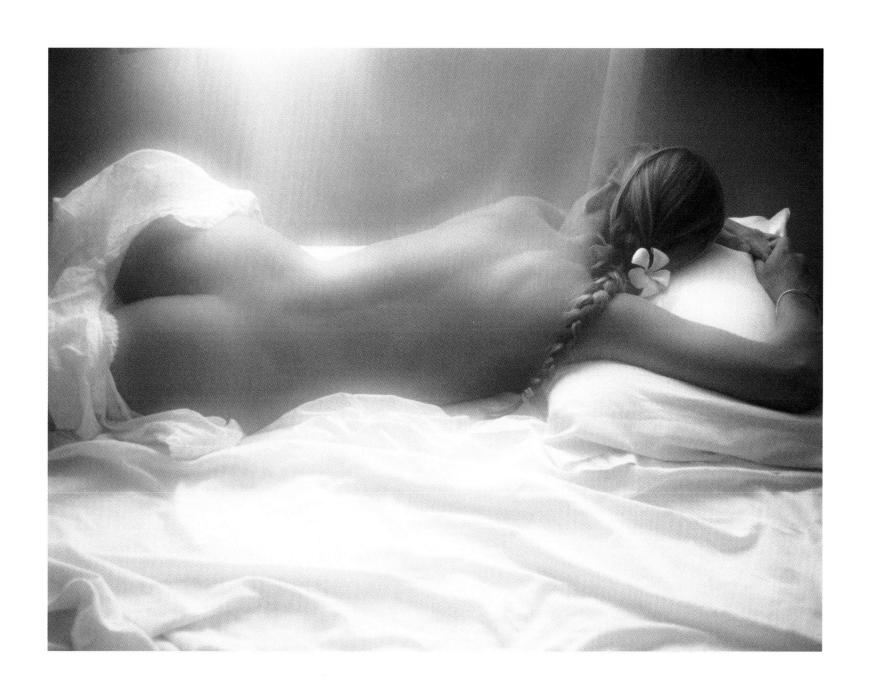

Alexia, Guam, 1987

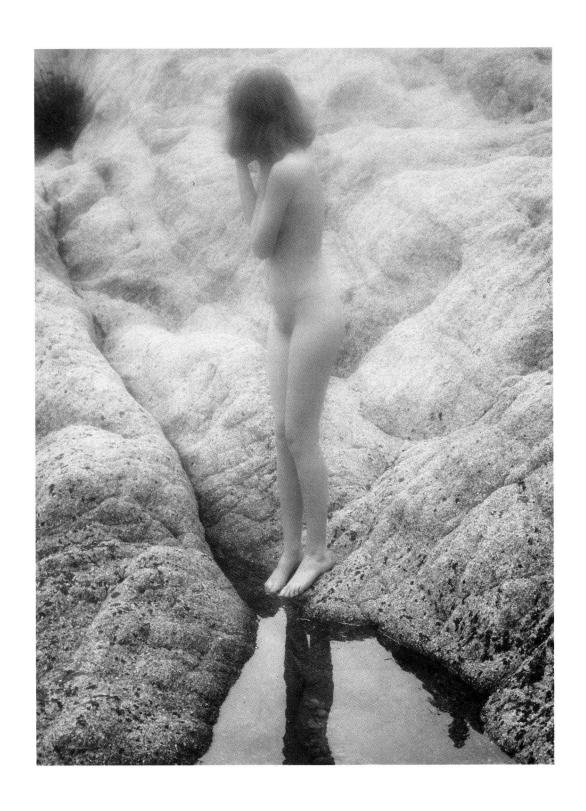

The rock pool, Saint-Tropez, 1973

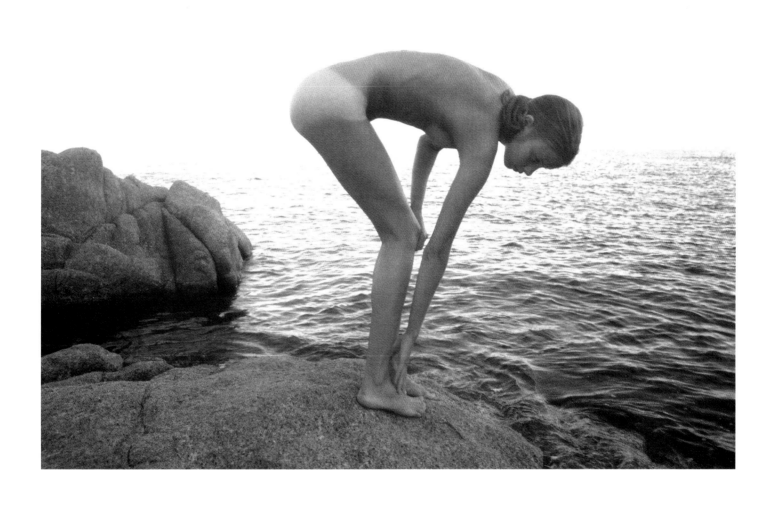

The rock nymph, Saint-Tropez, 1969

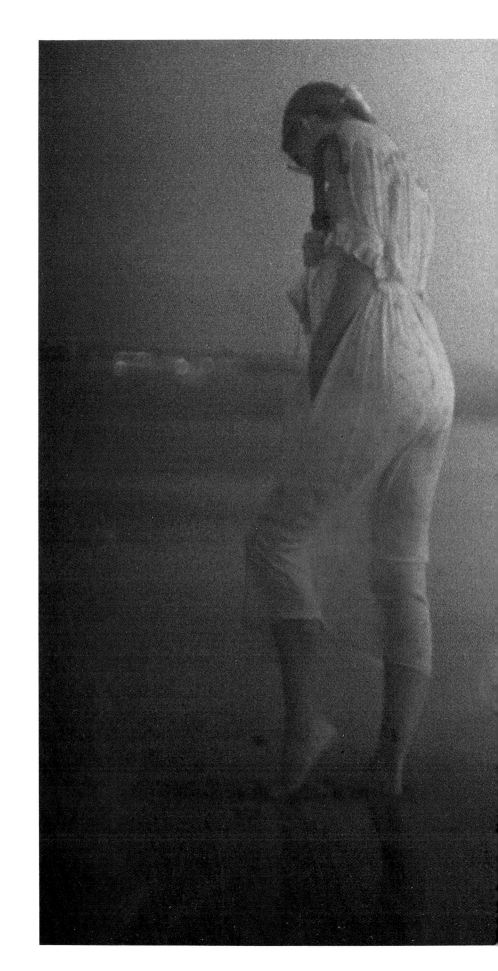

The shell seekers, Agadir, 1971

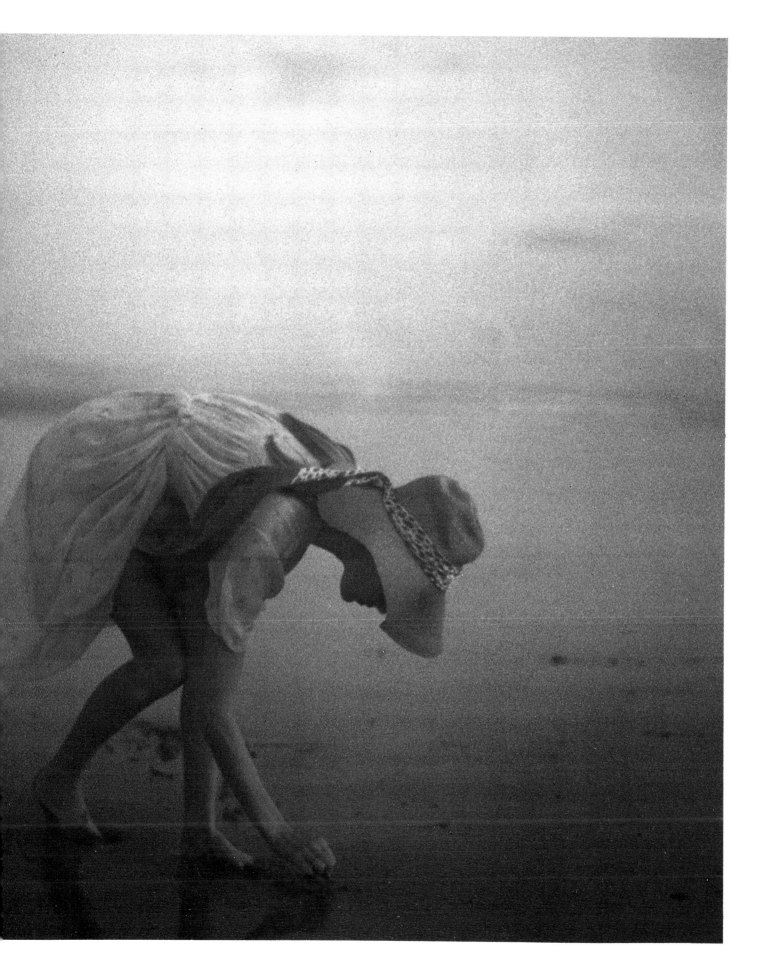

L'Air du Temps, Sylt, 1972

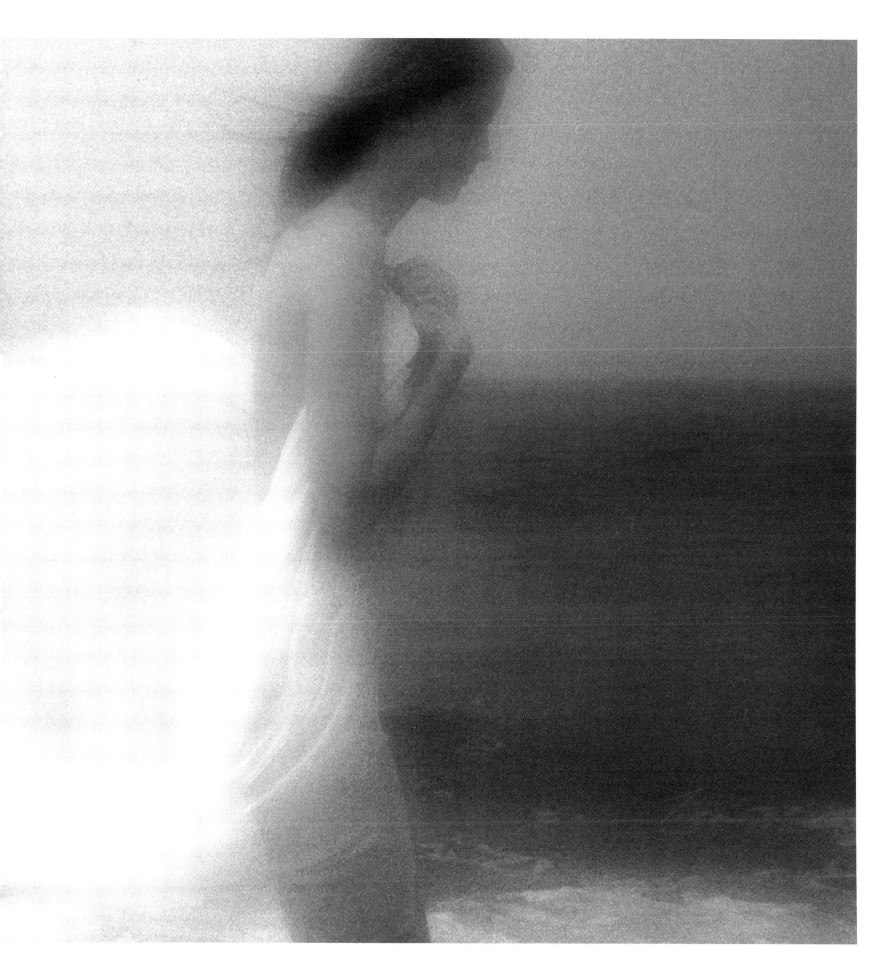

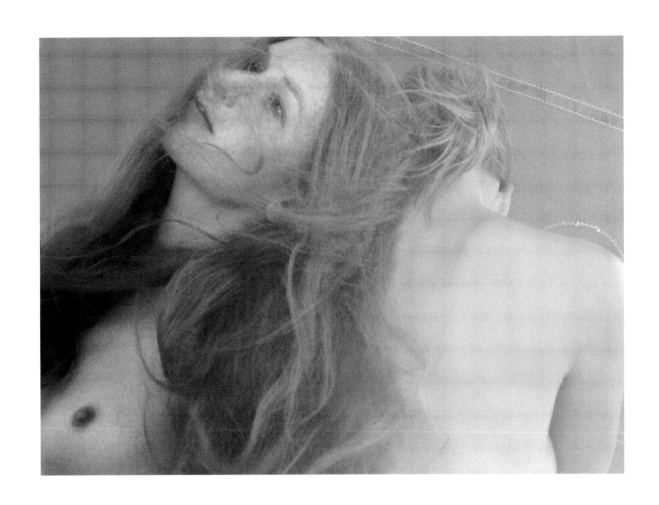

Summerbreeze, Agadir, 1971

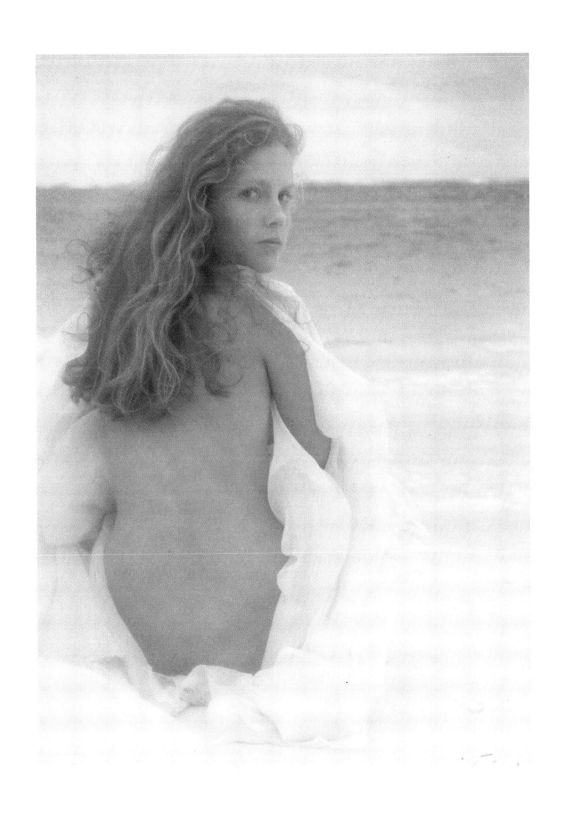

Surprised, Bahamas, 1978

La joie de vivre, Phuket, Thailand, 1986

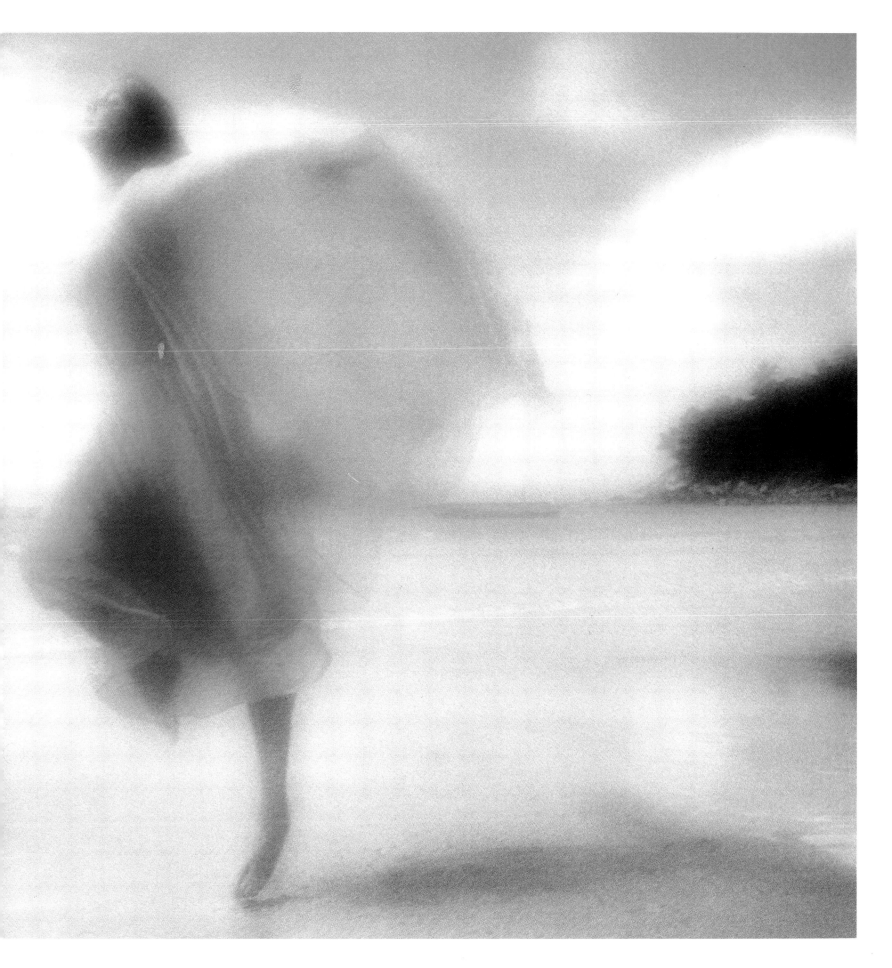

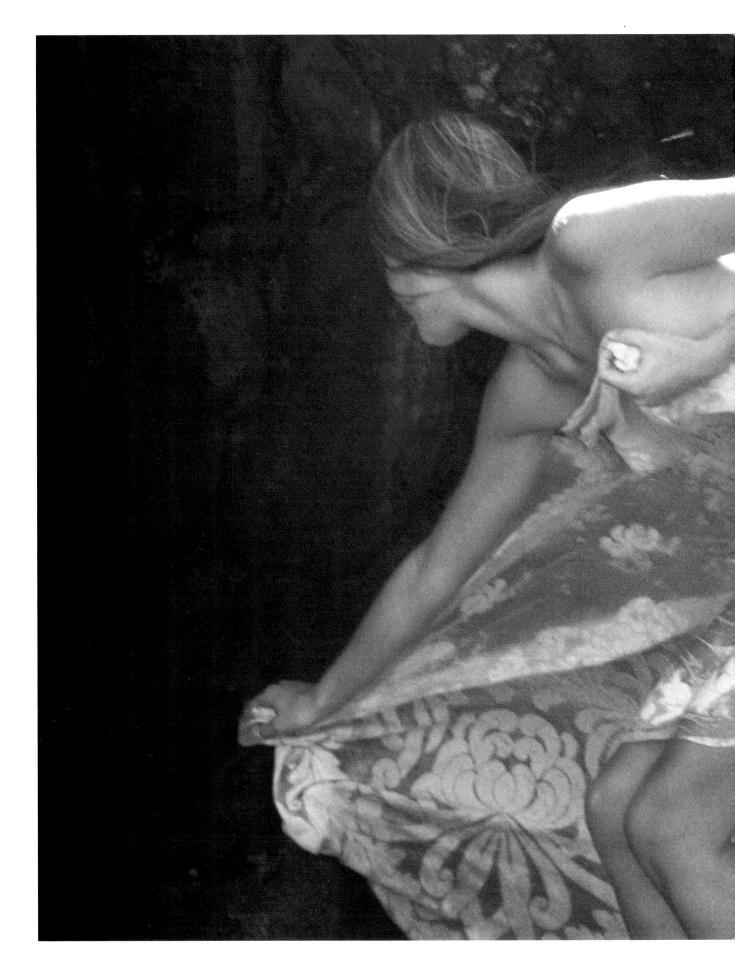

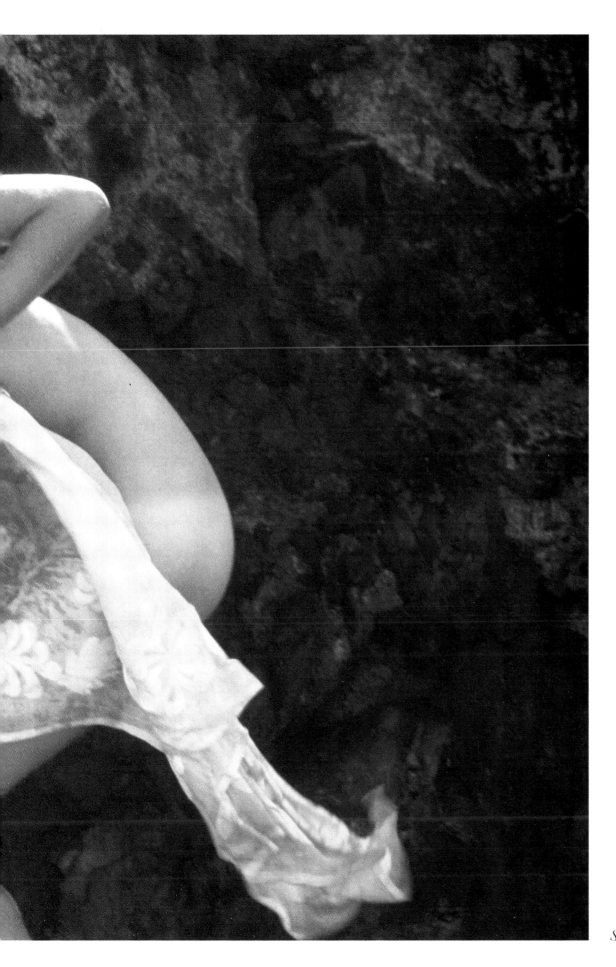

Surprised by the wind, Hawaii, 1973

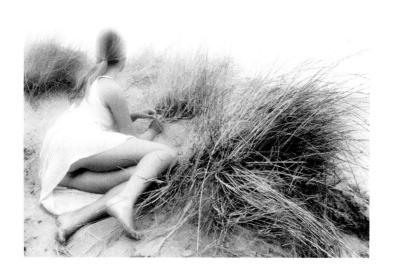
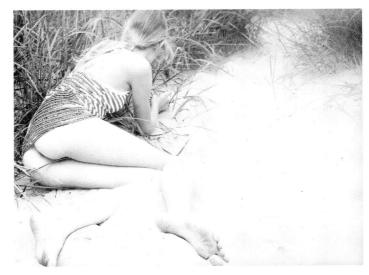
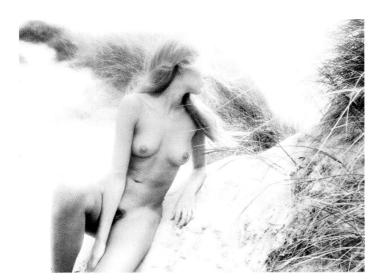
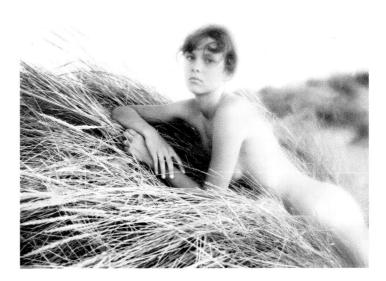

Dune nymphs

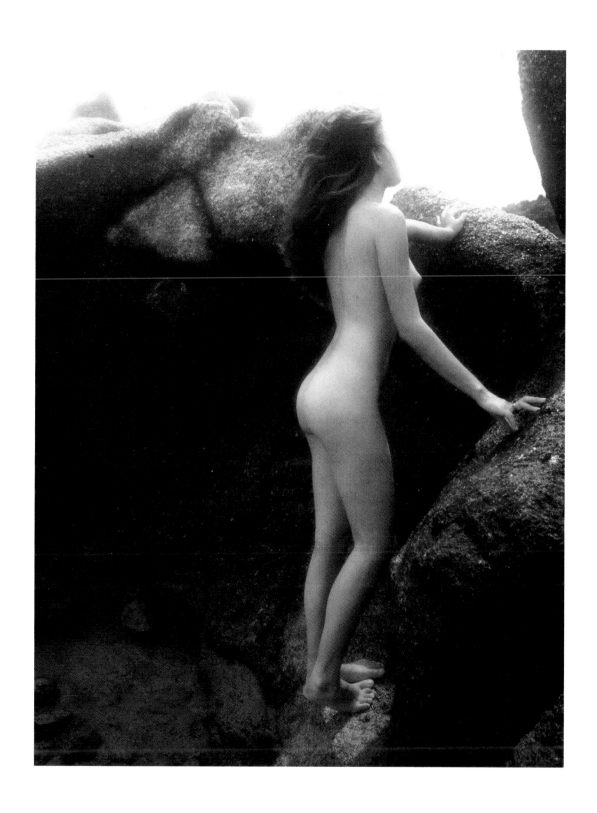

My secret place, Thailand, 1981

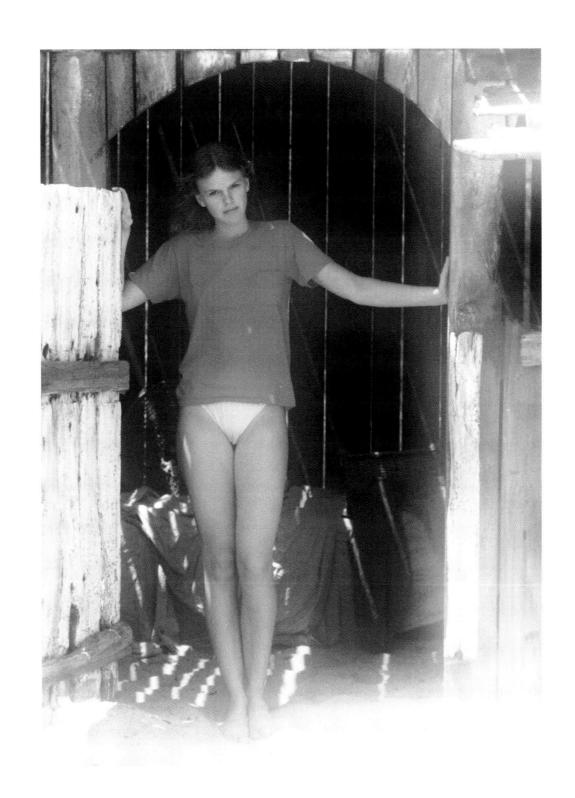

The beach hut, Saint-Tropez, 1983

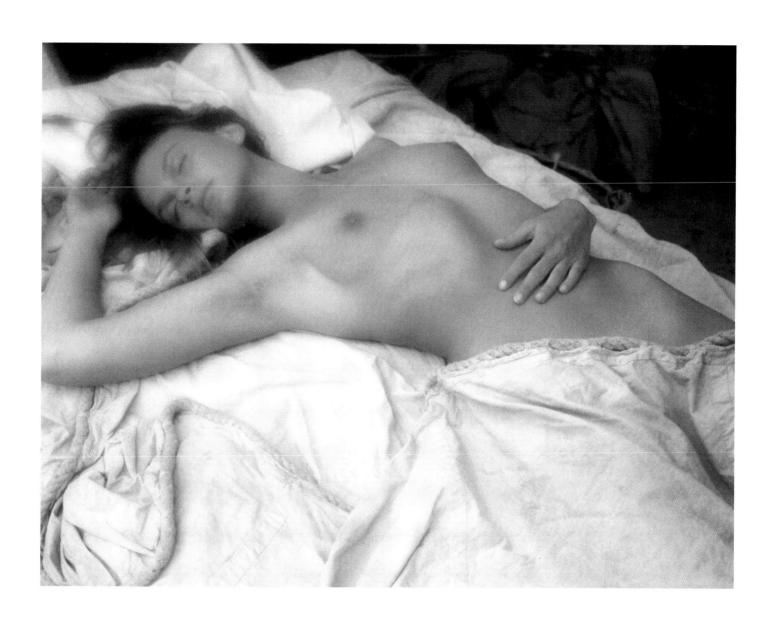

Monica, Saint-Tropez, 1983

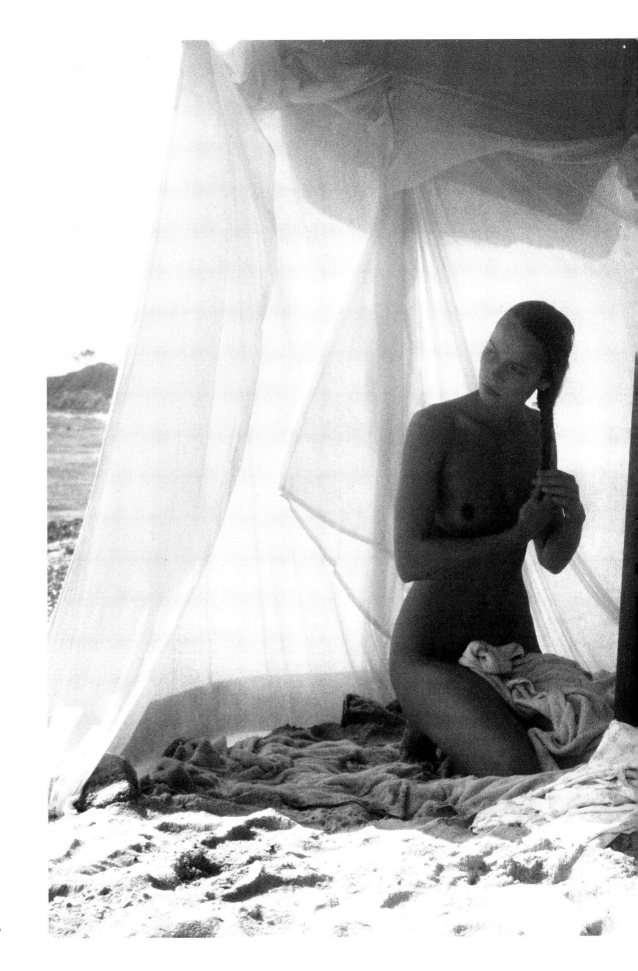

The red tent, Saint-Tropez, 1982

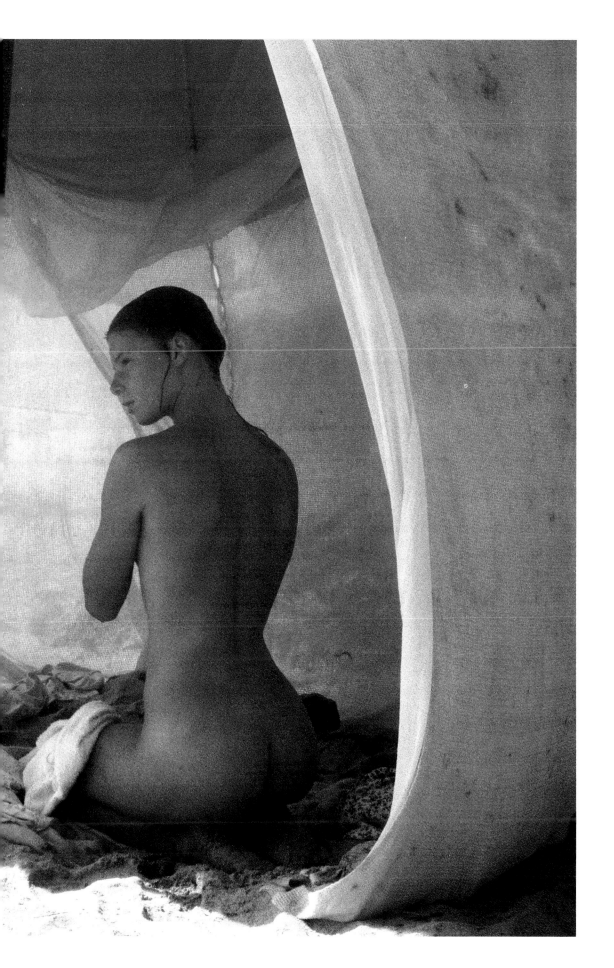

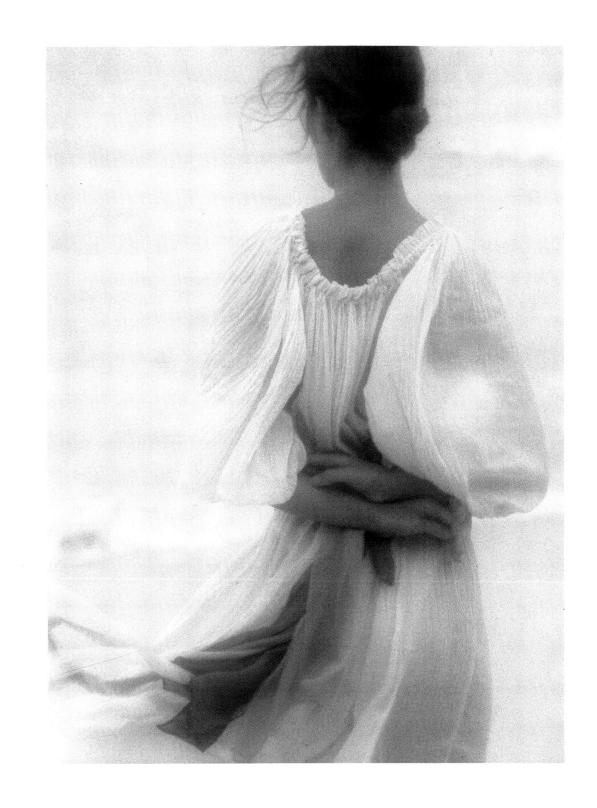

Ribbons, Mauritius, 1989

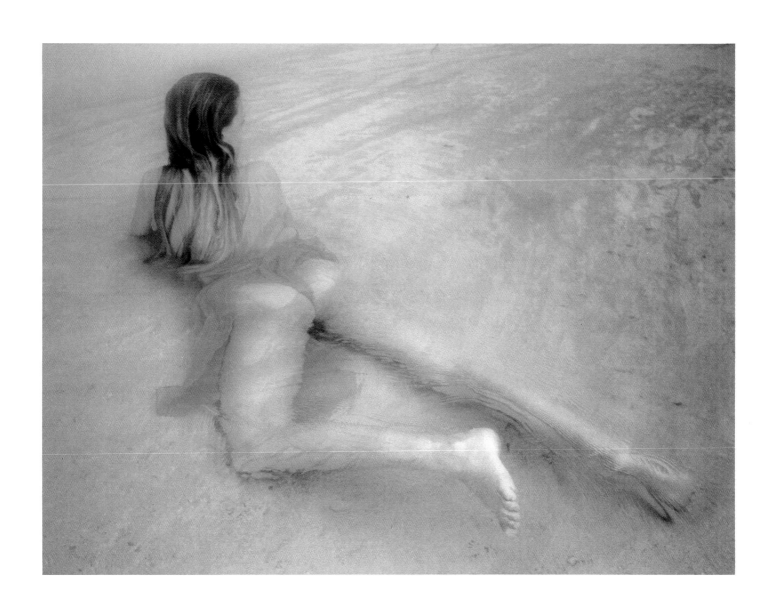

Cooling off, Tahiti, 1987

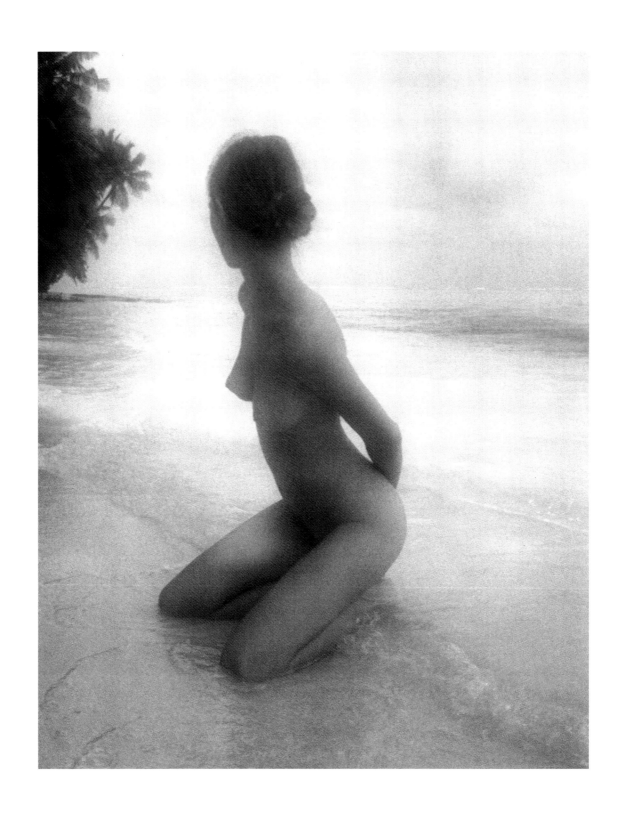

A beach of one's own, Maldive Islands, 1978

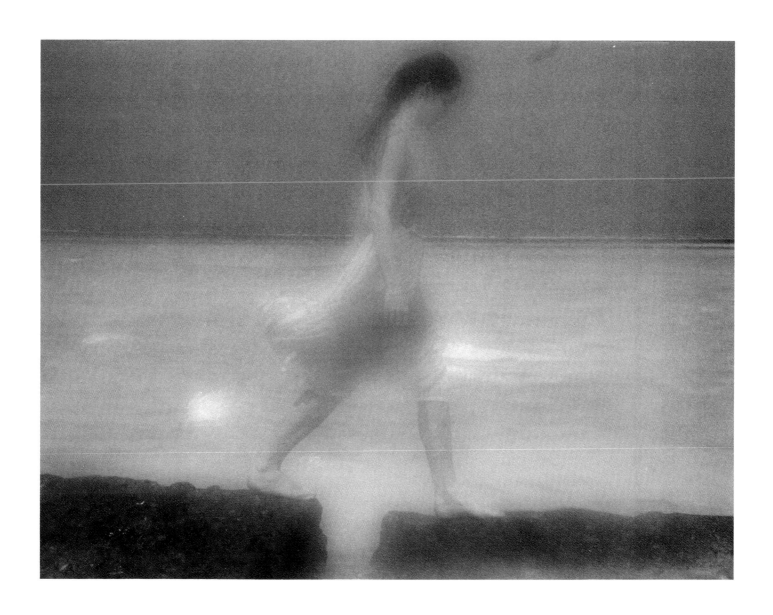

Before the storm, Guam, 1987

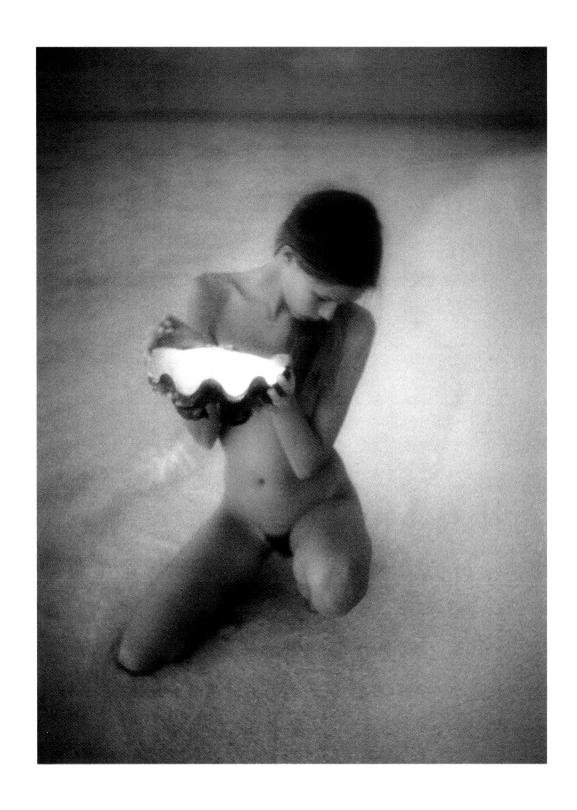

The shell, Maldive Islands, 1978

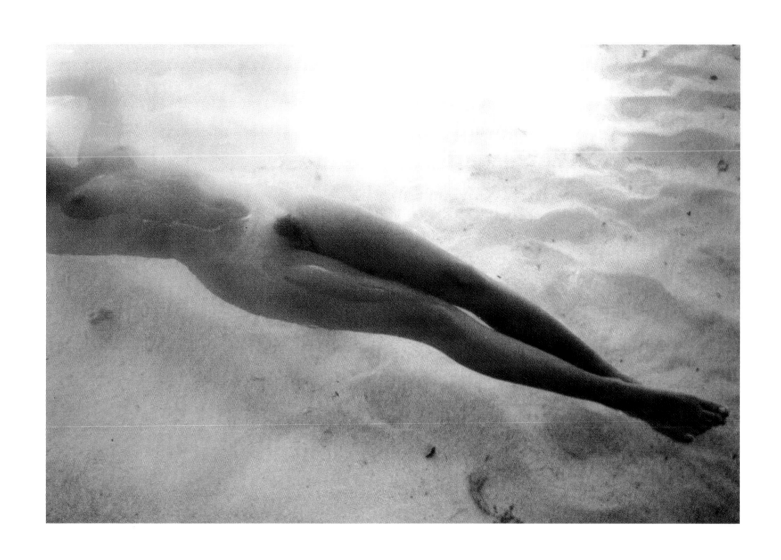

Floating, Tahiti, 1987

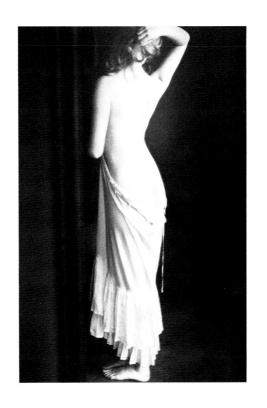
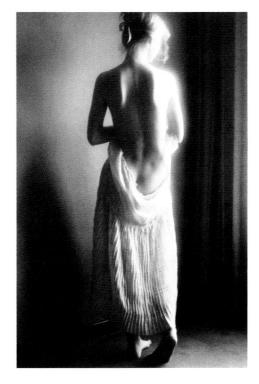
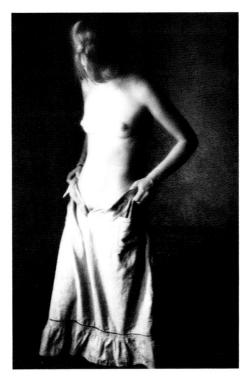
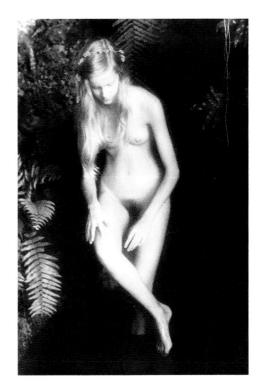

Solitude

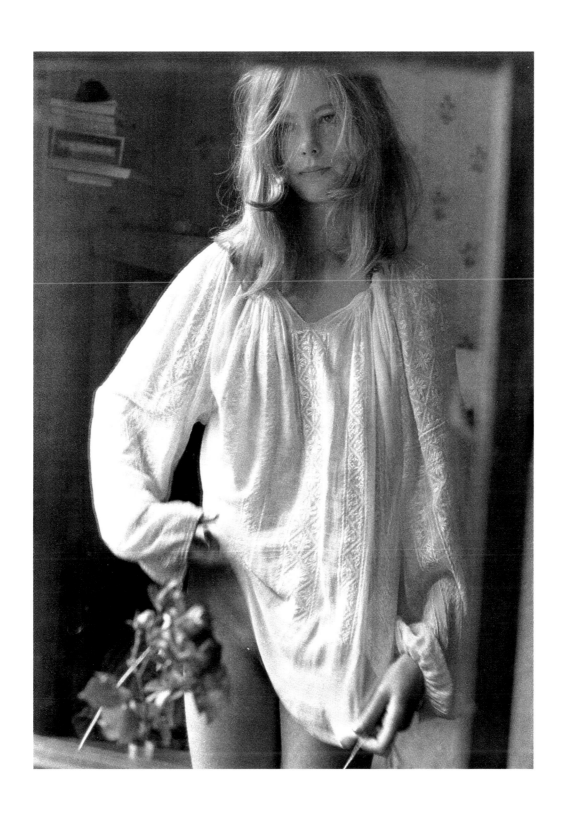

Awakening, England, 1970

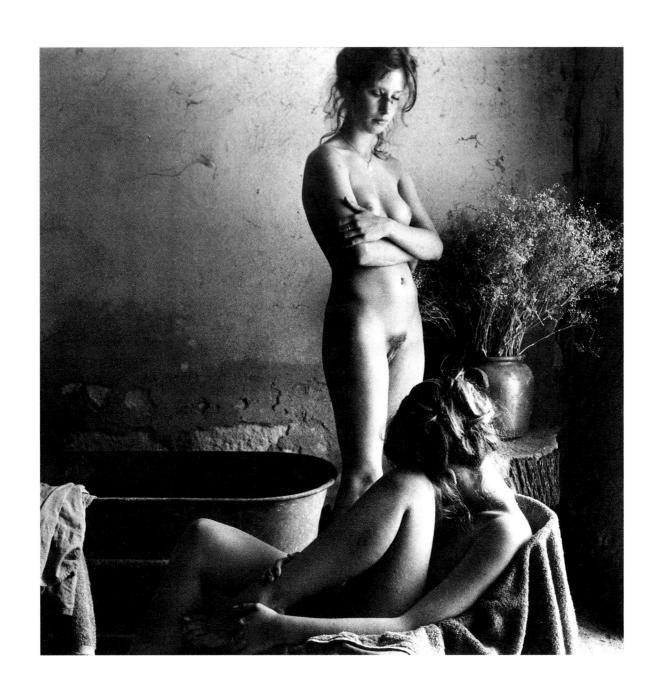

The bath, South of France, 1980

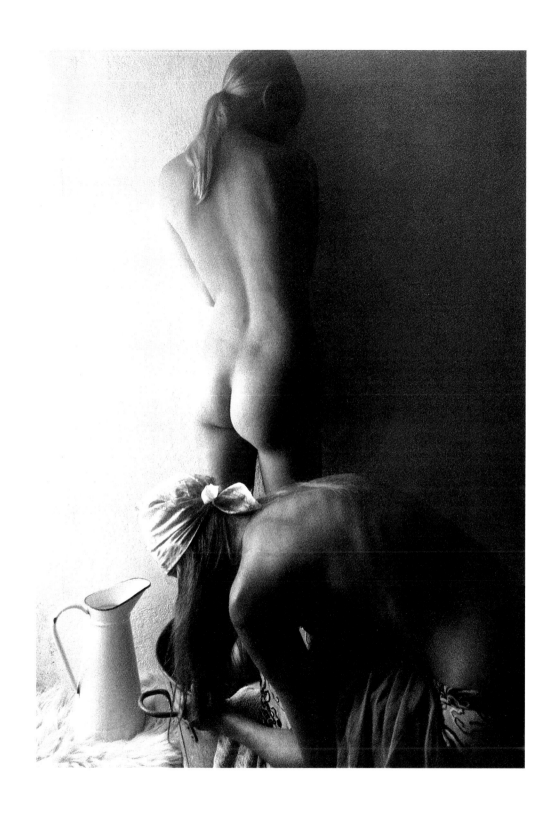

Washing, Ramatuelle, 1971

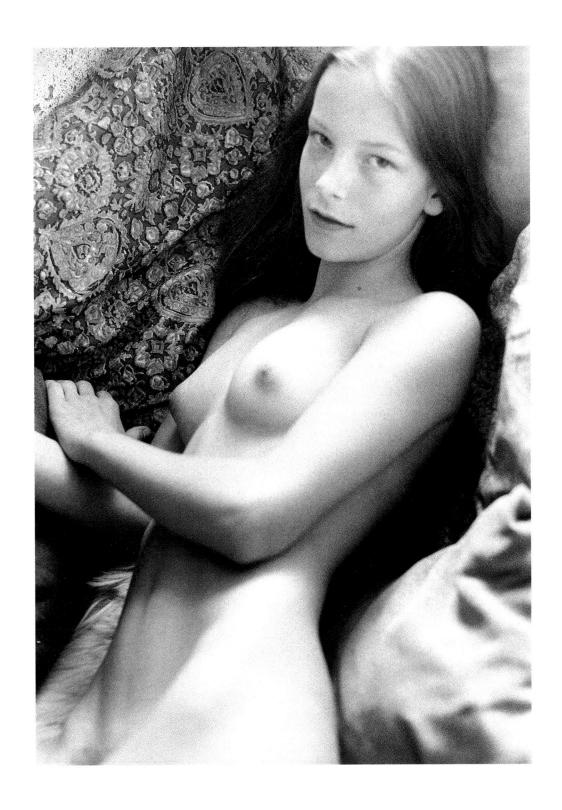

Heidi, Ramatuelle, 1971

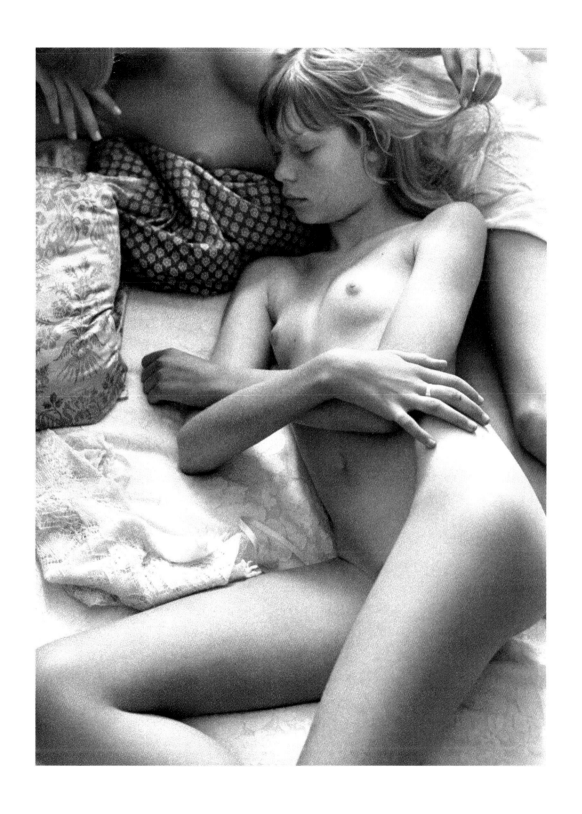

The young colt, Ramatuelle, 1972

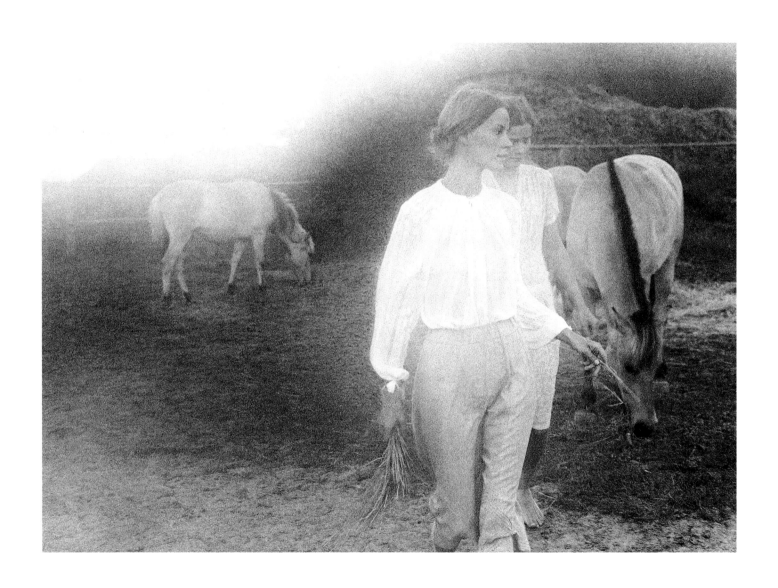

The farm, Sylt, 1972

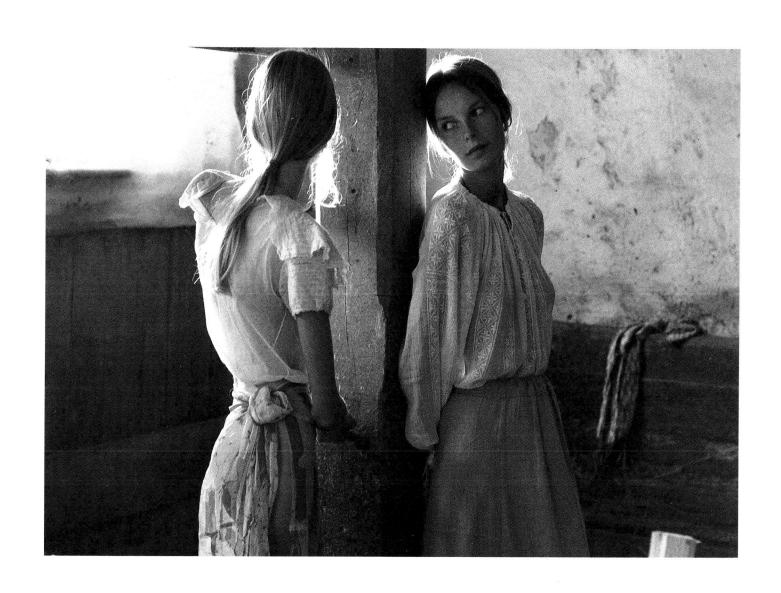

The hayloft, Sylt, 1972

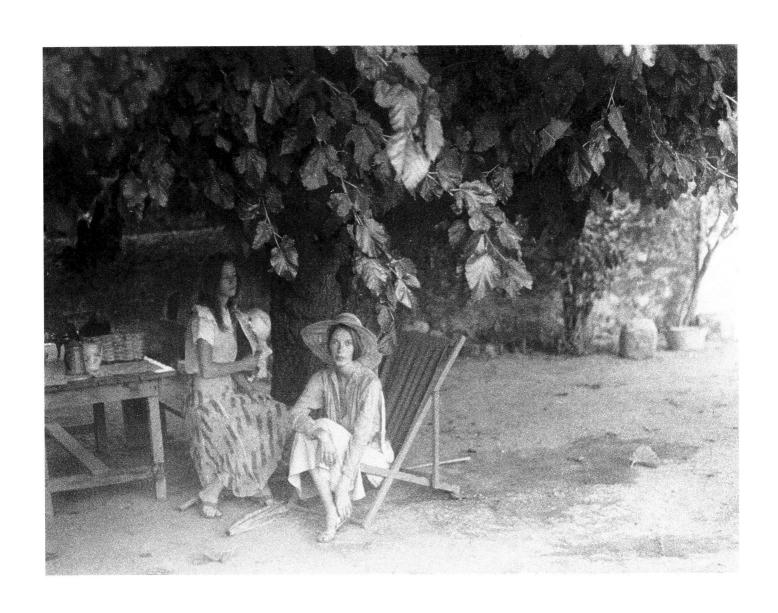

In the shade of the mulberry, Saint-Tropez, 1972

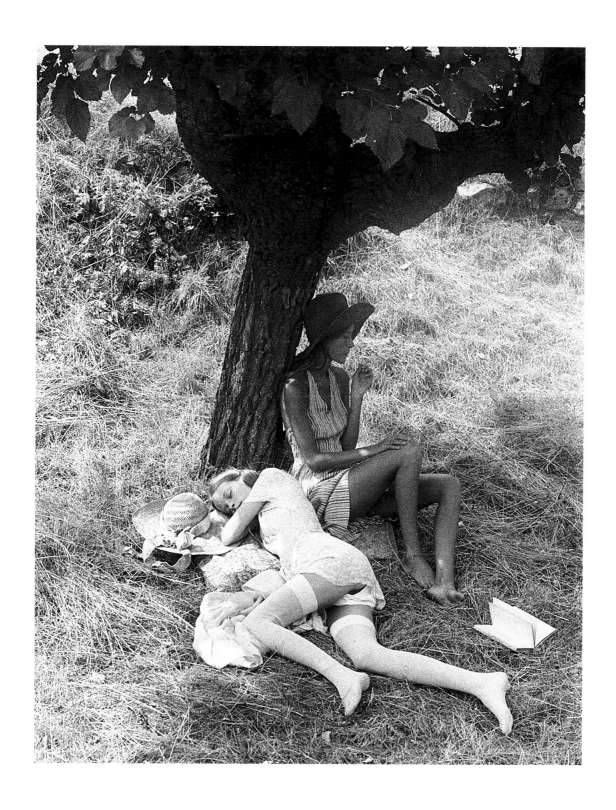

Summerheat, Saint-Tropez, 1972

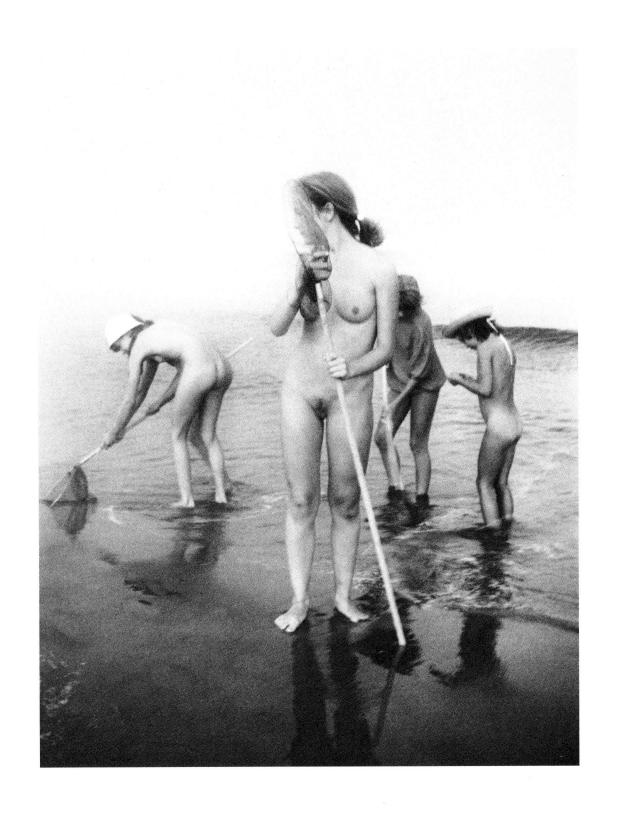

Shrimping, South of France, 1983

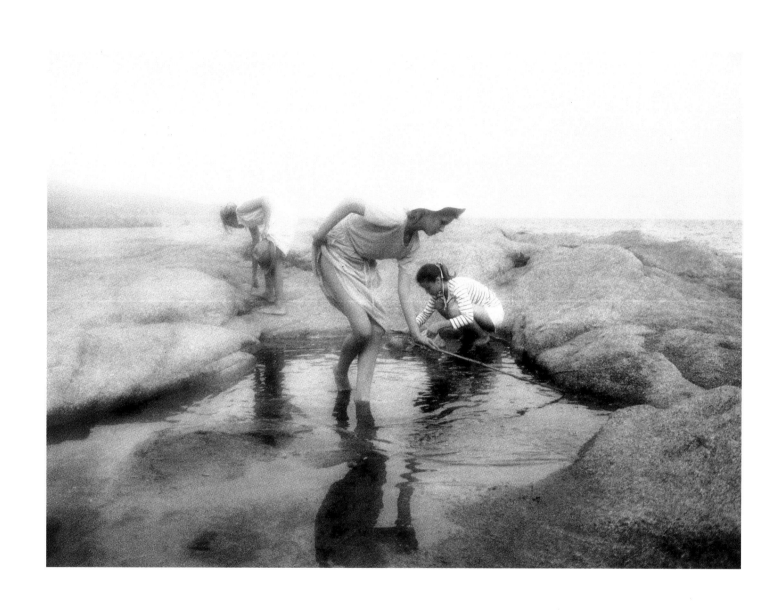

The ebb tide, Saint-Tropez, 1988

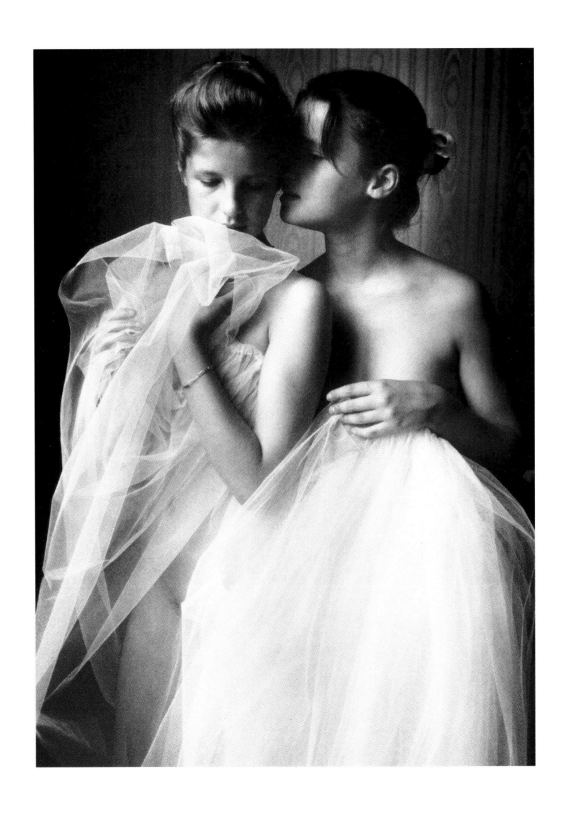

The secret, Bordeaux, 1988

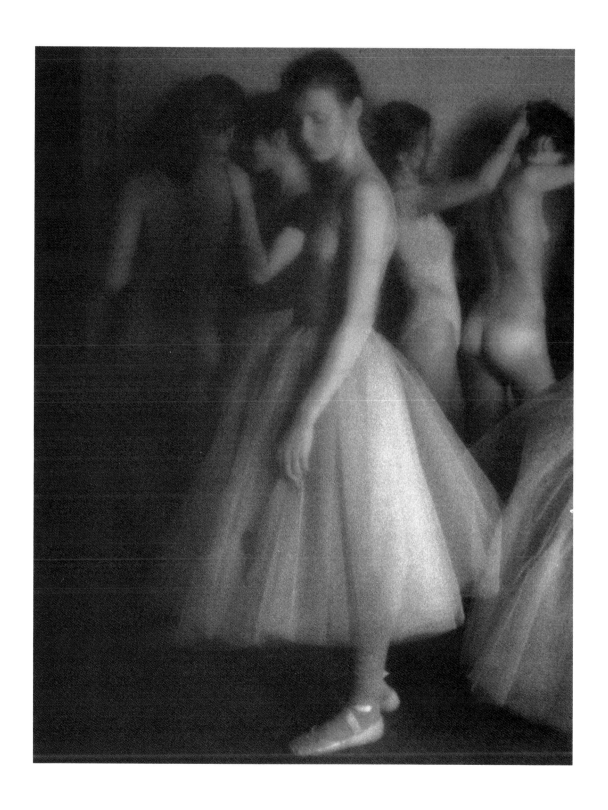

The début, Saint-Tropez, 1979

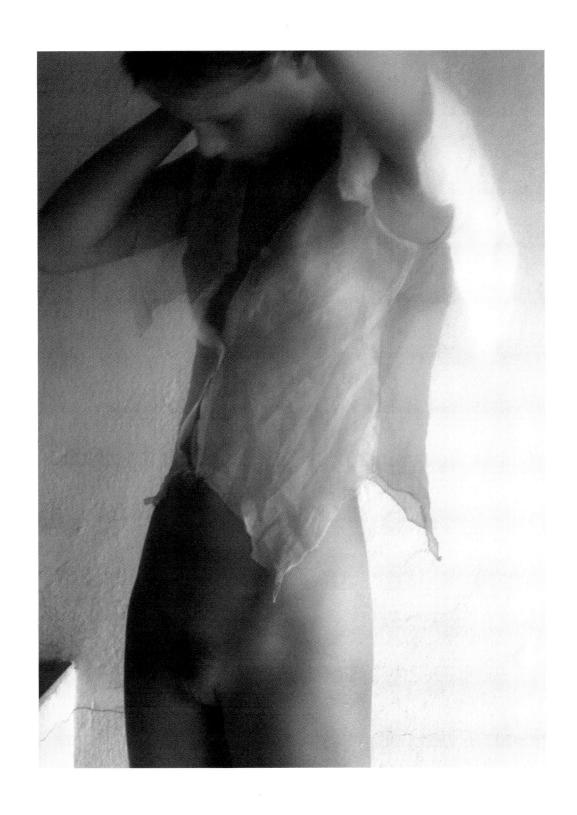

Pastel pinks, Saint-Tropez, 1976

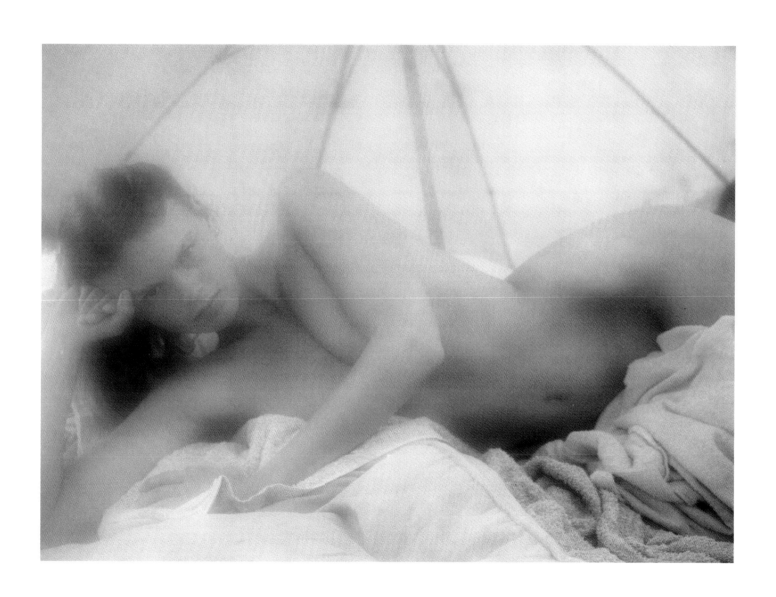

Caught napping, Saint-Tropez, 1983

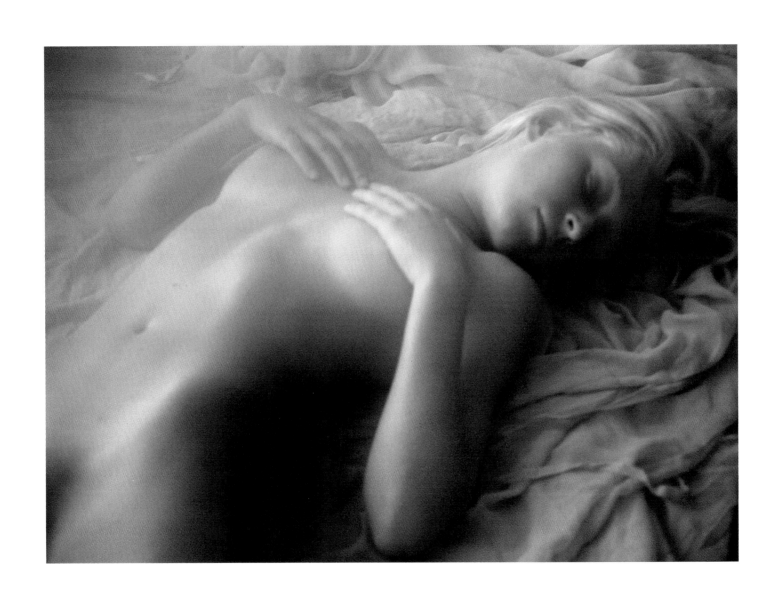

Sleeping beauty, South of France, 1991

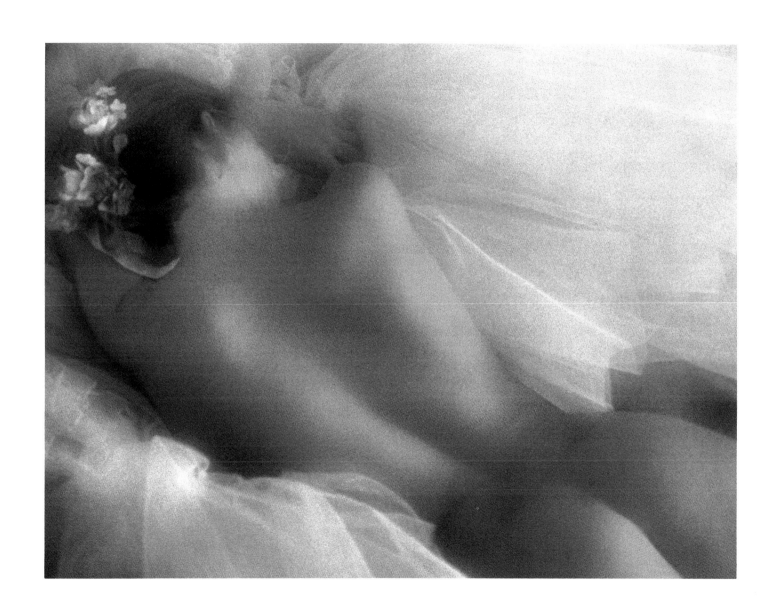

A bed of pastels, South of France, 1986

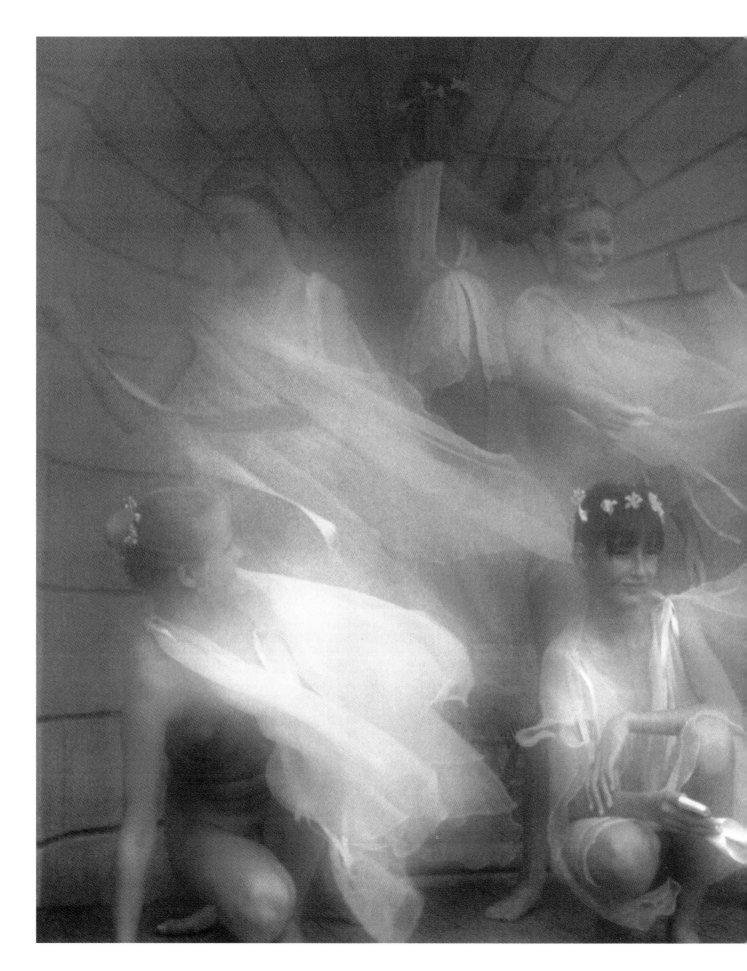

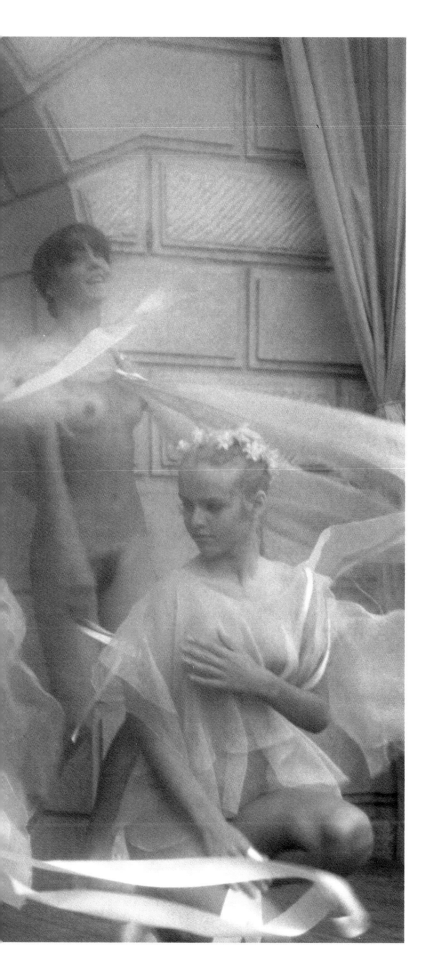

The schoolperformance, "Bilitis", Saint-Tropez, 1976

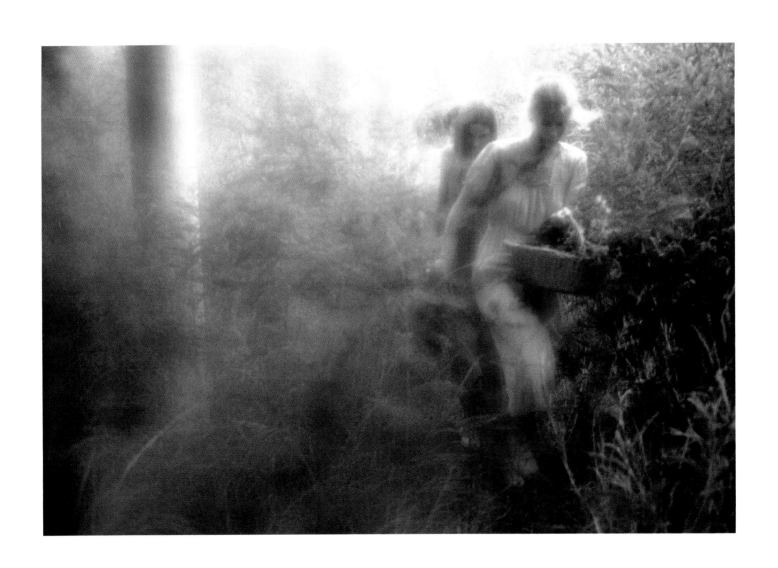

Out of the woods, Saint-Tropez, 1982

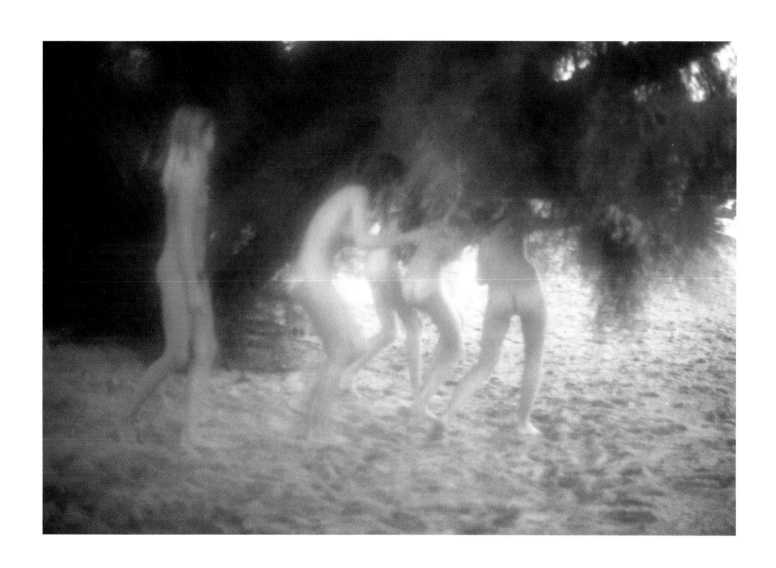

Onto the beach, Saint-Tropez, 1976

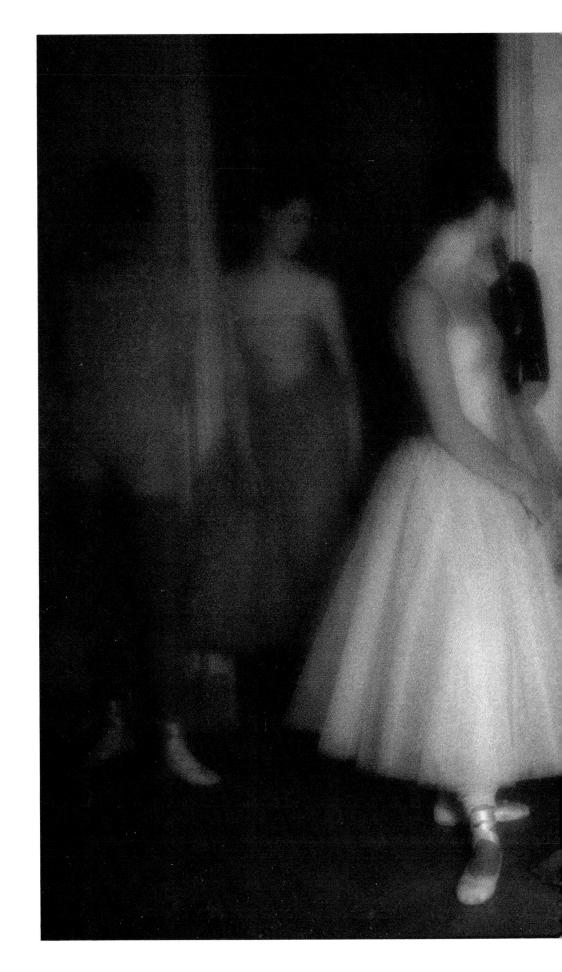

The ballet school, Saint-Tropez, 1979

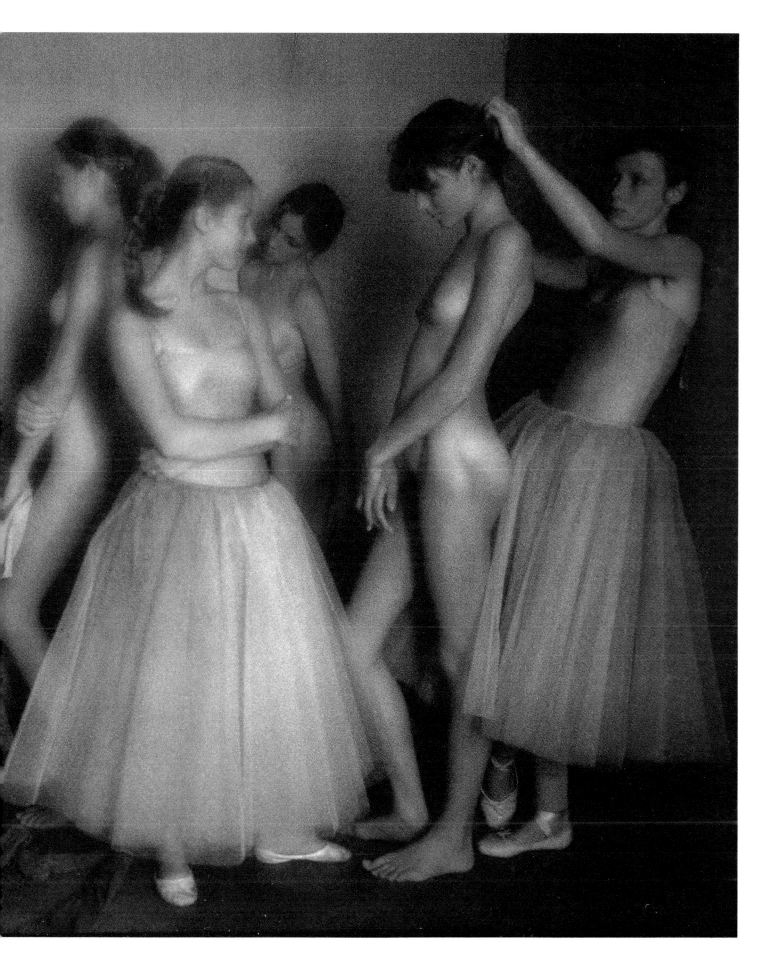

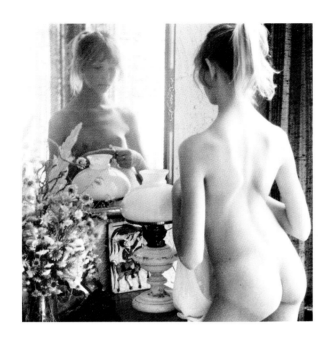
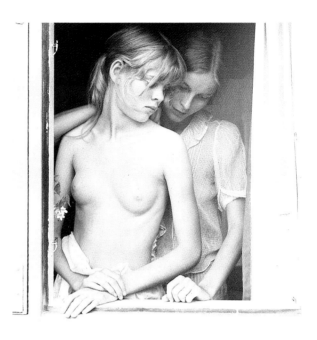
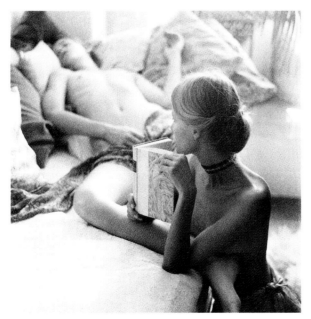
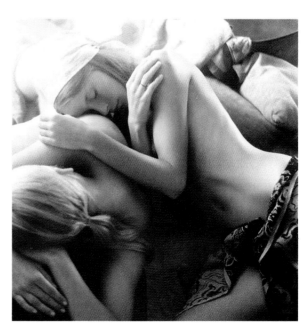

Intimate friends

116

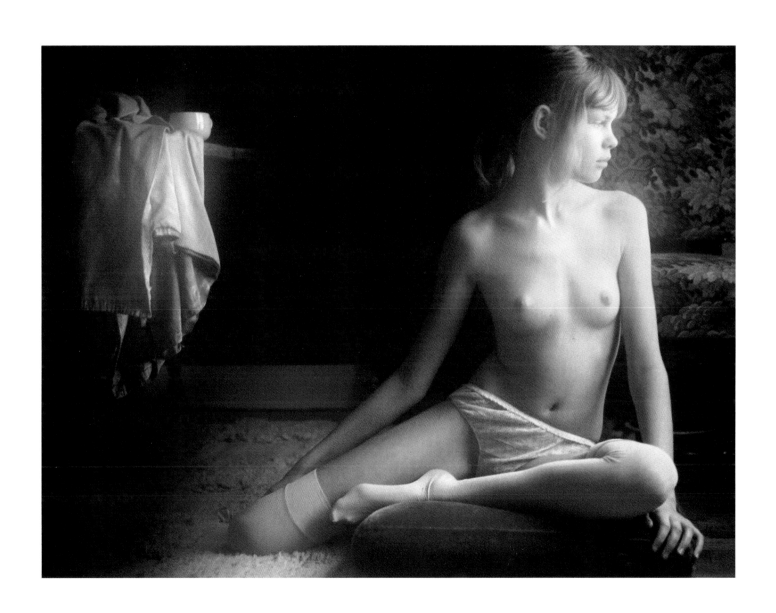

Lolita, Paris, 1973

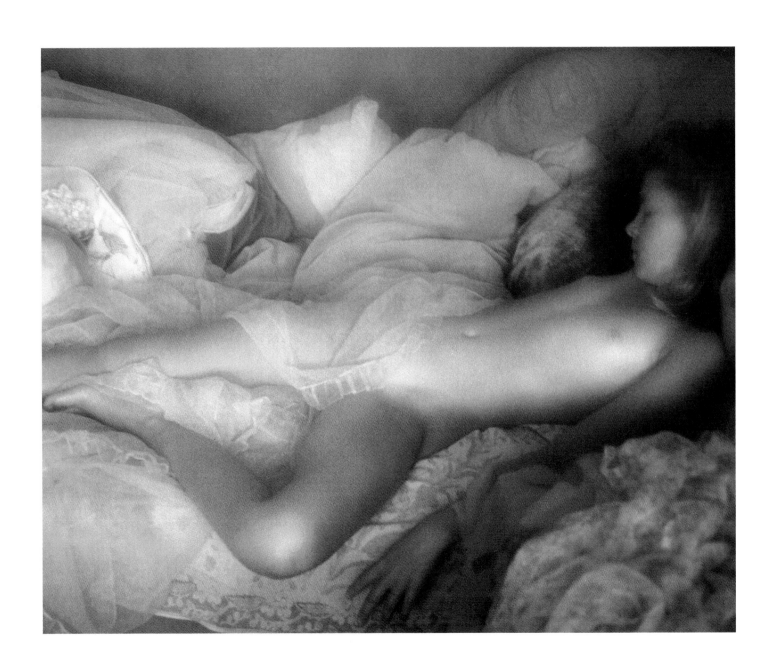

Napping, South of France, 1988

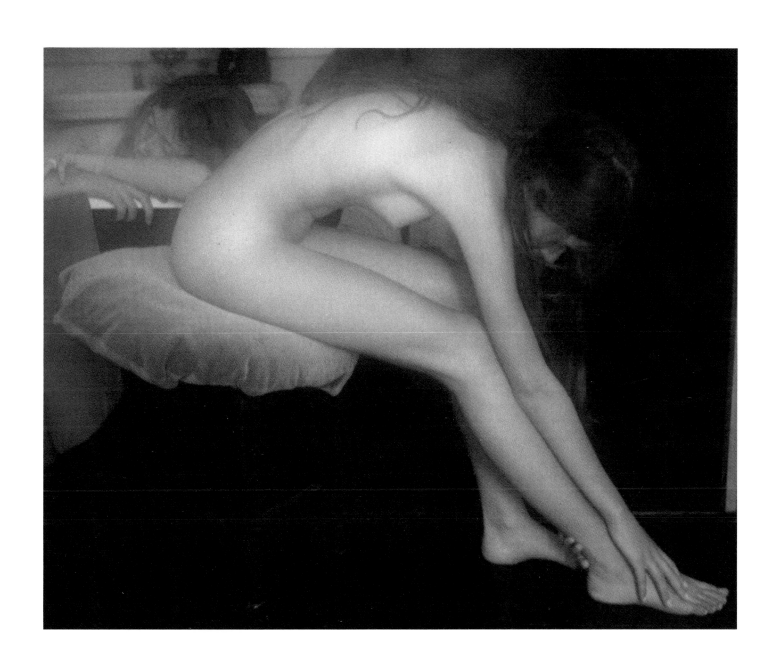

The Italian school, Ramatuelle, 1982

119

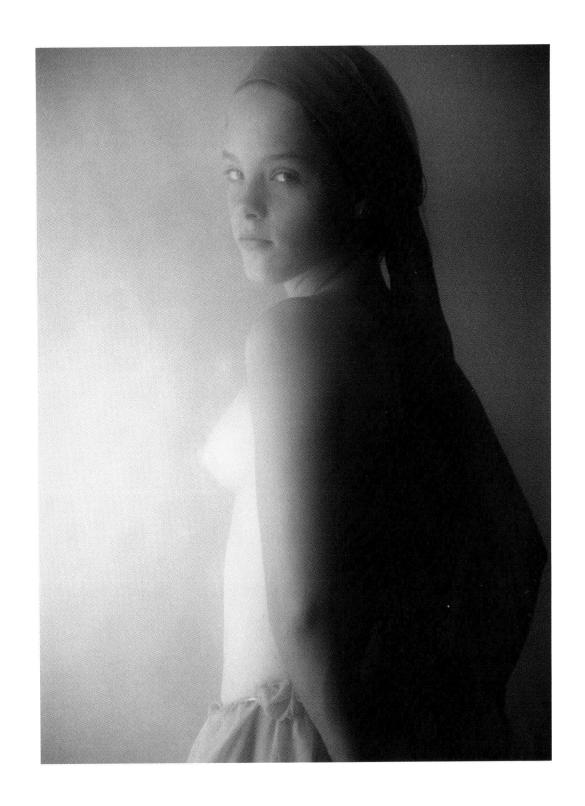

Anja, South of France, 1990

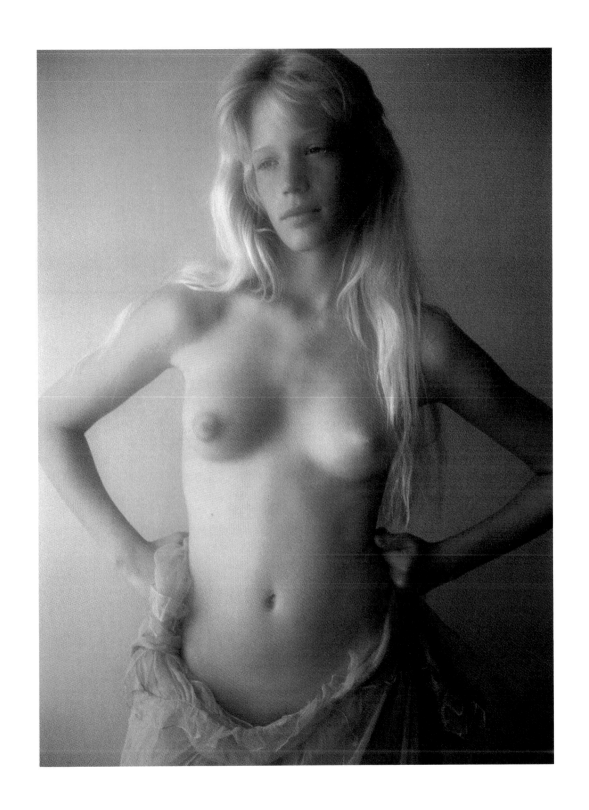

Stephanie, South of France, 1988

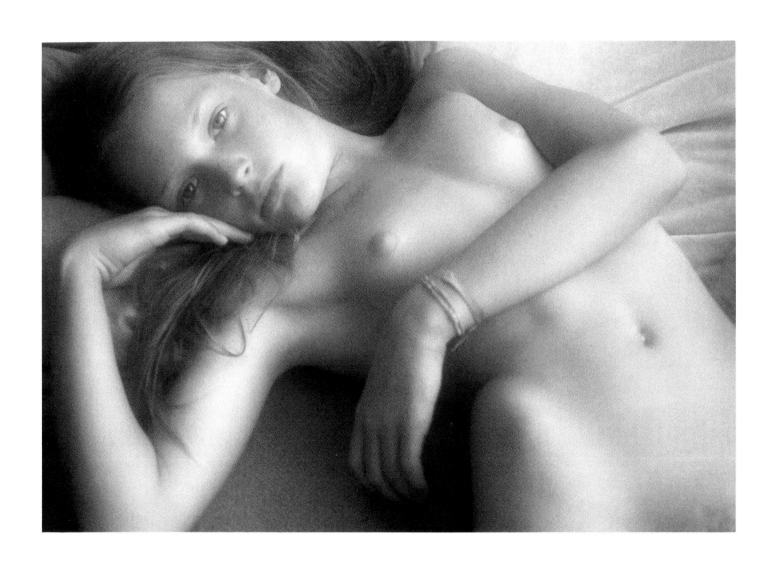

Josephine, South of France, 1985

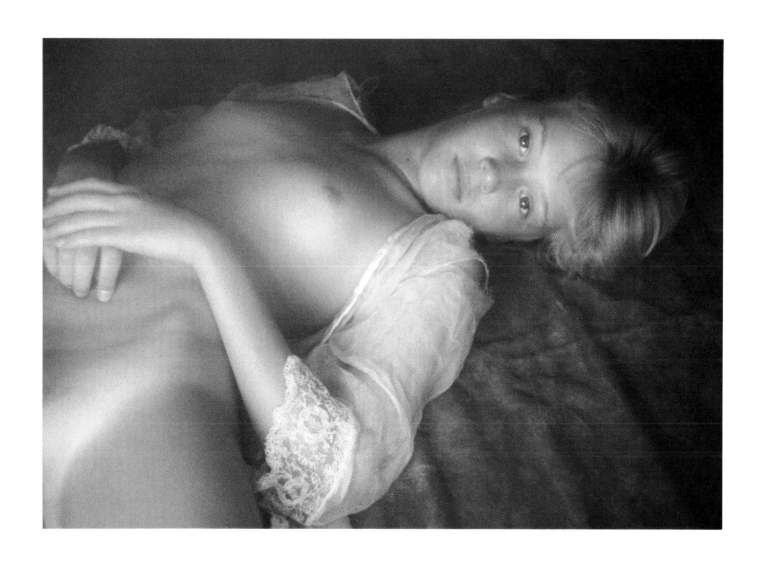

Rowena, South of France, 1985

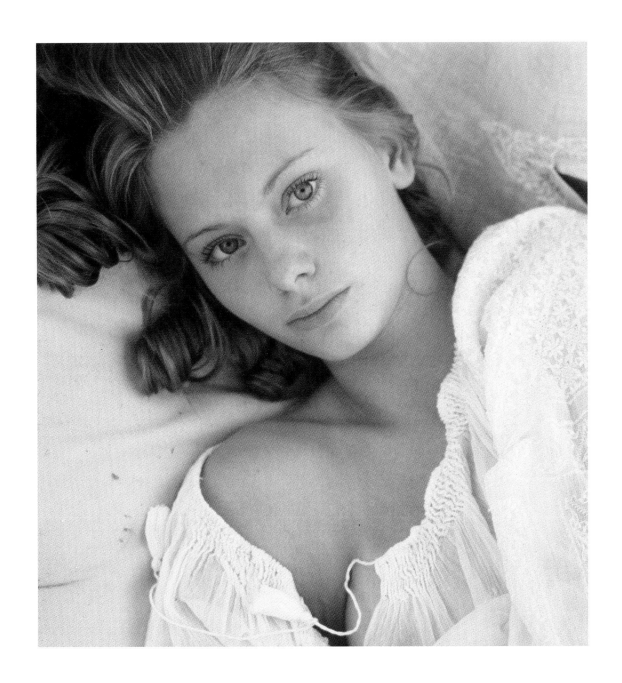

Blue eyes, Saint-Tropez, 1969

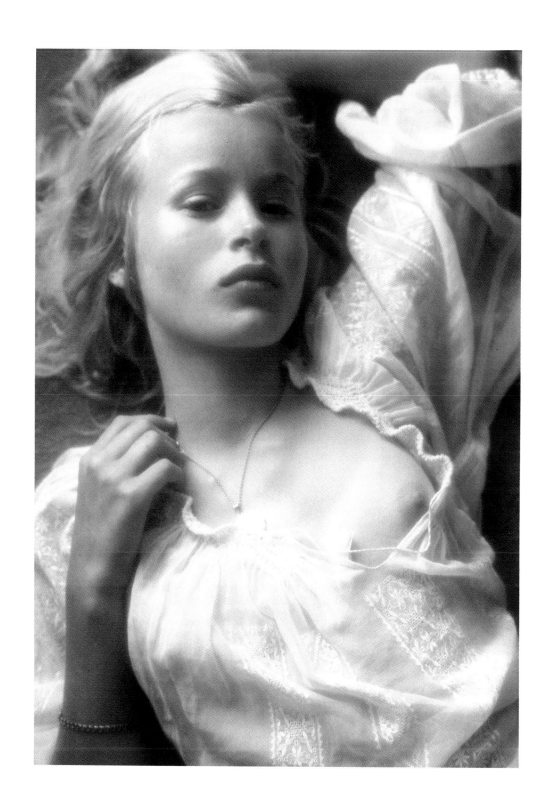

Stolen moments, Sylt, 1968

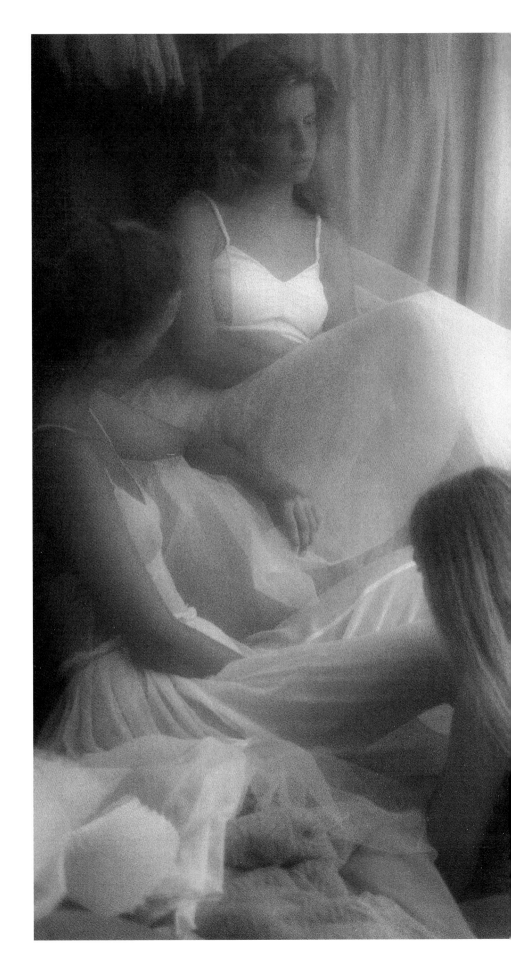

Gathering, South of France, 1984

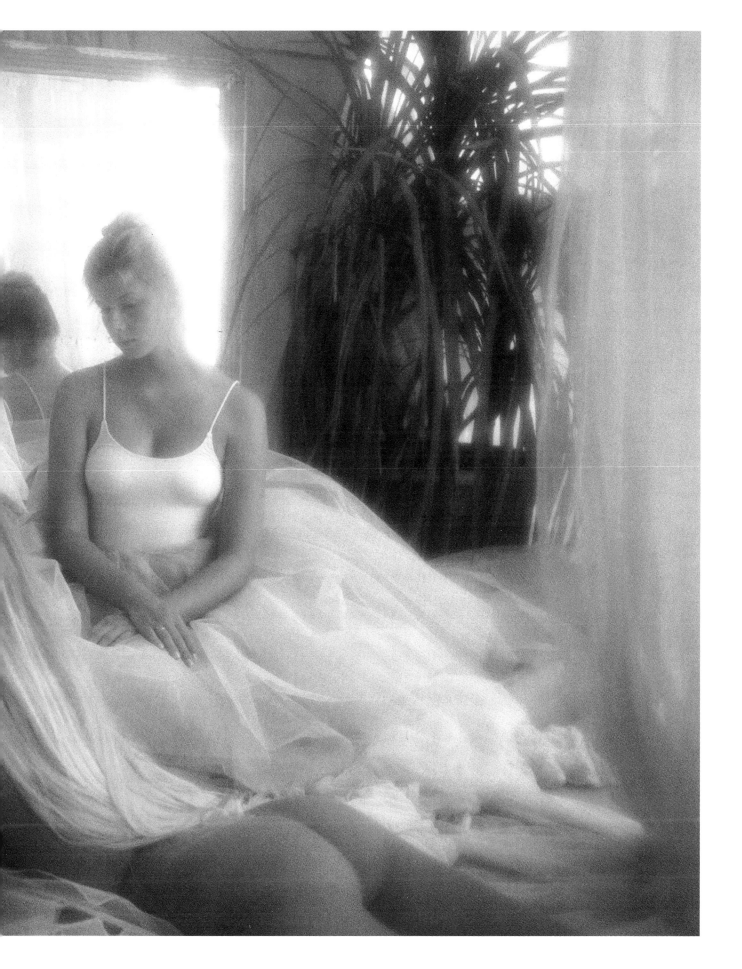

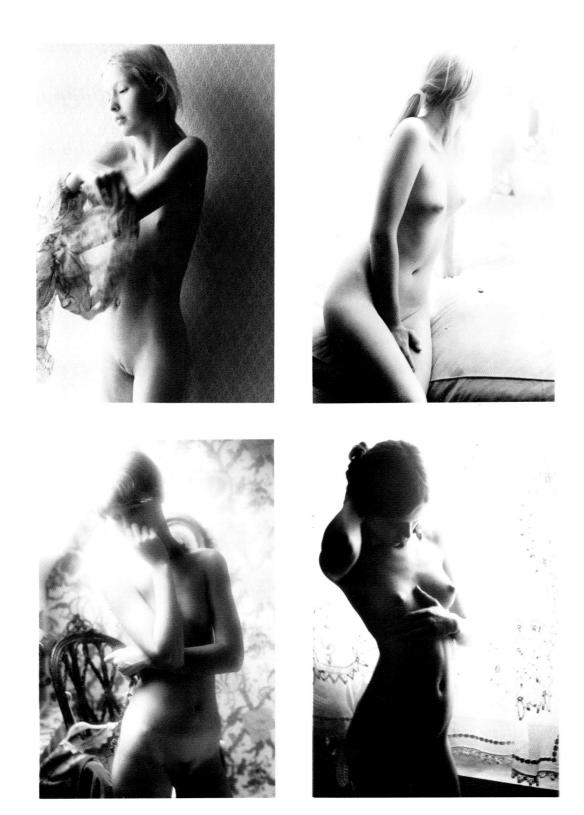

Morning

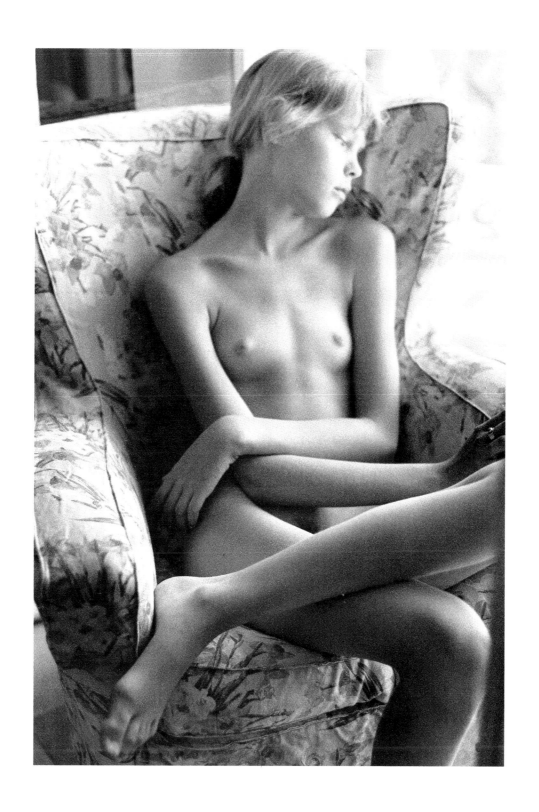

Limpid beauty, Italy, 1973

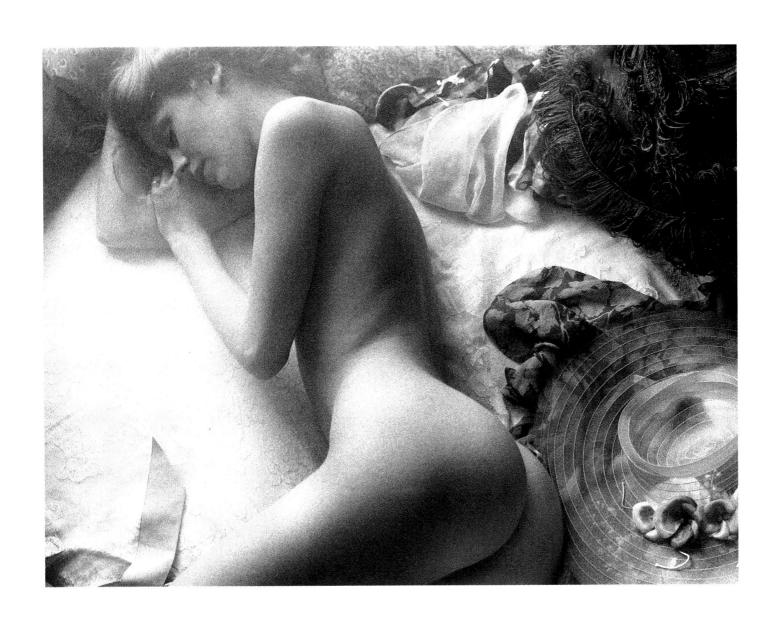

Dreaming, Ramatuelle, 1972

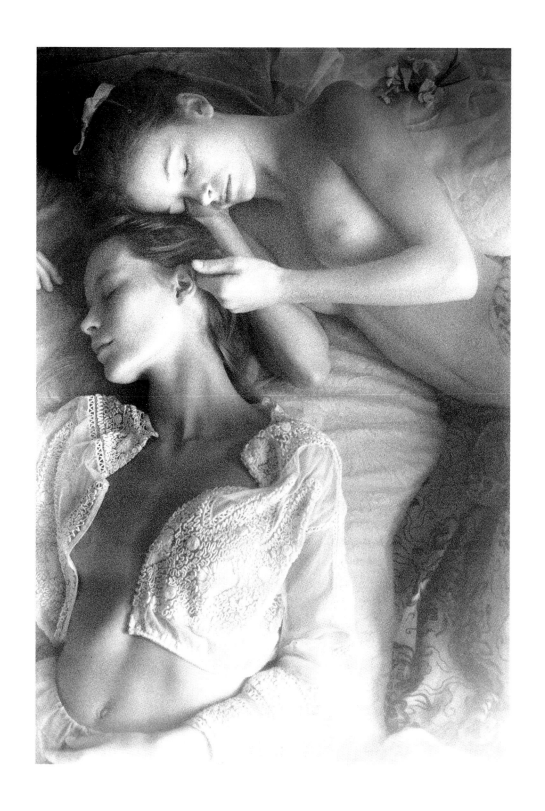

Heidi and Mona, Ramatuelle, 1972

131

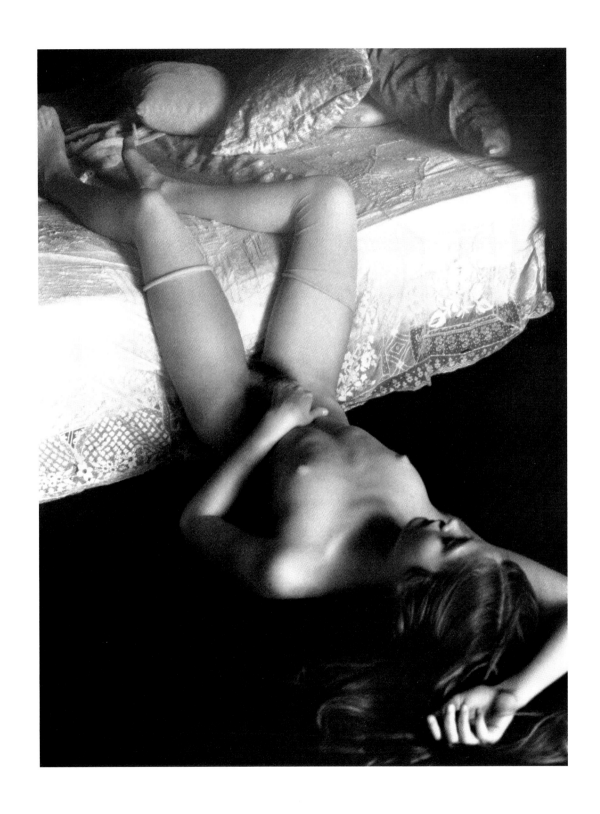

Lazyness, Ramatuelle, 1973

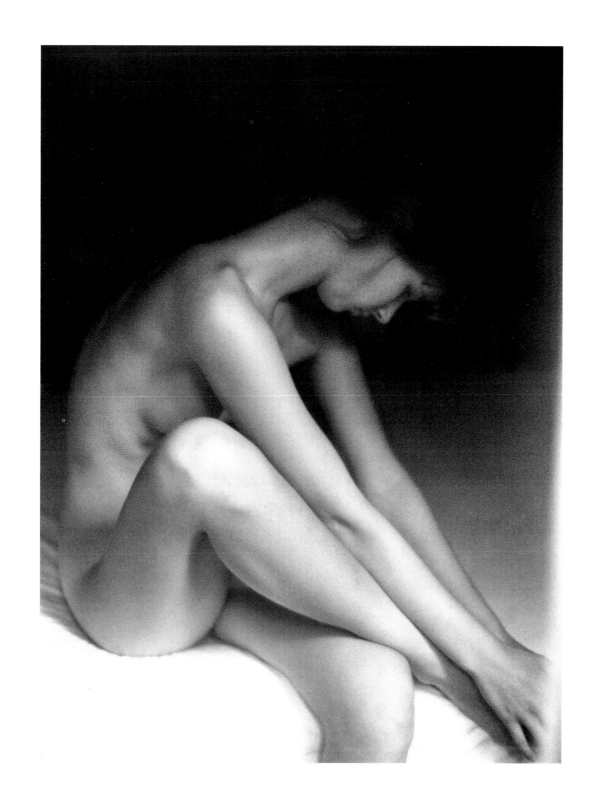

Clair obscur, Copenhagen, 1974

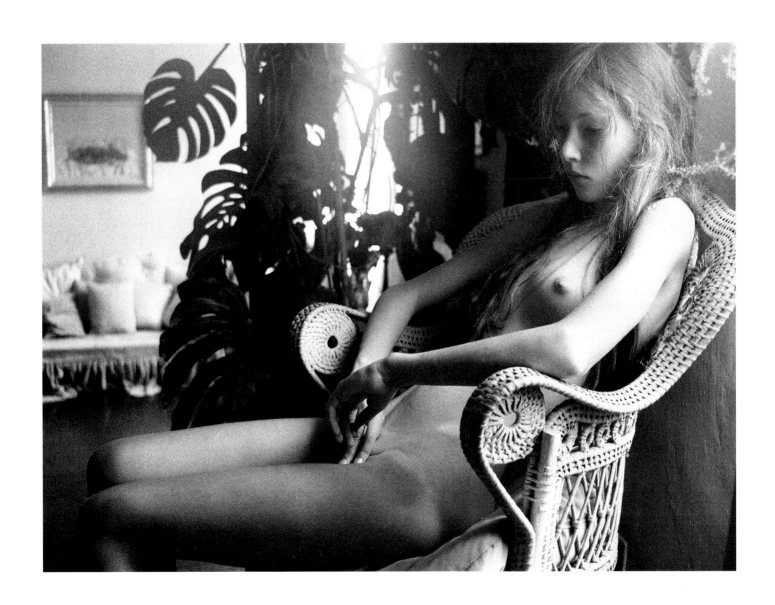

Secret thoughts, Ramatuelle, 1982

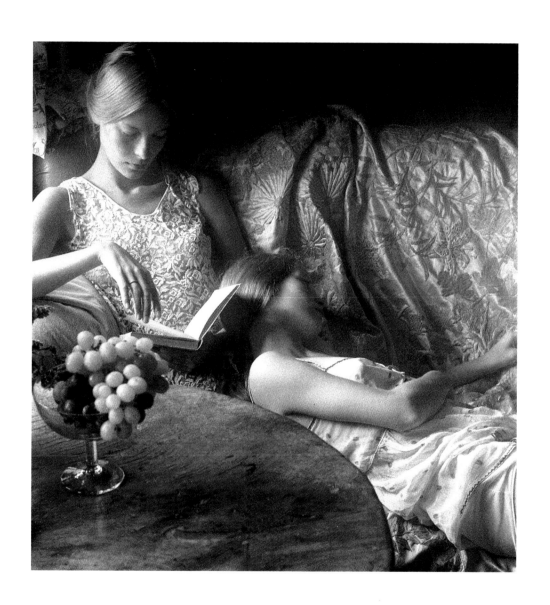

Sunday afternoon, Ramatuelle, 1971

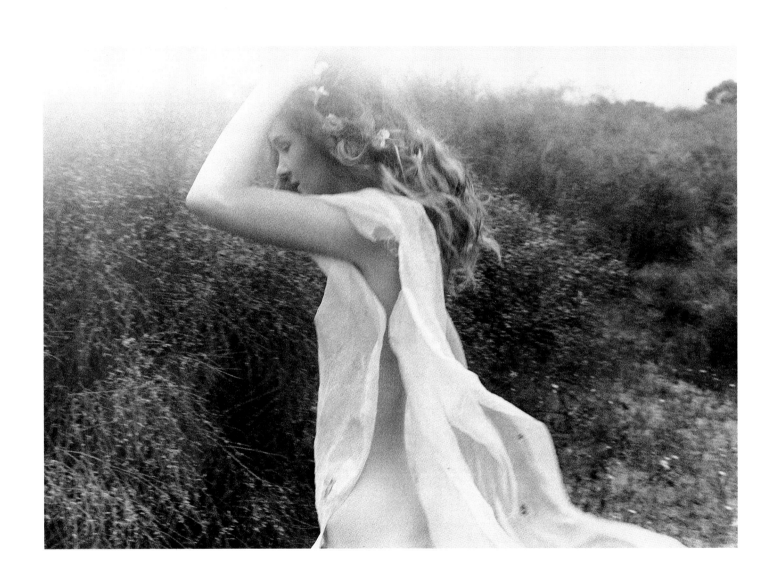

Escaping, Agadir, 1971

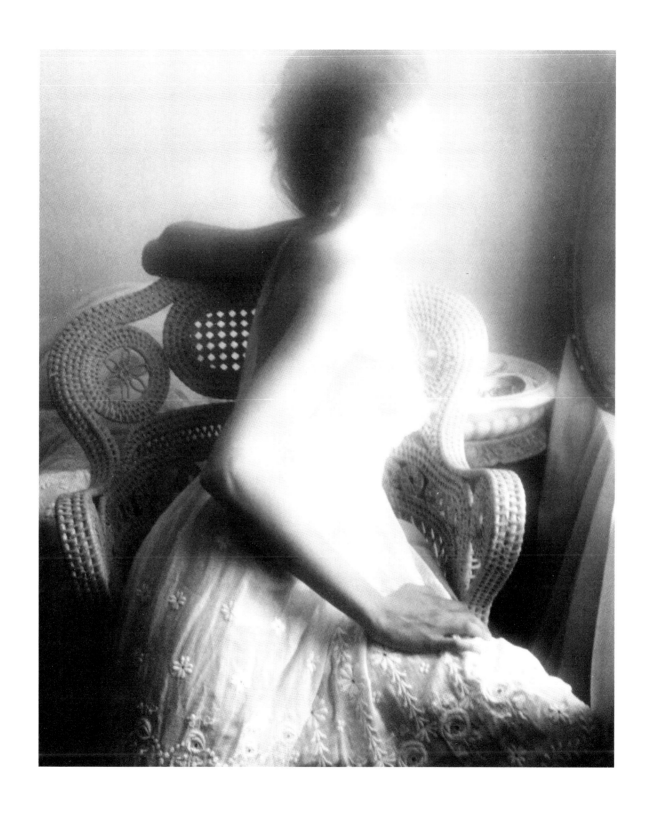

Pre-Raphaelite beauty, Ramatuelle, 1984

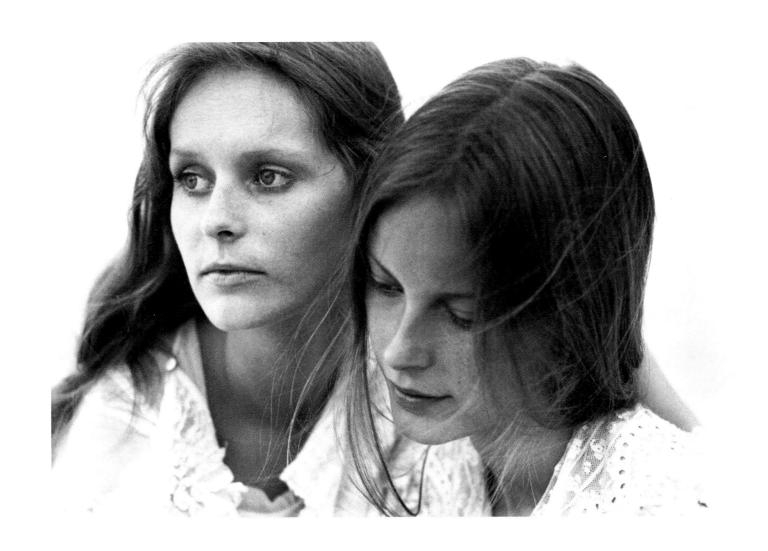

Classic beauties, Hawaii, 1974

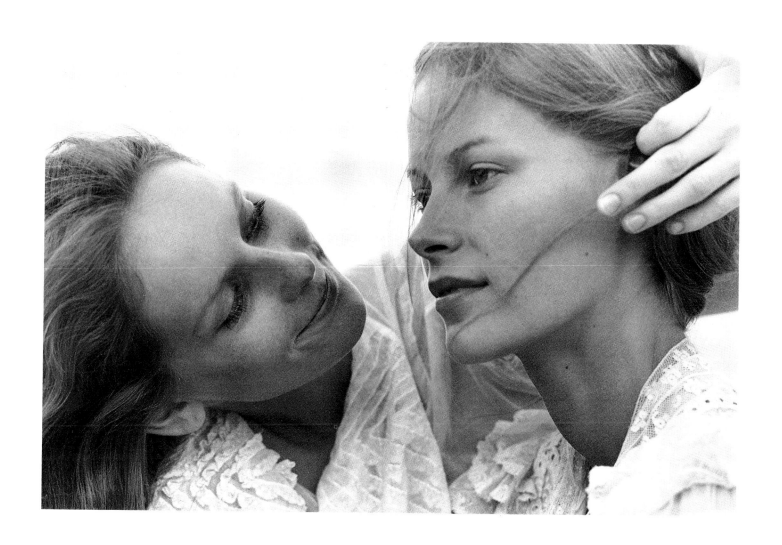

Anietta and Mona, Hawaii, 1974

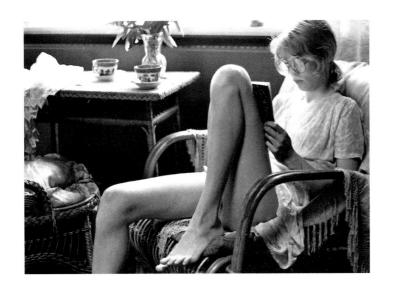
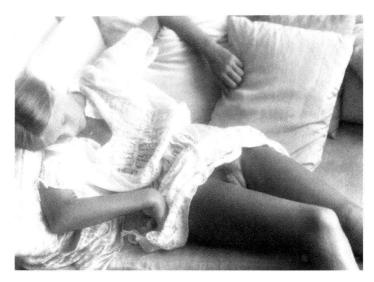
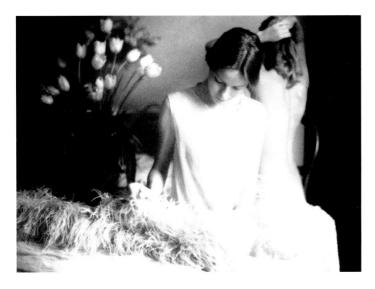
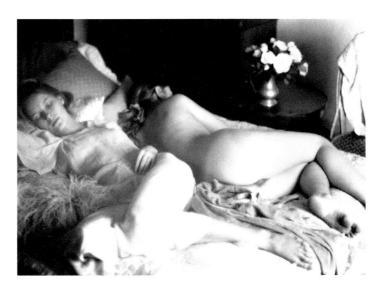

Lazy afternoons

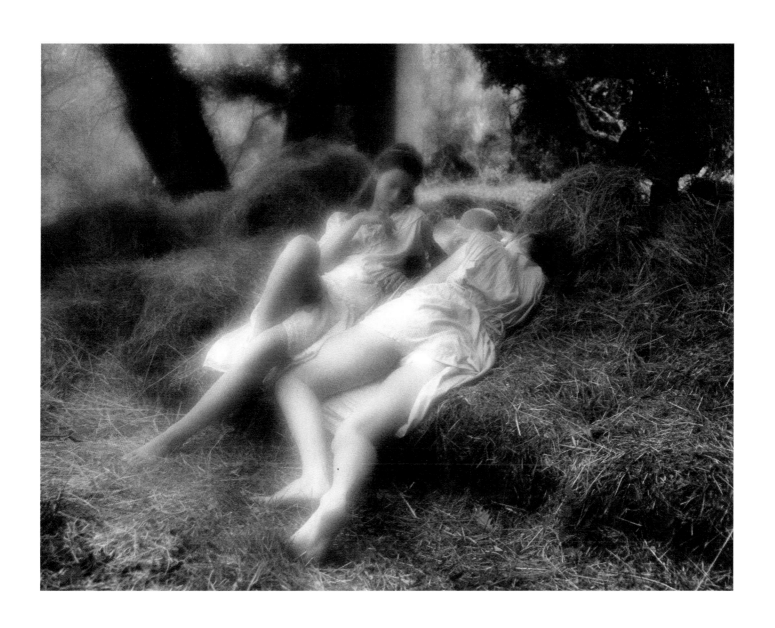

Scene from "Tender Cousins", South of France, 1980

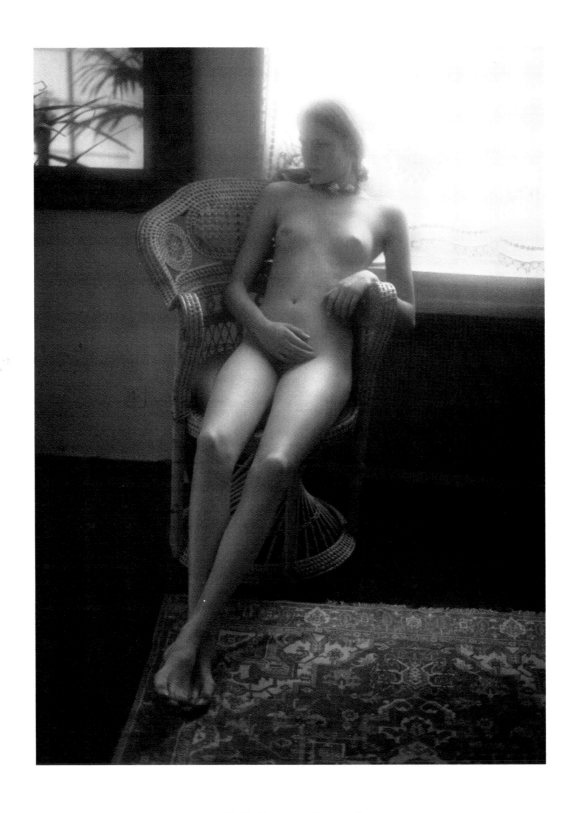

Helle, Ramatuelle, 1974

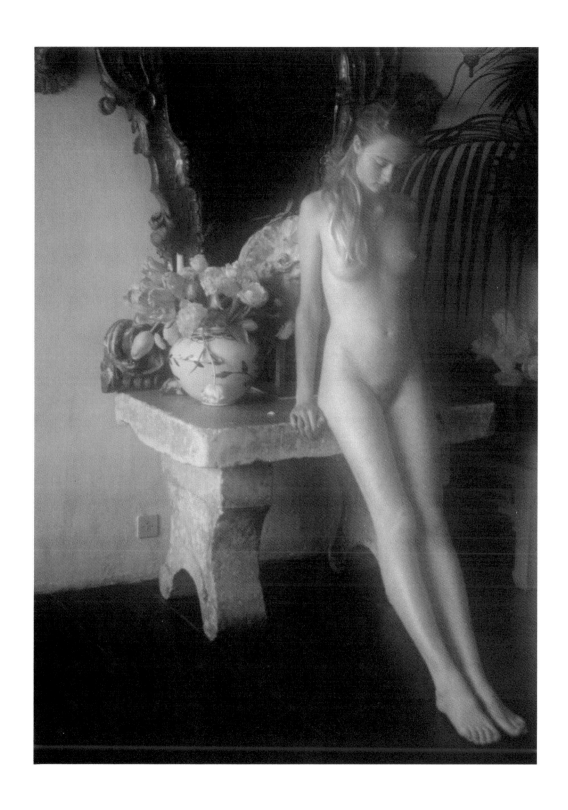

Sascha, Ramatuelle, 1988

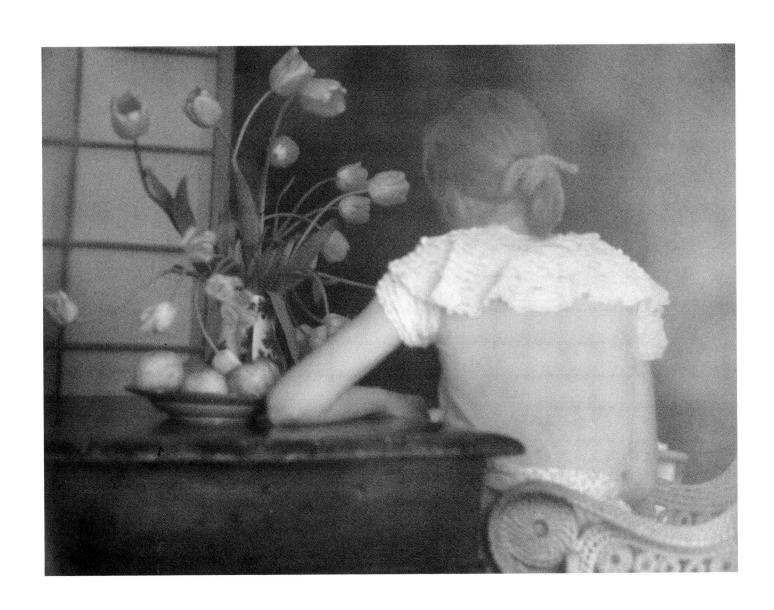

A quiet moment, Ramatuelle, 1985

144

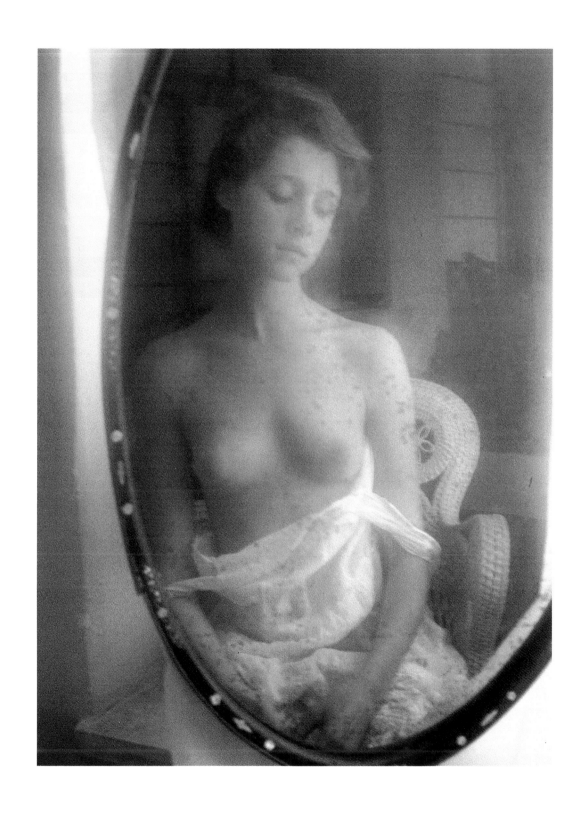

The looking glass, Ramatuelle, 1984

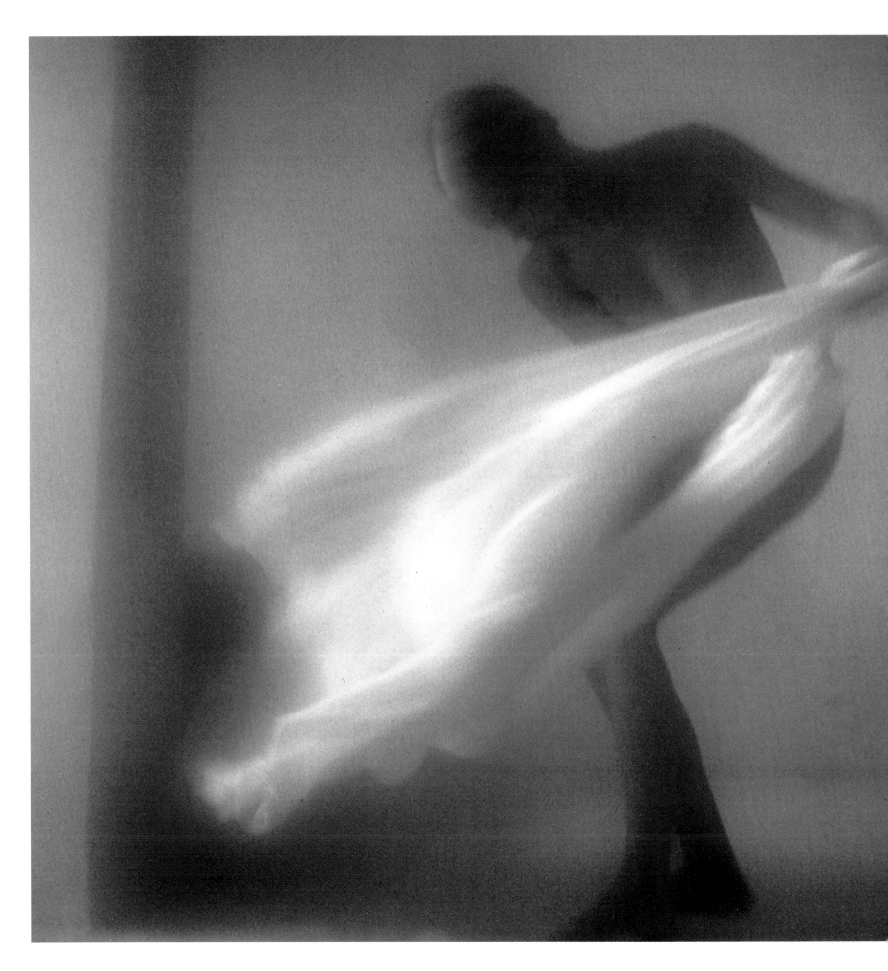

The muse, Ramatuelle, 1978

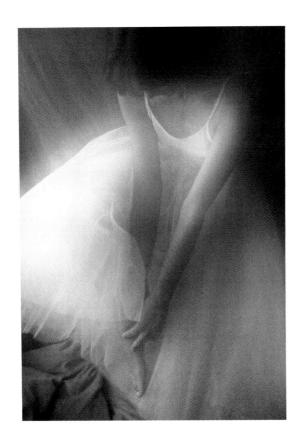
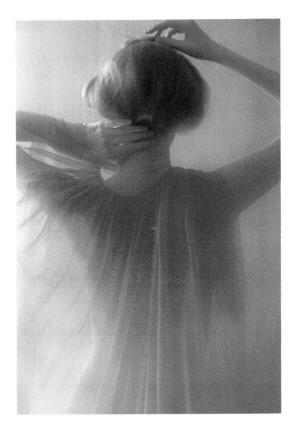
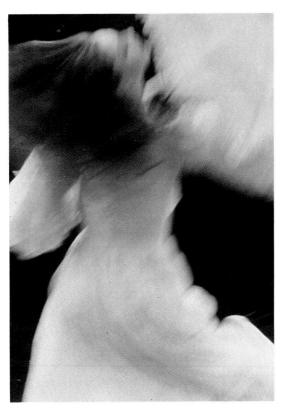
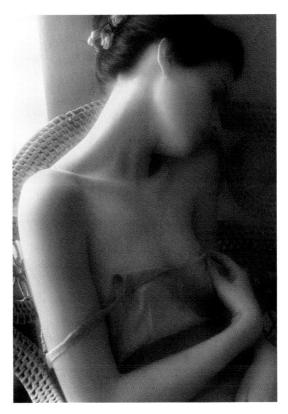

L'Air du Temps; Nina Ricci

The combination of David Hamilton's photographs and Nina Ricci's perfume is probably unique in the annals of publicity. Unique not only because it lasted for more than twenty years but also because of its nature: David was never required to do anything other than be himself. Each year, when I was preparing the publicity campaign for the perfume *L'Air du Temps*, I would see David's agent and choose several of his latest prints, from which Robert Ricci and I would select three or four. There was, in fact, a remarkable similarity between David's work and the message Robert Ricci wanted to convey to the public. David's photographs depicted the lush freshness of young girls, scantily dressed, and such girls, symbolised the romantic dreams of many women.

When the first publicity shots created by David Hamilton for *L'Air du Temps* appeared in 1970, the hippie movement, the greatest socio-cultural movement of the post-war years, had won over an entire generation which wanted nothing but to dream about life rather than to build it. Because of the climate of the time, the photographs became an instantaneous and immense success.

L'Air du Temps undoubtedly owes its tremendous popularity as much to the originality of its fragrance as to the renowned beauty of the doves and to the theme carried through by David's work.

Marc Tagger

huge woman came out, accompanied by her 'client'. The concierge smiled knowingly and suggested that perhaps he could arrange something similar for us ! We spent a lot of time near the Deligny Pool and were very attracted to the girls there but never dared to approach them, particularly as neither of us could speak French.

In London, the only opportunity we had to meet girls was at the dance-hall, called Grey's Club, on Saturday nights. The girls we met there had to leave before midnight and so we would take them home in the hope of a goodnight kiss. If we were lucky, and lingered over this, we missed the last bus home and had to walk across London, back to Kennington. One night, at the dance, I had a success. I met a girl who seemed to like me and let me take her home. When we arrived, she told me that her family was out and invited me in. I was totally inexperienced so she made all the advances. She kissed me over and over again, holding me close, and then she began to shake. I wondered what on earth was happening to her: was she having an epileptic fit ? What was I supposed to do ? I never saw her again but my first sexual encounter was far more disconcerting than it was edifying. As things were at the time, it would have been virtually impossible anyway to sustain a sexual relationship, or indeed any relationship with a girl. We had little privacy, little money and very few opportunities.

At twenty I left home and moved to an attic flat in Hampstead. I met my first girl friend, Marie, at a par-ty and for several months we shared my small flat. In the winter we froze; the gas meter had to be fed with shillings to keep the fire going. The relationship was brief but important. It was the first time that either of us had made love and it happened on the third day of spring. For many years after, we celebrated this special day and would send each other postcards: "It's the third day of spring !". It was with Marie that I made my second trip to Paris. We booked into an hotel near the République. One night we forgot to draw the curtains and provided a fascinating entertainment for our neighbours !

My early trips to Paris convinced me that I should settle there. The first year was very difficult. I had left everything in London and had lost what little money I had, playing cards. I lived in a tiny "chambre de bonne" near the place Gambetta, but I acquired a stamp: DAVID HAMILTON – PARIS, which impressed my friends when I went home on visits.

Having worked for some time with a firm of architects in London, I had assembled a collection of drawings which, I have to admit, were not all mine. I showed them to Siegel, a company in Paris. They told me: "If you obtain a work permit, we will hire you". I went immediately to the Work Ministry, where they wanted to see a work contract before they would issue a permit. It was incredible, my first experience with French bureaucracy. Finally, I told the people at Siegel that I had this precious permit, and they hired me without even asking to see it. Several weeks later, having had

(Cont. page 184)

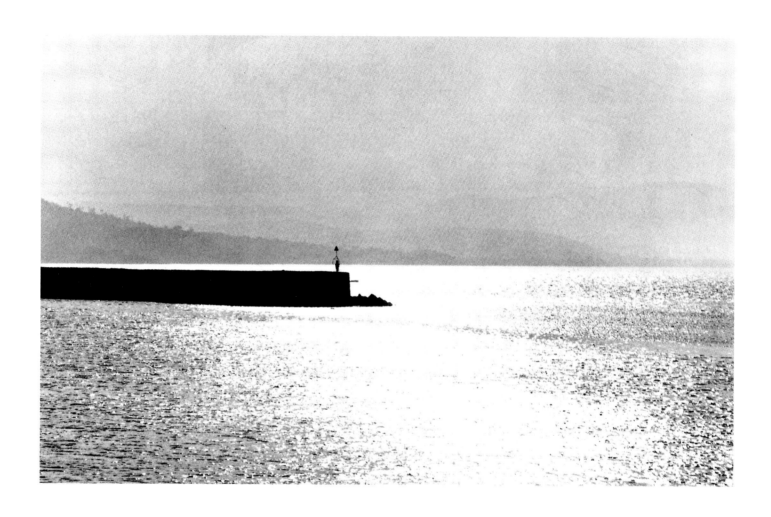

The bay of Saint-Tropez, 1968

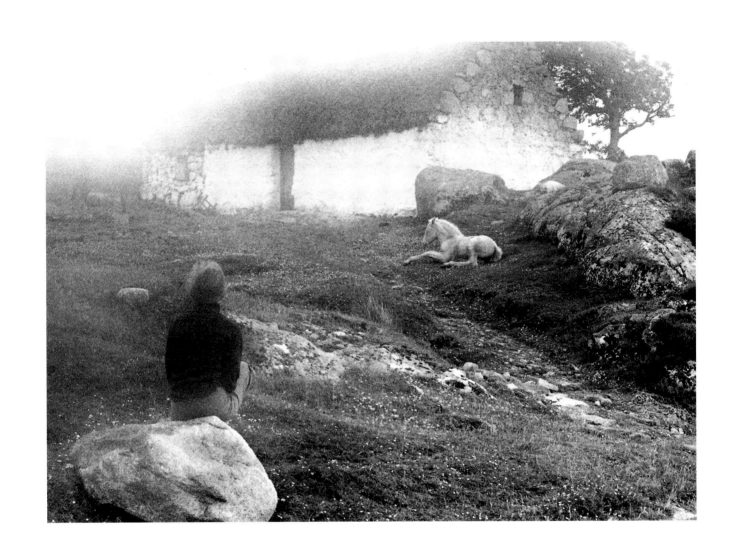

County Cork Ireland, 1971

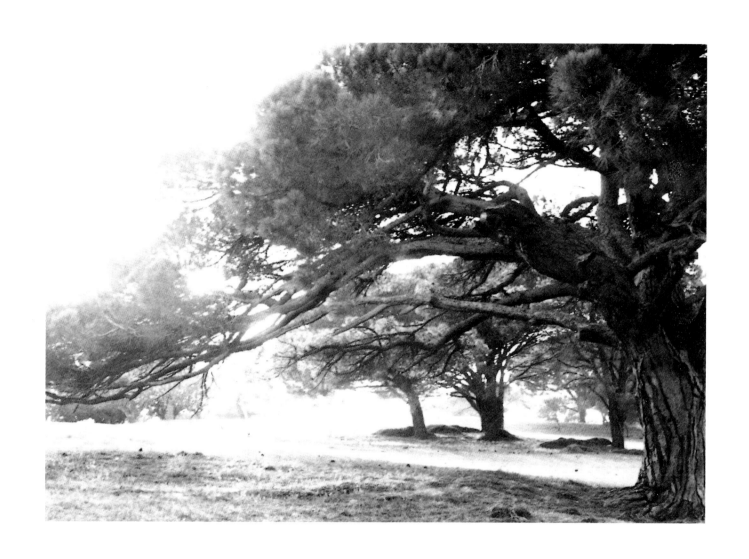

Cedar trees, Ramatuelle, 1969

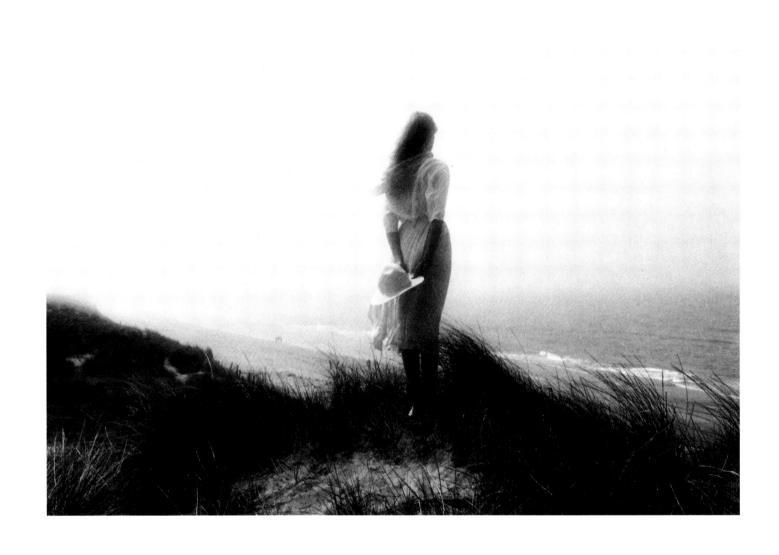

The dunes of Knokke, Belgium, 1985

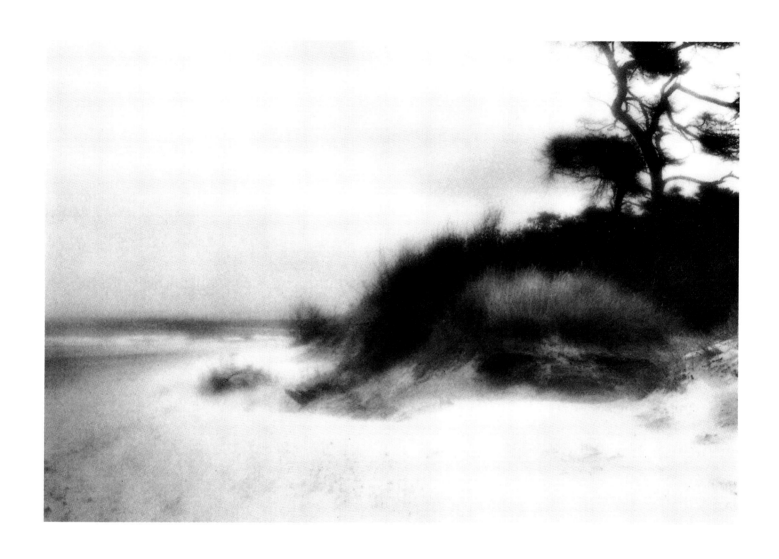

Bornholm, Denmark, 1984

155

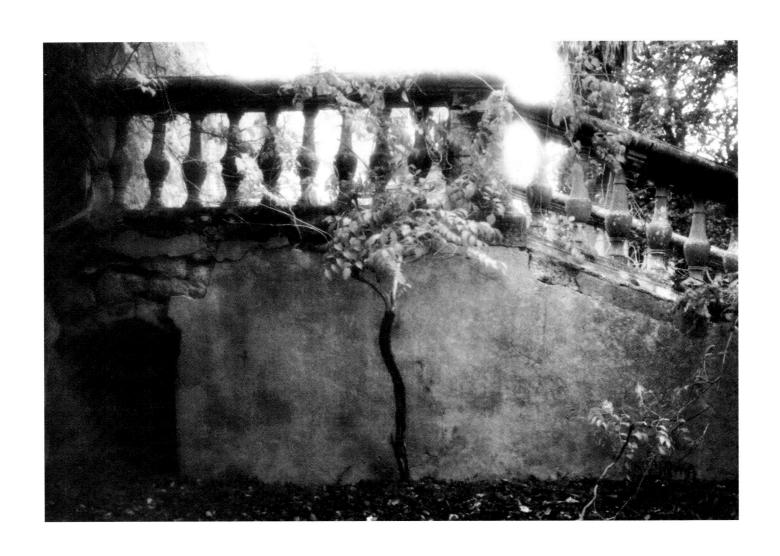

The stone staircase, Ibiza, 1982

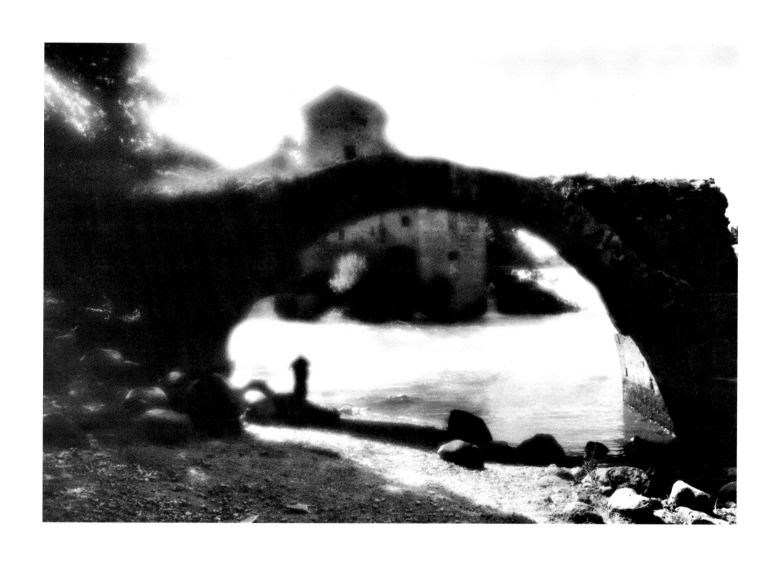

The Roman bridge, Bessan, 1980

Sea breeze, Bahamas, 1981

The beach tents, Cabourg, 1987

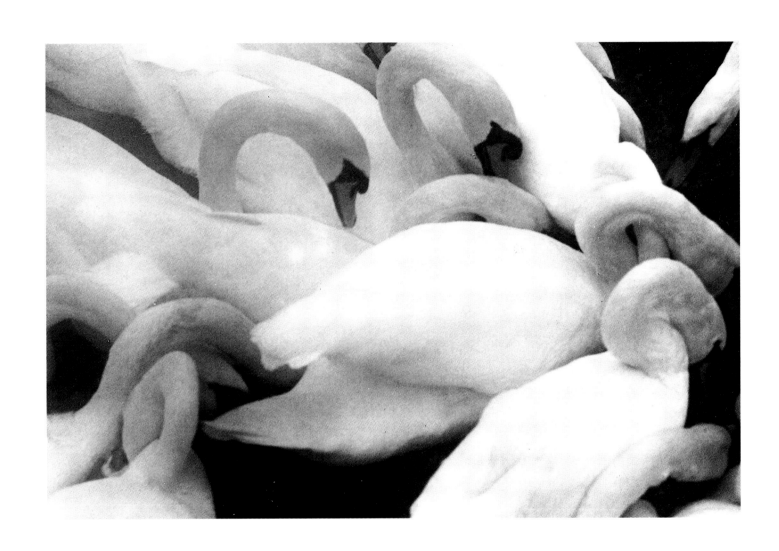

Swans, Austria, 1971

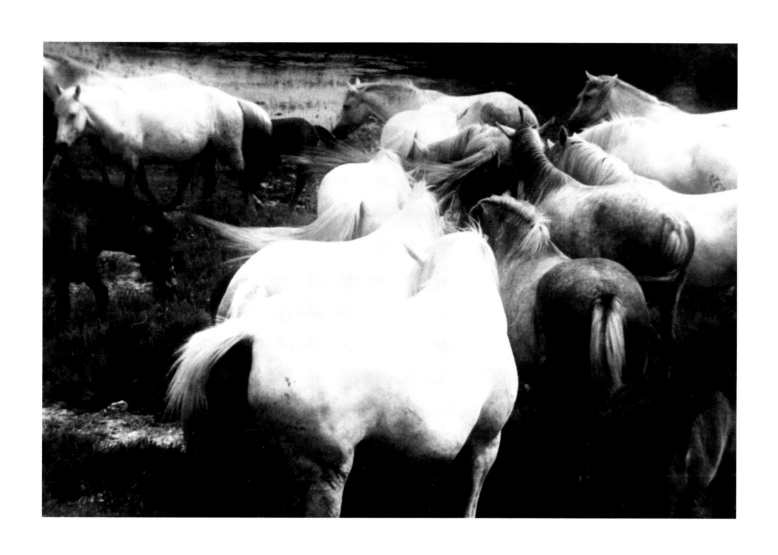

Wild horses, Camargue, 1973

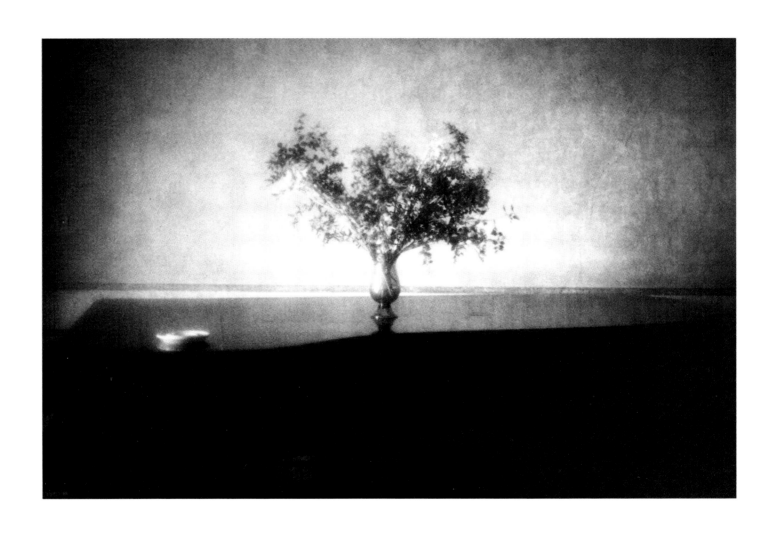

The grand piano, Villa Medicis, Rome, 1974

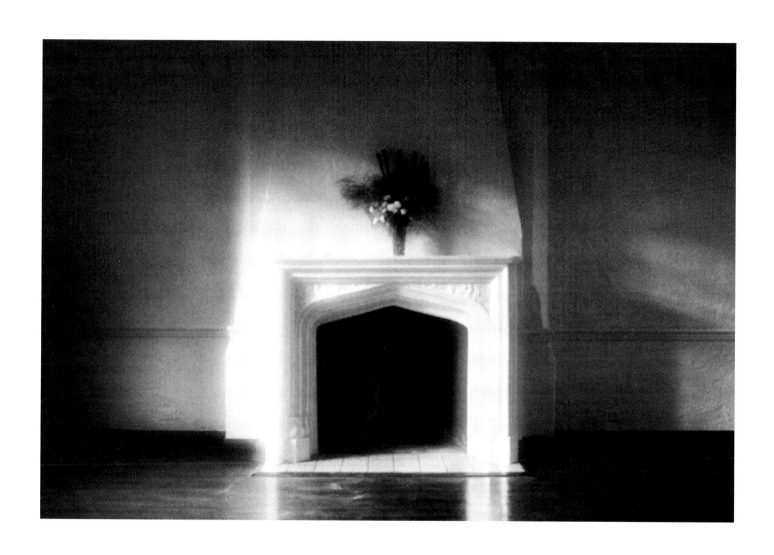

The fireplace, Greenwich Connecticut, 1975

The parc, Château de Sully, 1978

The lake, Château de Sully, 1978

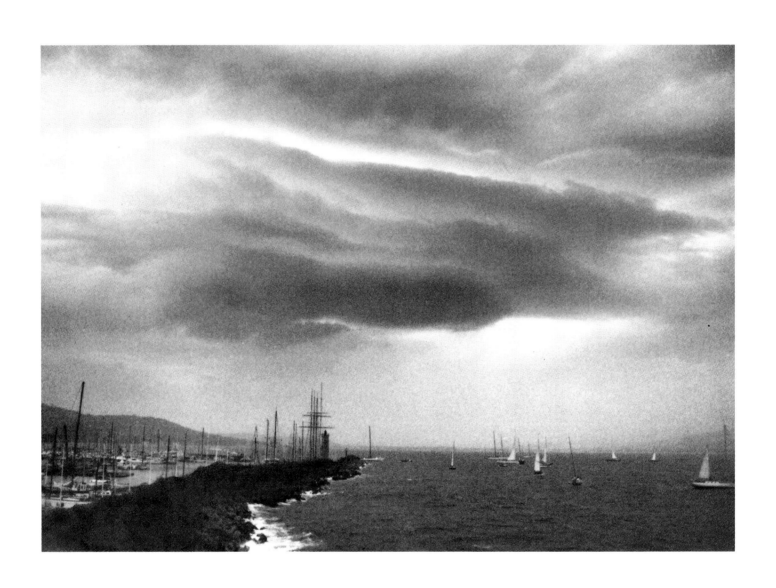

The harbour of Saint-Tropez, 1985

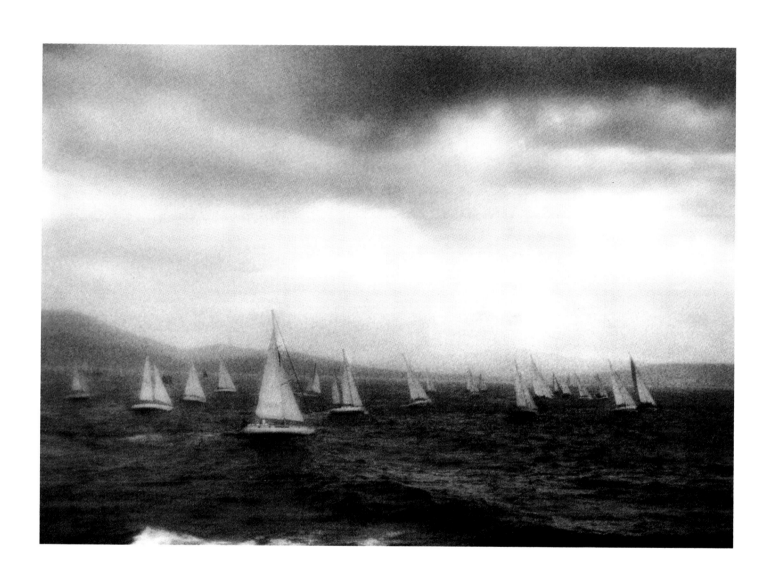

The Nioulargue, Saint-Tropez, 1985

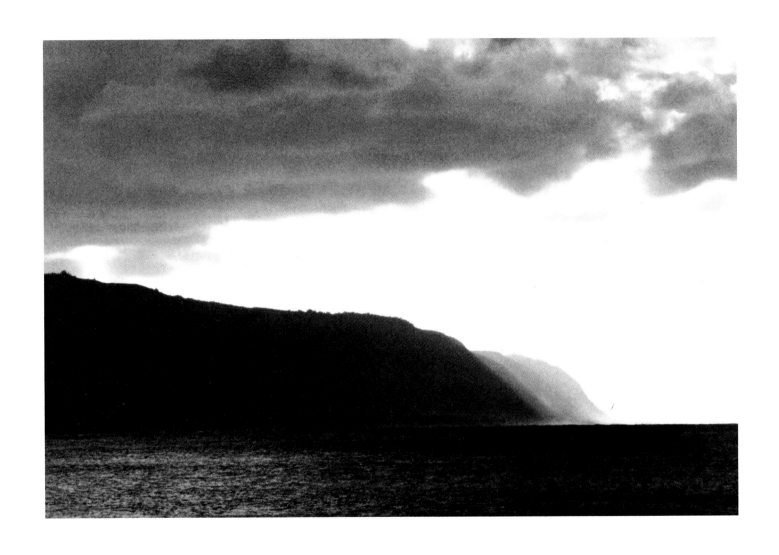

Mountains, Hawaii, 1978

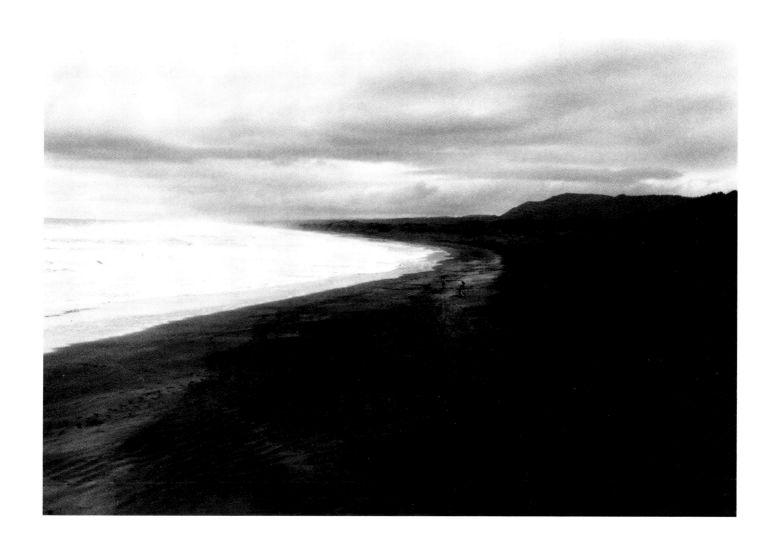

The bay, Auckland, New Zealand, 1986

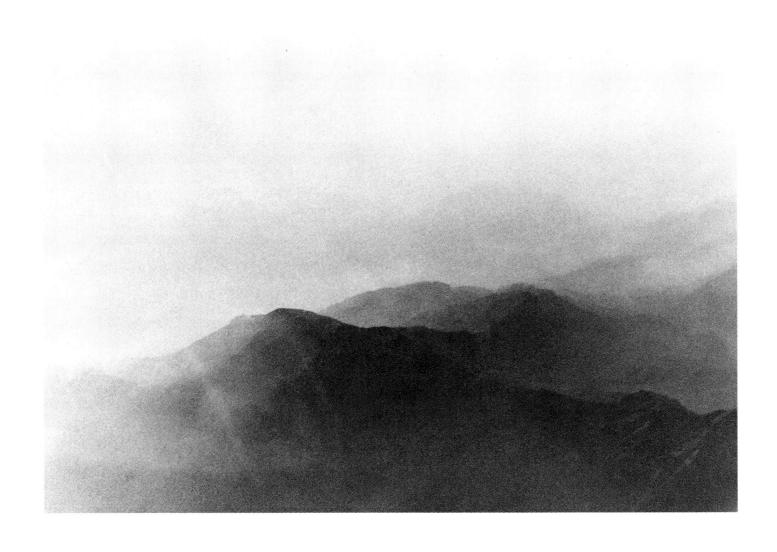

Flying over the Italian Alps, 1981

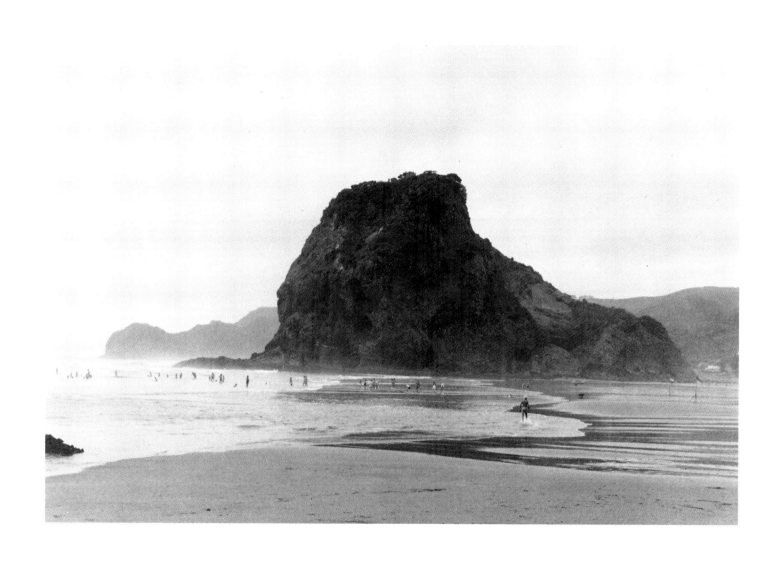

Lion Rock, New Zealand, 1986

View from the Villa Favorita, lake Lugano, 1980

The lake of Geneva, 1980

The route of the Château Saint-Amé, Saint-Tropez, 1976

The marshes of Cabourg, 1987

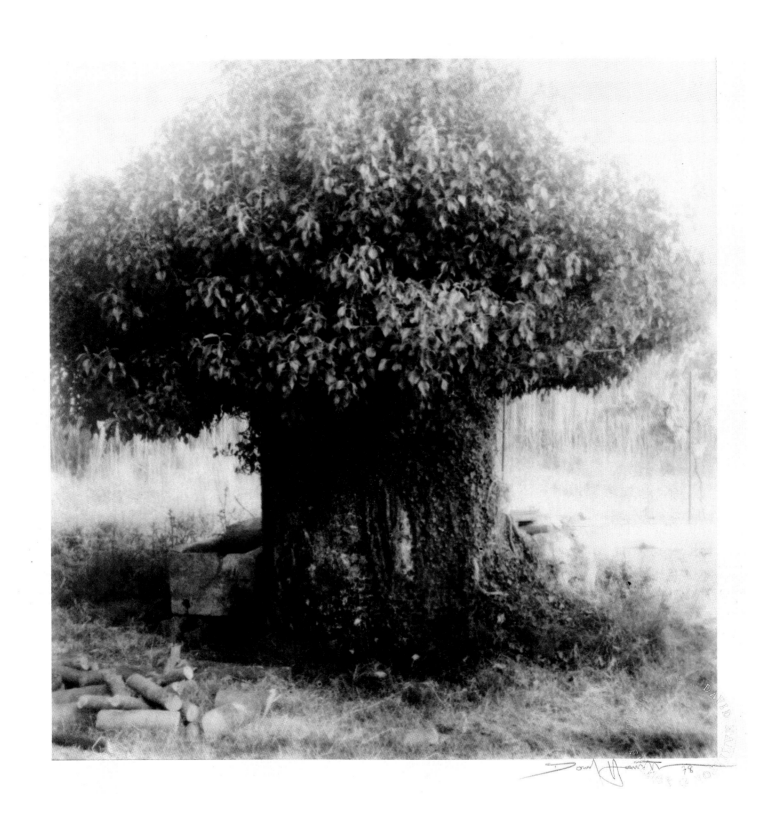

The old well, Saint-Tropez, 1978

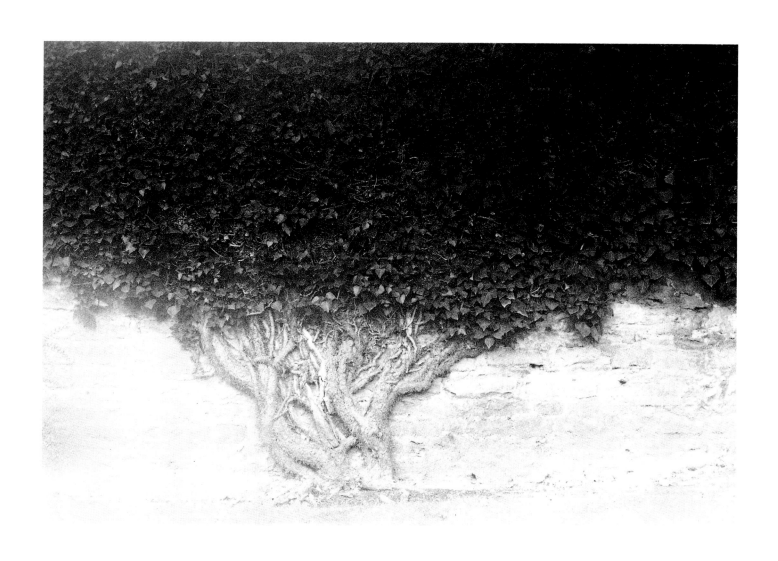

The ivy tree, Château d'Antoing, Belgium, 1986

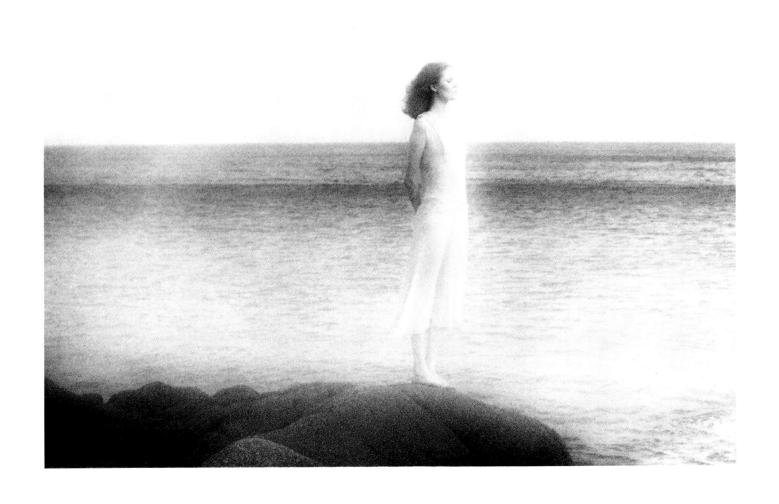

The rocks of the Escalet, Ramatuelle, 1973

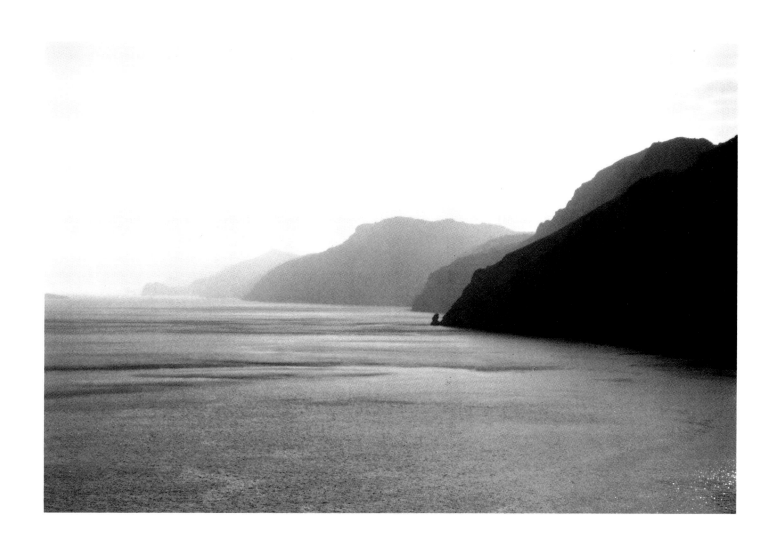

The bay of Positano, 1986

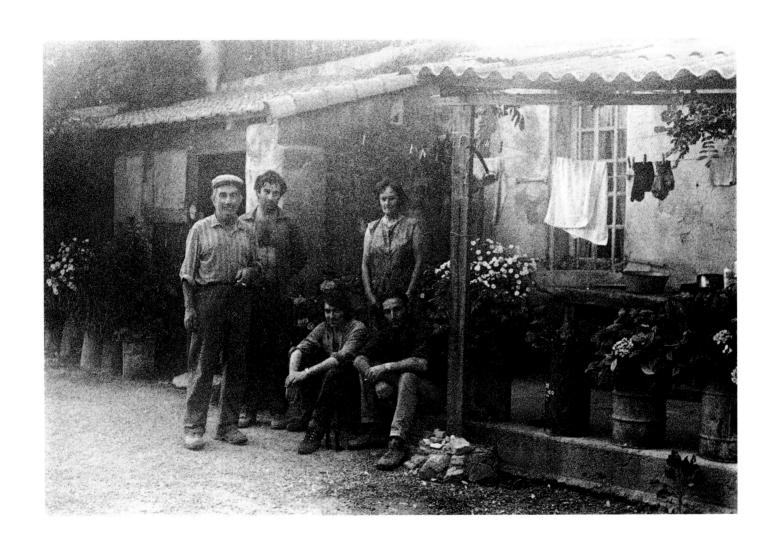

Farmers of Ramatuelle, 1968

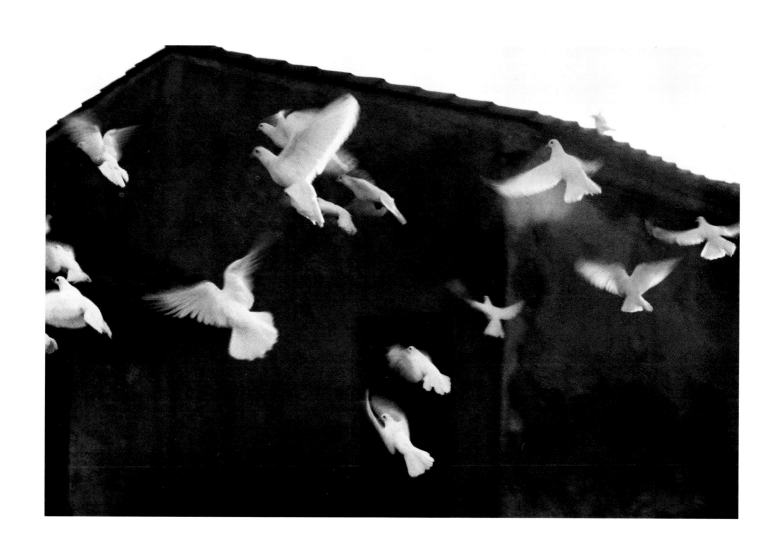

The white doves, Ramatuelle, 1969

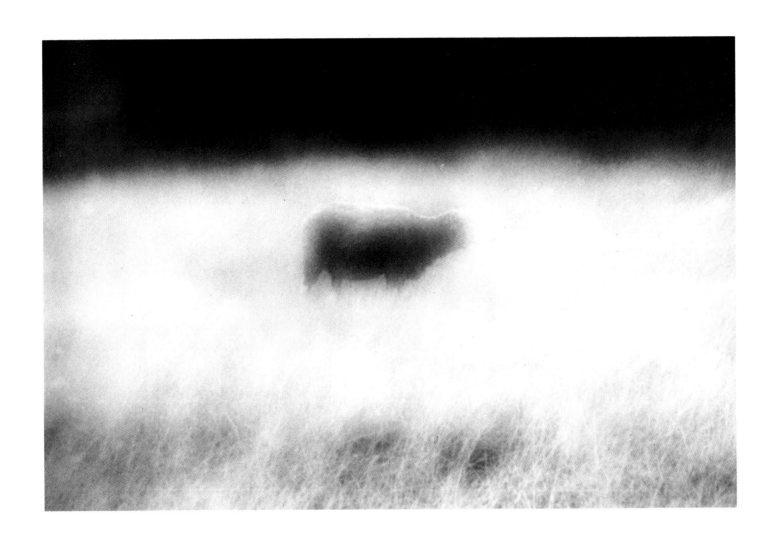

The lost sheep, Bornholm, 1984

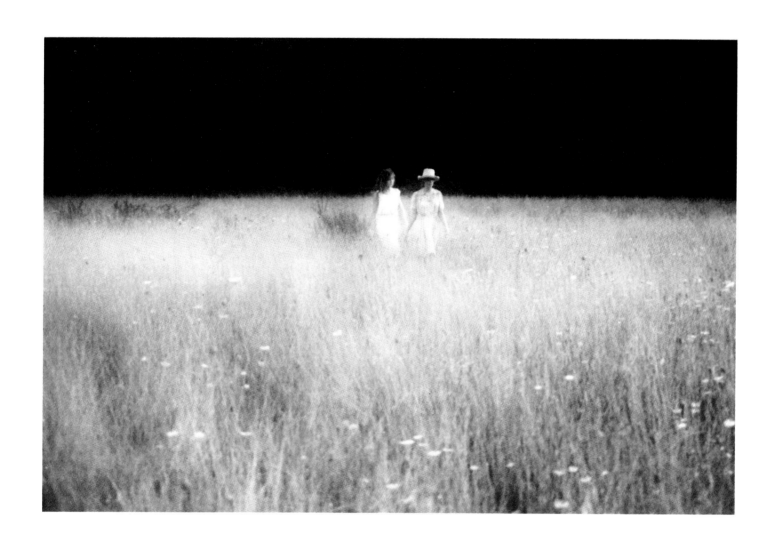

The summer of '82', Saint-Tropez

the opportunity to prove my worth to them, they enabled me to obtain the correct papers. I was paid 300 francs a month. The rent of my small room was 50 francs; a croissant cost 20 centimes, and 25 centimes extra with butter. Often I went without the butter!

I changed employers but was always paid the same meagre sum for drawing store layouts. I found a room near the Pagode on the Rue de Babylone. One of my jobs was with architects whose offices were on Rue de Poncelet, near the Avenue de Wagram. The business had been started by a Frenchman and a young American, Bill Perry, with whom I became a close friend. He was rich, had a Mercedes-Benz, and spoke some French. He was my first mentor, and life became a little easier.

I had begun to paint, which was what I liked doing best. Max Ernst's *La Ville Endormie* fascinated me. In my cramped room I had painted a very large canvas, part of which hung outside the window. I had to turn it around in order to paint the other end. Eventually, after all this strenuous effort, I noticed one section that I particularly liked, right in the centre. I cut this out and submitted it to the Biennale, where it was chosen, along with three hundred entries, from three thousand applicants. I had dreamt of being a painter, but after several cocktail parties given by the Vicomtesse de Noailles, on the Place des États-Unis, to which young painters were invited, I realised that painting would not pay the rent and so I continued to work in the architects' offices, in their research department.

Later, I moved to the Rue d'Alger, near the Rue de Rivoli where I again had a 'chambre de bonne'. From my window I could see, on the other side of the courtyard, the inside of another room where a young woman lived. Often, in the mornings or evenings, we would wave and smile to one other. We had never spoken but nevertheless, these few silent gestures had created an intimacy between us. She would undress and wash herself in front of the window with a total lack of concern. One summer morning, very early, I decided to visit her. It seemed that all the girls living in the building knew each other, as the doors of their apartments were open to let in the cool air. With a rose in one hand, and my shoes in the other, I tiptoed across the hall. I came to a door which was ajar, and recognised my neighbour. She was naked on her bed; lying on her back, one leg outstretched and the other bent over. A lovely picture – a painting by Bonnard come to life. I looked at her for a moment, then realised that she was not alone; a man slept next to her, he too was naked. I left the rose for her. In my mind's eye the image remains; the girl asleep in that beautiful position, the sheets in disarray; it is a favourite pose, which I have used many times in my photographs.

I was walking along the Rue de Rivoli one day when a Mercedes-Benz pulled up and the driver called out, "Hey, boy! Want to work for me?" It was Peter Knapp whom I had met several times at exhibitions. He offered me a job on his magazine *Elle*. I was responsible for the layout of the magazine and it

(Cont. page 208)

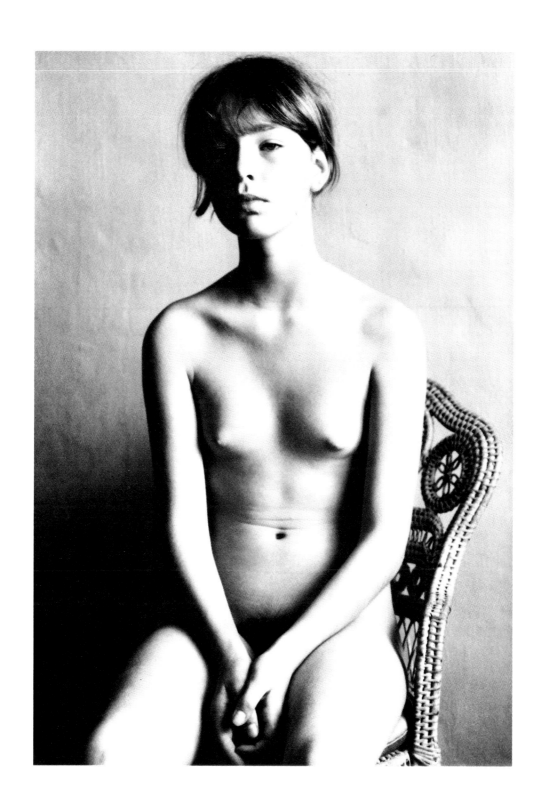

Lisette, Saint-Tropez, 1981

185

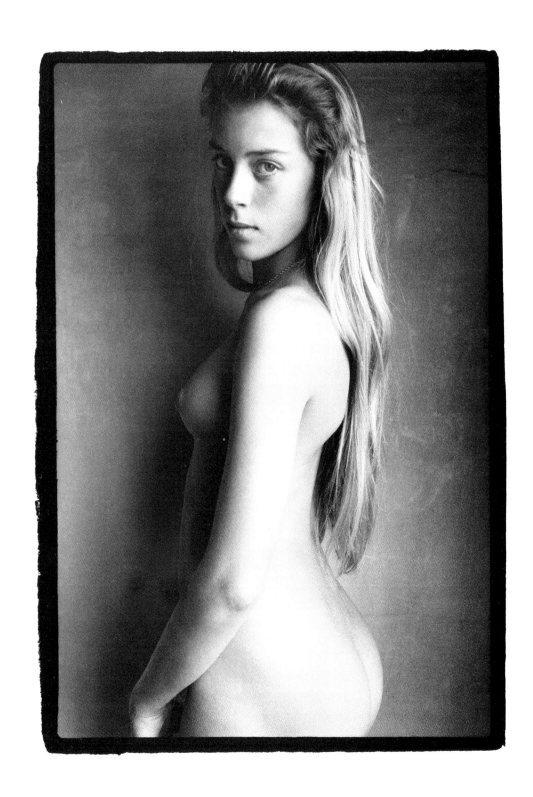

Ann-Karin, Paris, 1985

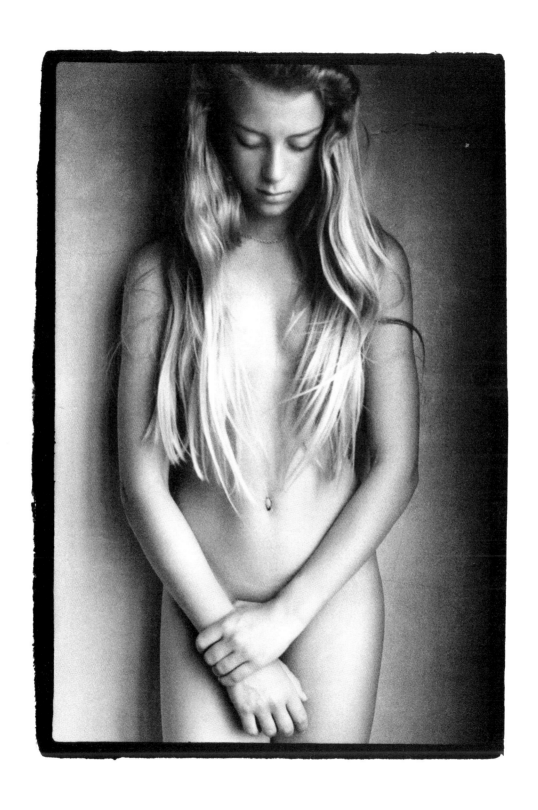

Modesty, Paris, 1985

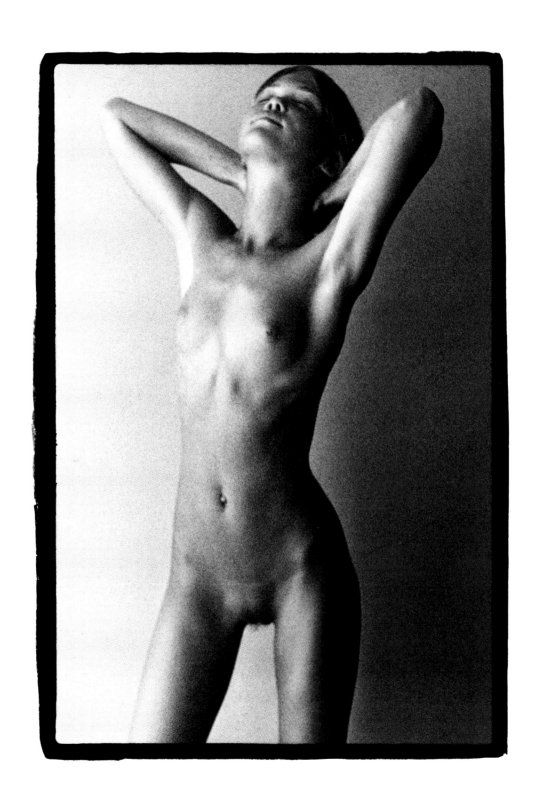

Lena, South of France, 1979

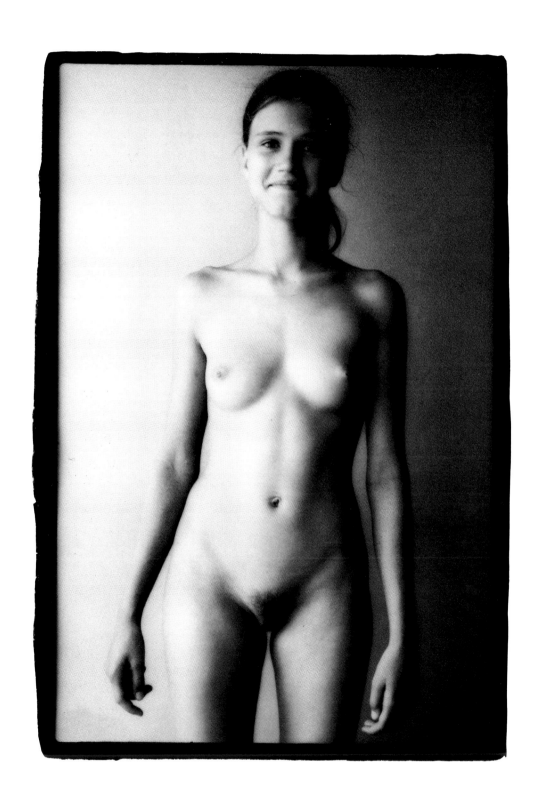

Suzanna, South of France, 1980

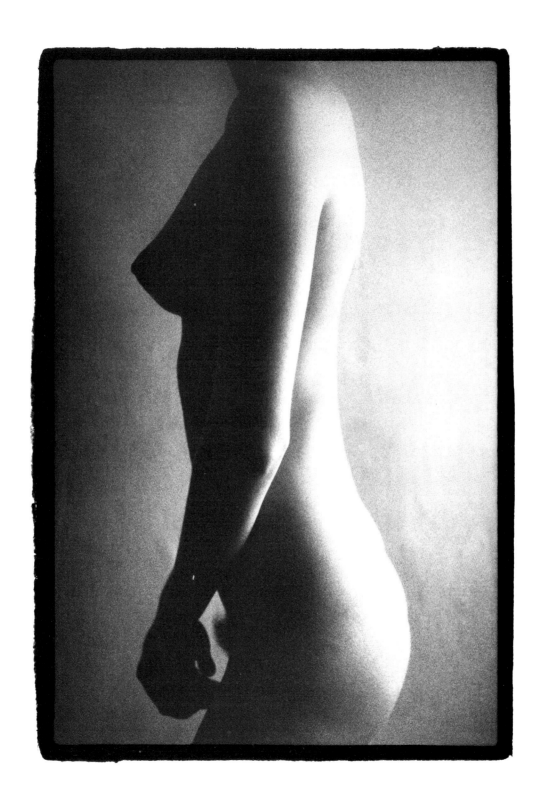

Profile I, South of France, 1981

Profile II, South of France, 1981

The forbiden fruit, South of France, 1980

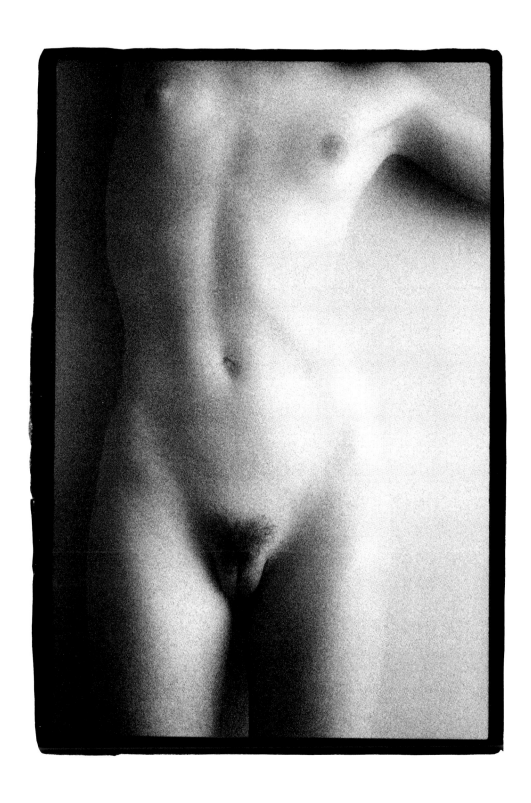

What dreams are made of, South of France, 1978

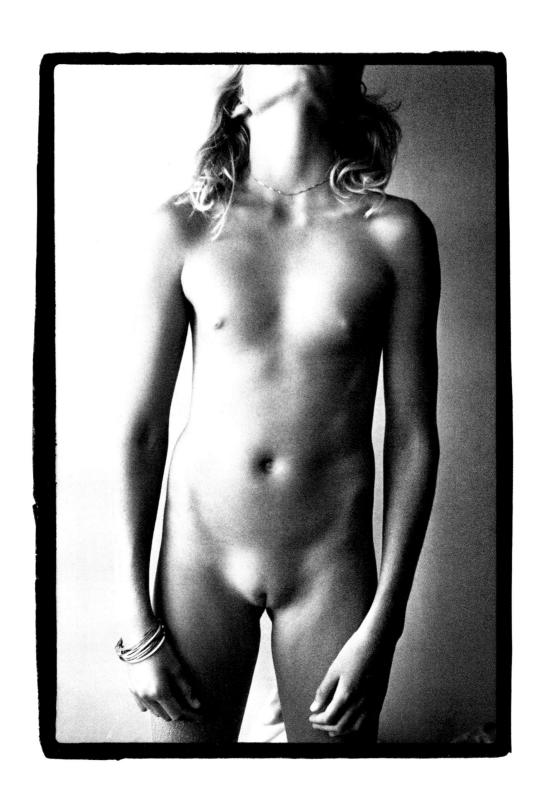

Miss P., South of France, 1986

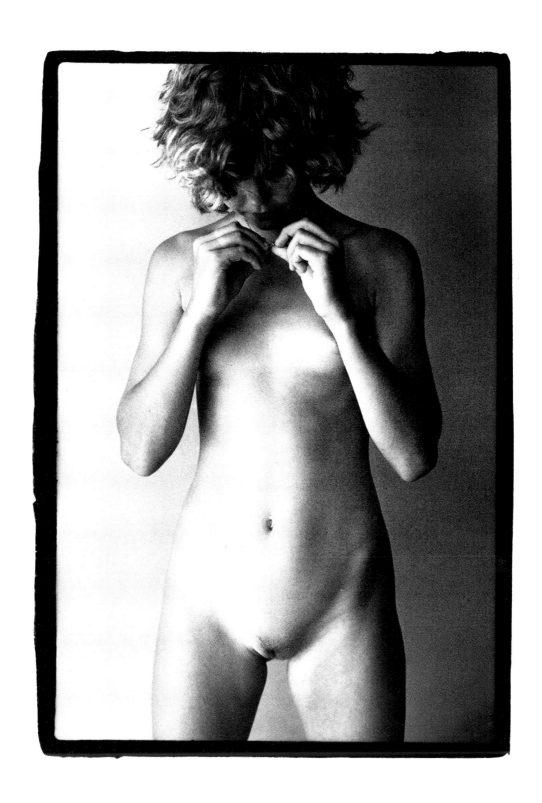

Miss T., South of France, 1982

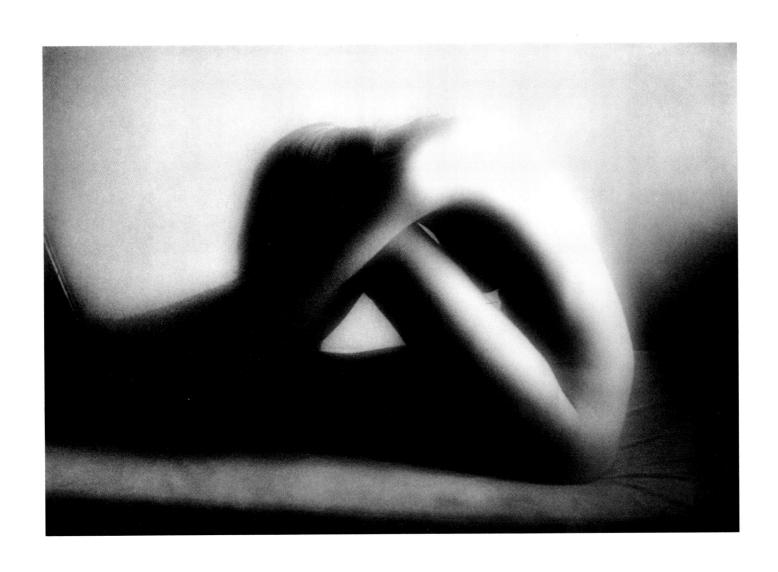

Hiding, Ramatuelle, 1979

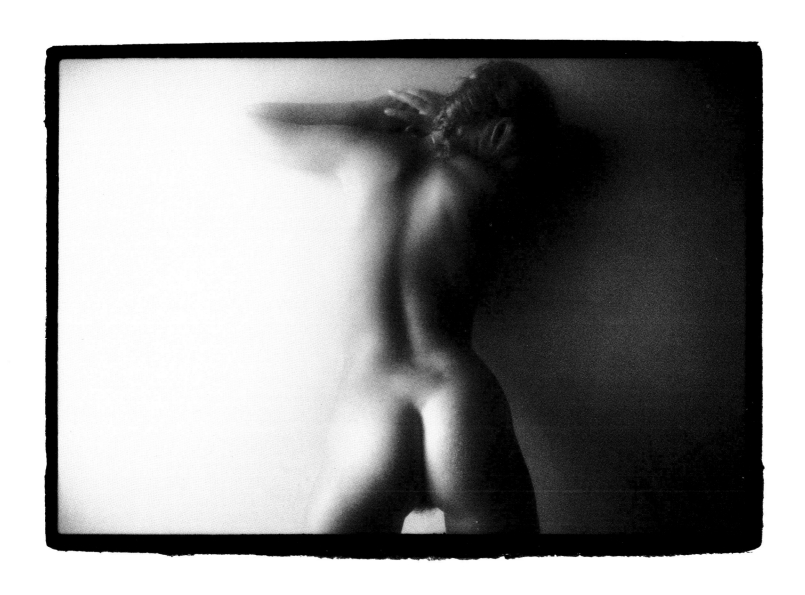

Feigning innocence, South of France, 1983

197

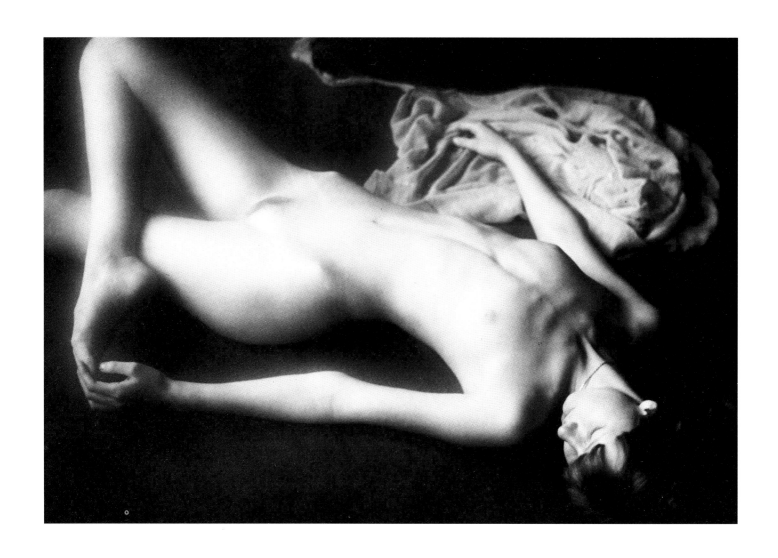

Idle youth, Copenhagen, 1973

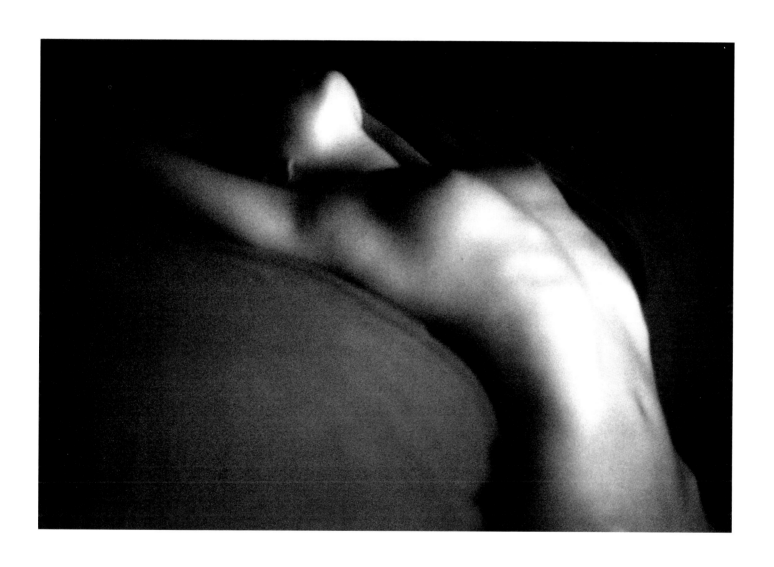

The arch, Ramatuelle, 1974

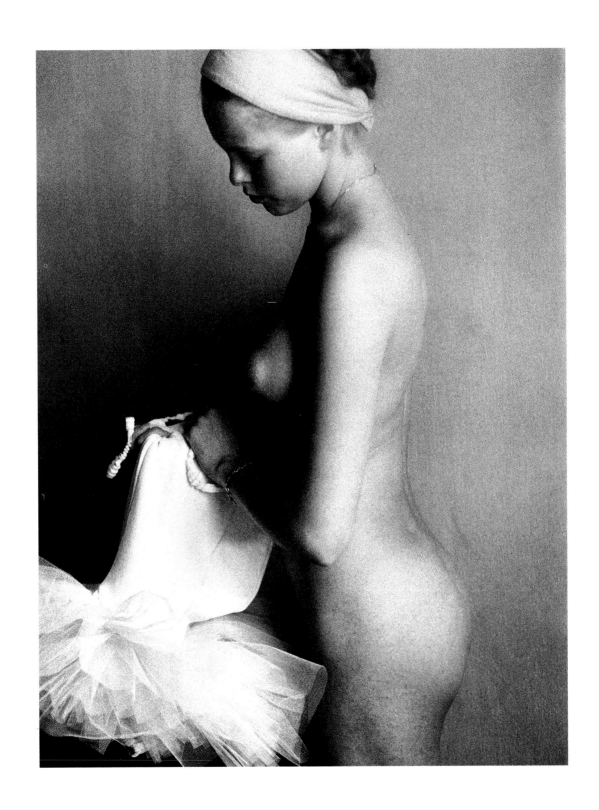

The white tutu, Ramatuelle, 1976

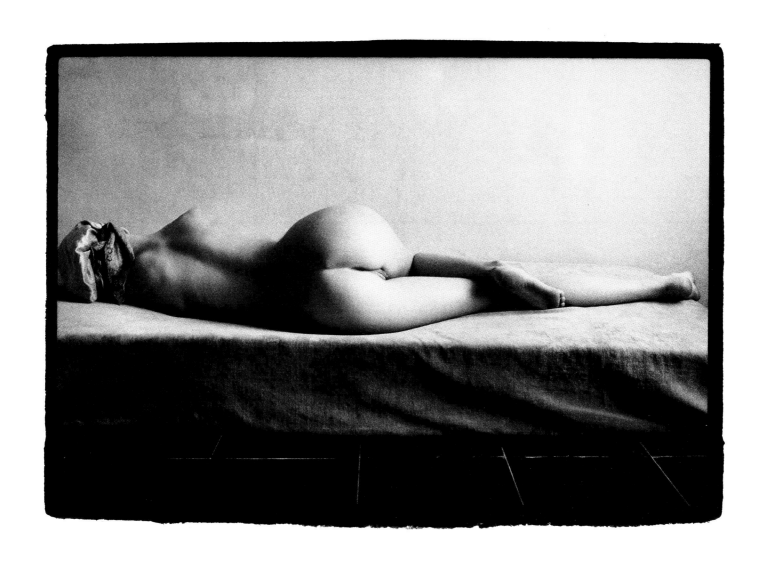

Repose, Ramatuelle, 1979

201

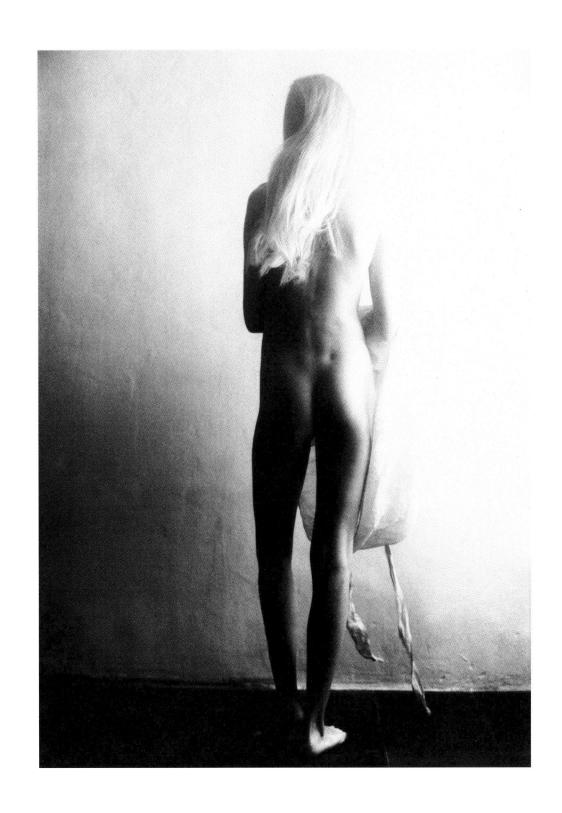

Early morning, Ramatuelle, 1972

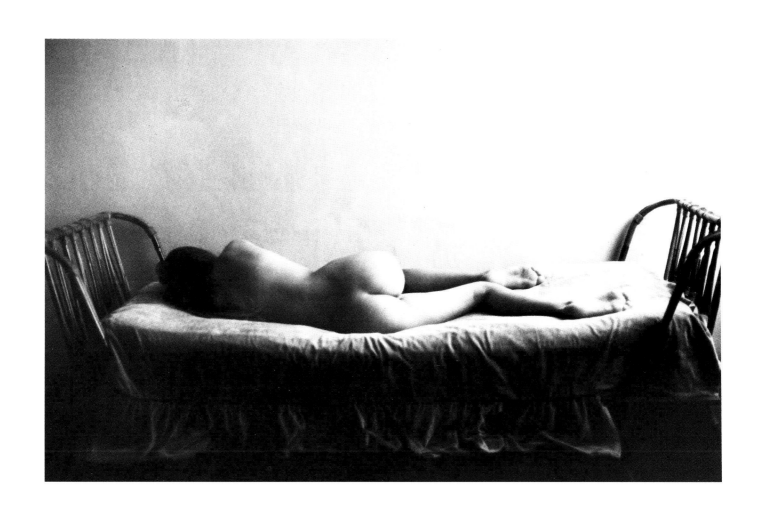

Alone, Ramatuelle, 1975

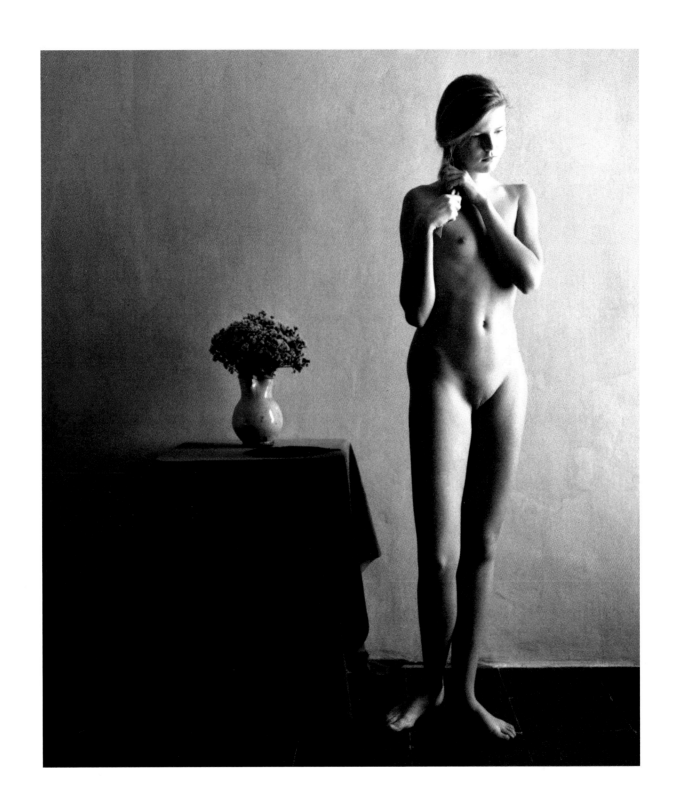

The artist's model, Ramatuelle, 1986

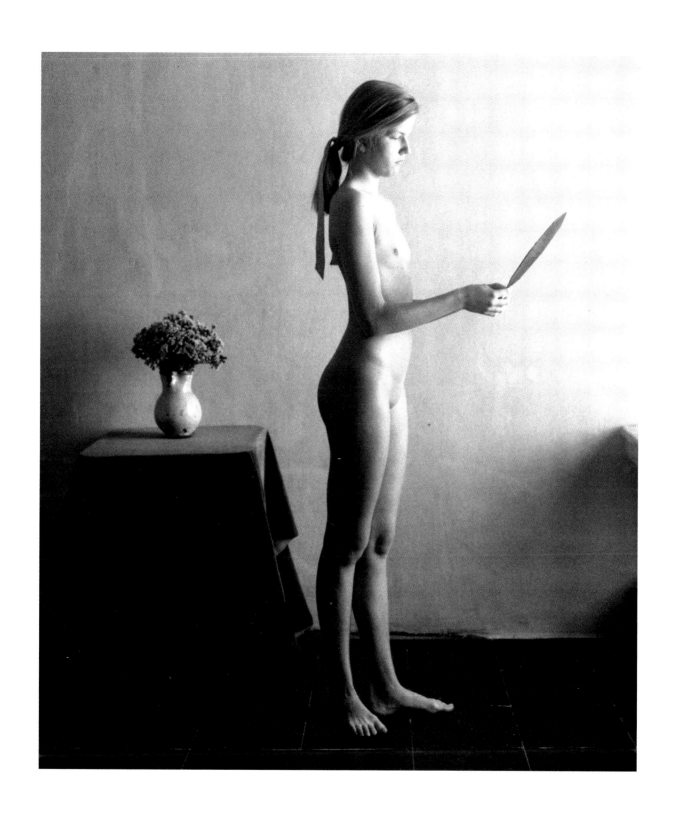

The mirror, Ramatuelle, 1986

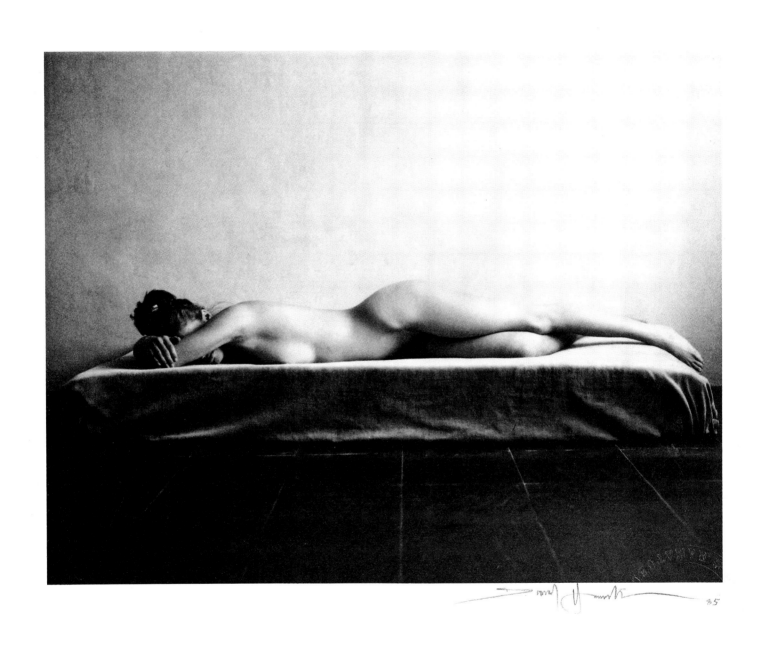

The studio couch, Ramatuelle, 1984

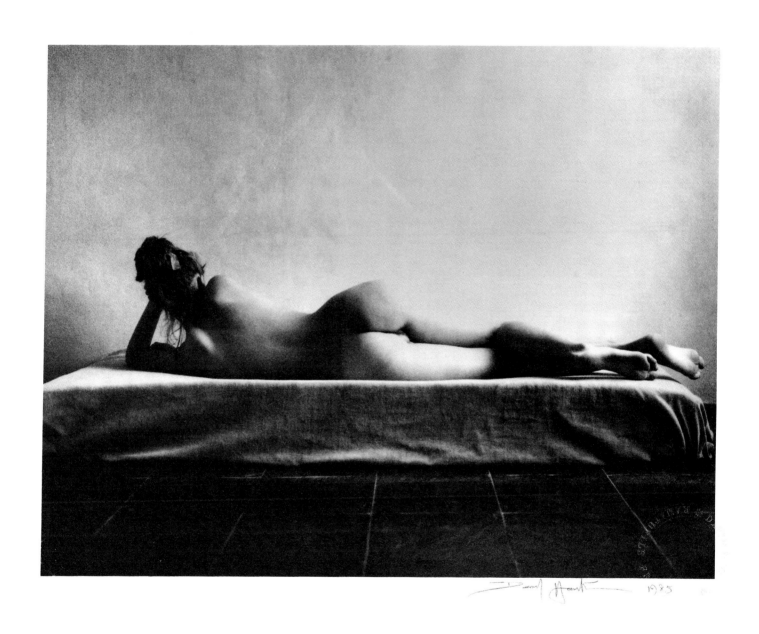

Posing, Ramatuelle, 1984

207

was there I met Michel Paquet who became a close friend and colleague. Soon after I started with *Elle*, I walked past Buntings on the Rue du Faubourg Saint-Honoré and saw a pair of shoes in the window which I immediately coveted. The salesman, puzzled, said " They are a little old, monsieur. They have been in the window since 1927". "I don't give a damn", I said, "I want those shoes !" They cost me a month's salary, were too small and the leather was dry but they were the most beautiful pair of shoes in all of Paris.

In 1959, *Elle* was one of the best-selling magazines in the world. It was not as chic as *Vogue*, but it was a magazine of its time. Fully Eli was the photographer and Macha Meril was his beautiful model. Peter Knapp, who was the art director, would tell us what he wanted in each edition. I was in charge of the fashion section and would take the elements of the layout and organise them into 12,15 or 20 pages. This way of working was such an innovation that several of the top people from *Queen* magazine came from London to see us. Because I was English they offered me the position of art director. In 1960, I accepted the offer and returned to London taking Michel Paquet with me.

It was the beginning of the Swinging Sixties and London was an exciting place to be at that time. But I and my team, Michel, Max Maxwell and Barney Wan worked long hours to make a success of the magazine. In one issue we accidently published a reversed photo of Leonardo da Vinci's *Mona Lisa*. The reaction that it triggered ! Never before had we received so much mail. I also published one of the very first photographs of a David Hockney painting; he was at the Royal College of Art at that time, having won a contest at his school. One day Irving Penn's agent came to see me and unpacked a suitcase crammed with photographs. When I saw the strength and the quality of the work, I bought everything. It cost a small fortune but we published many of Penn's photographs over a period of time, all of which helped to contribute to the success of *Queen* and make it the most fashionable magazine in London.

I was earning a good salary and lived in a pleasant apartment which I had furnished with a Mies Van der Rohe's *Barcelona Chair*, and one designed by Herman Miller, known as the *Barber Chair*. I felt that I had finally accomplished something in my life and was even considering marriage with Paula Nobel, a model whom I was dating.

After more than a year with *Queen* I had a disagreement with Jocelyn Stevens, the chief executive, about one of Terence Donovan's photographs which I wanted to publish as a two page spread. Stevens was against the idea and like many editors and publishers, did not have a well developed graphic style. That day our discussion reached an impasse. "No, this is not worth a two-page spread", he insisted. "But of course it's worth a two-page spread", I retaliated. I was determined to stand firm because Terence Donovan was and is one of the greats of British photography, along

(Cont. page 230)

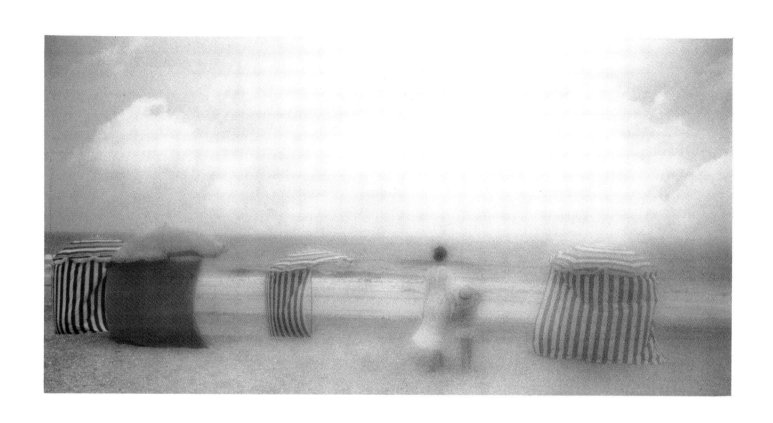

Homage to Boudin, Cabourg, 1987

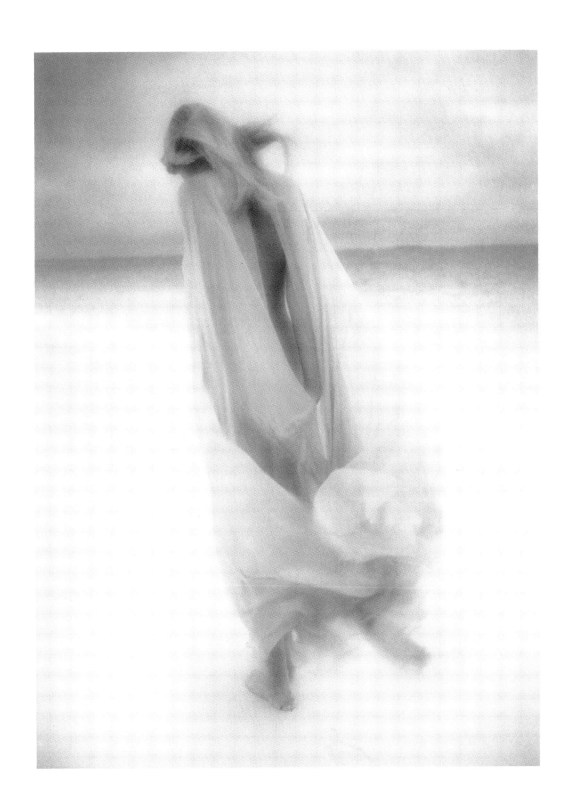

The grey bird, Bahamas, 1978

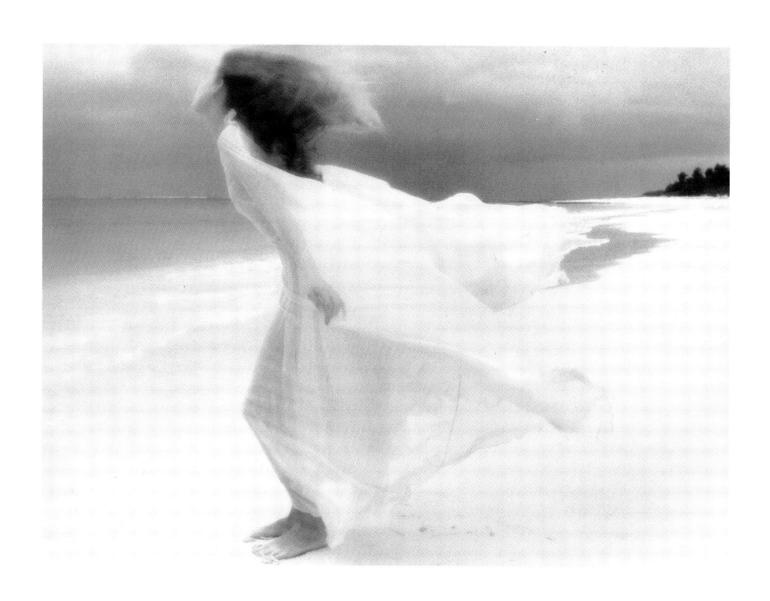

The pink sand, Bahamas, 1978

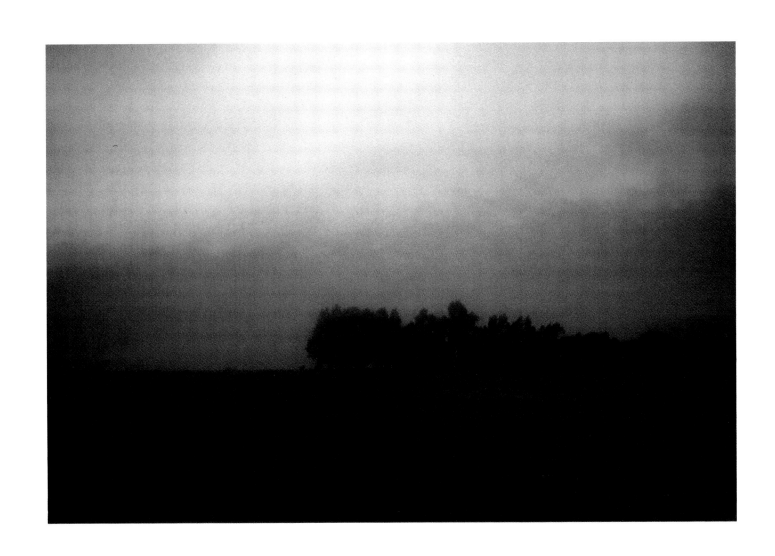

The pampas, Argentina, 1991

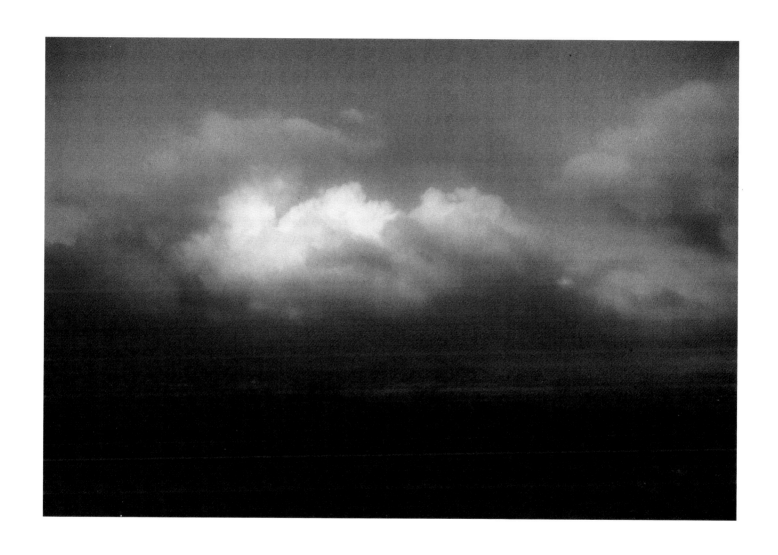

Moustique Island, 1978

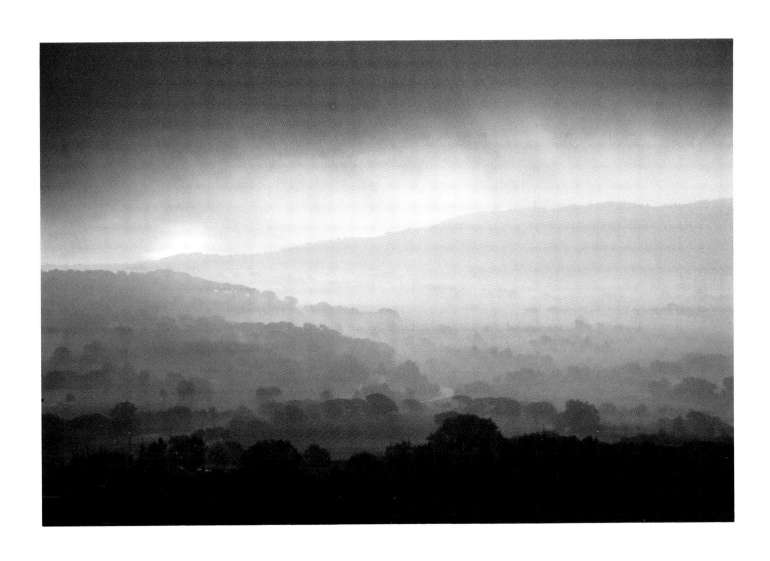

View from the terrace, Ramatuelle, 1982

The big white cloud, homage to Stieglitz, Guam, 1987

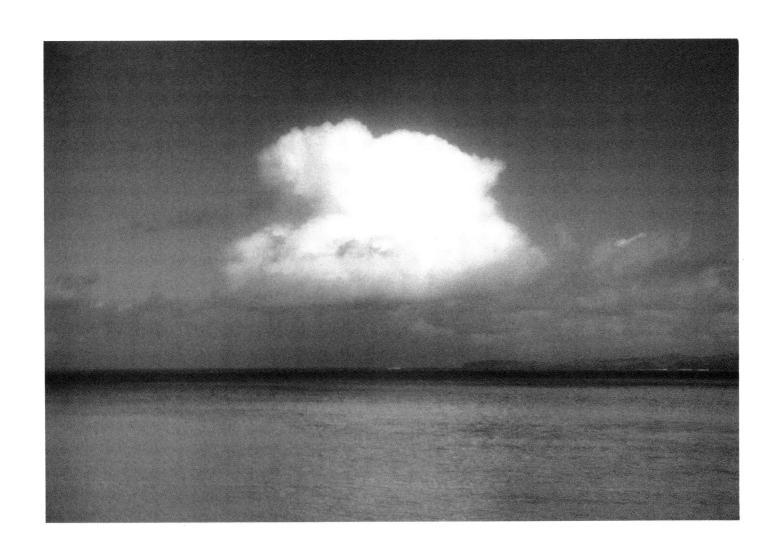

Seascape, Kuta, Bali, 1987

Tropical storm, Guam, 1987

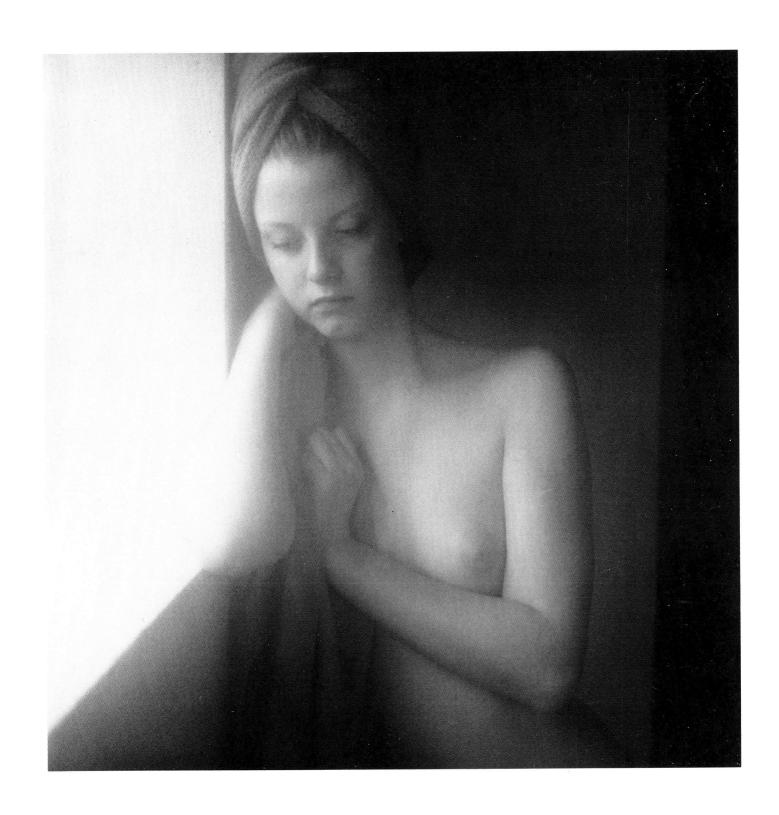

Mina, Phuket, Thailand, 1986

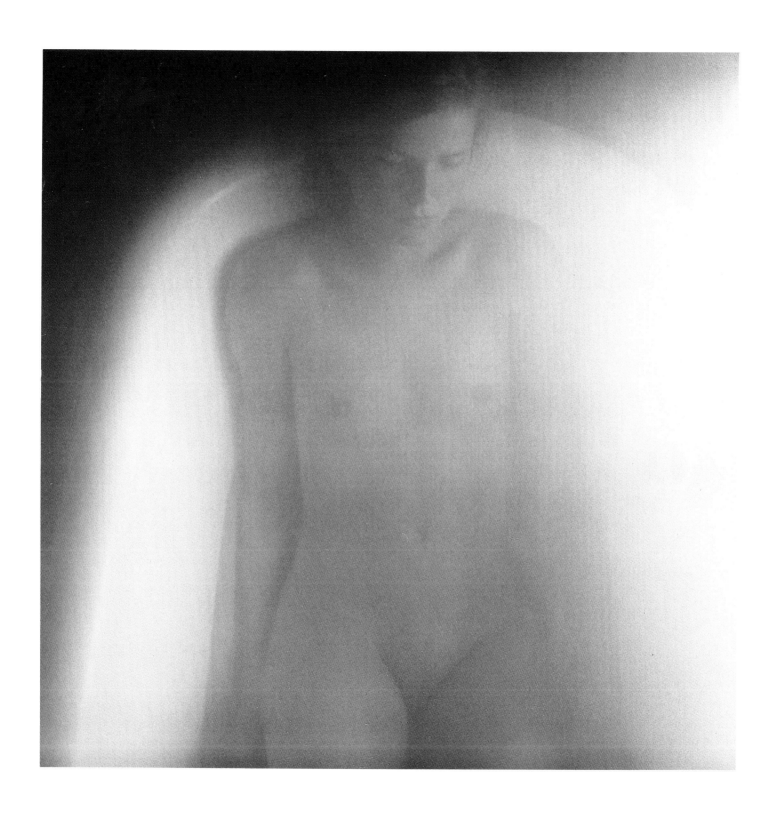

Young girl in the bath, homage to Bonnard, Ramatuelle, 1986

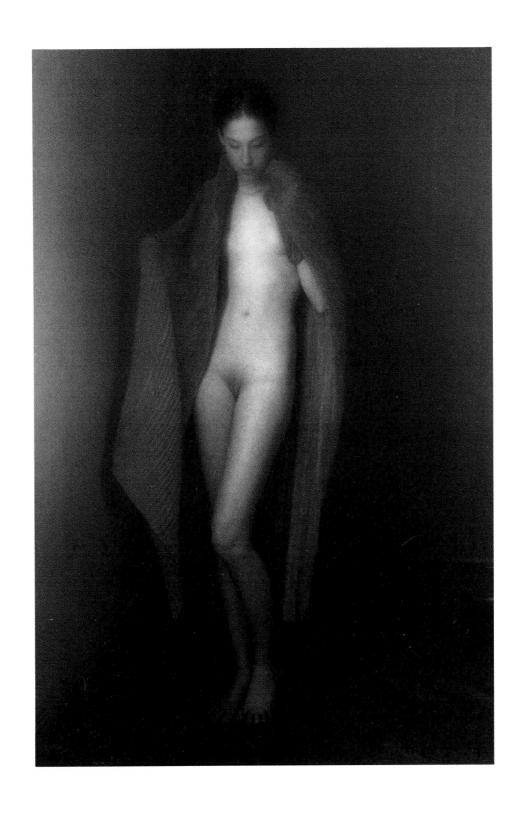

Renaissance nude, Château Saint-Amé, 1975

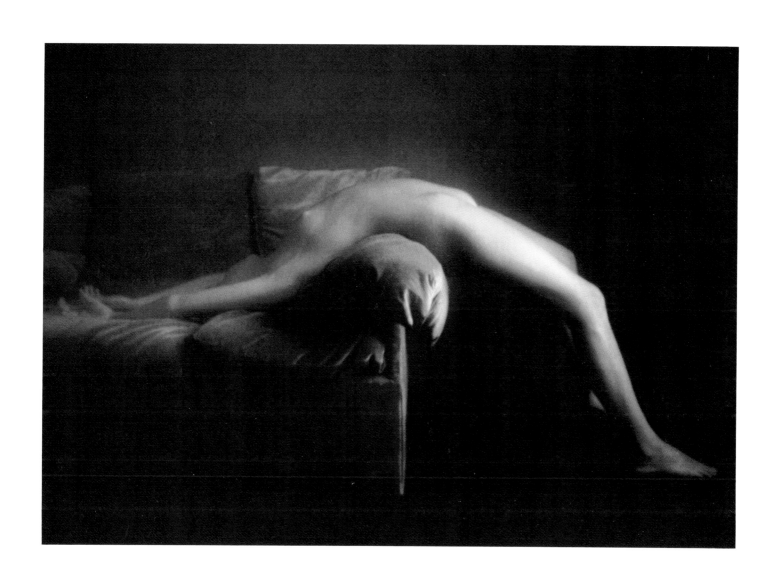

Shameless, Château Saint-Amé, 1978

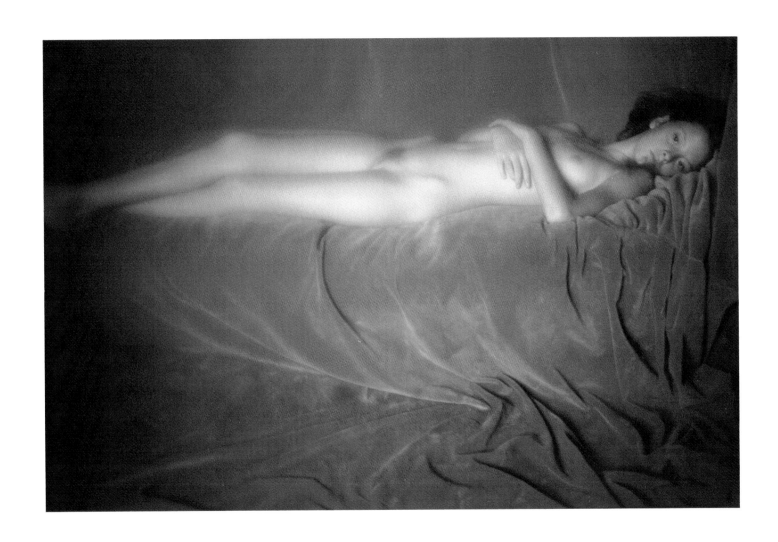

The red velvet, Paris, 1985

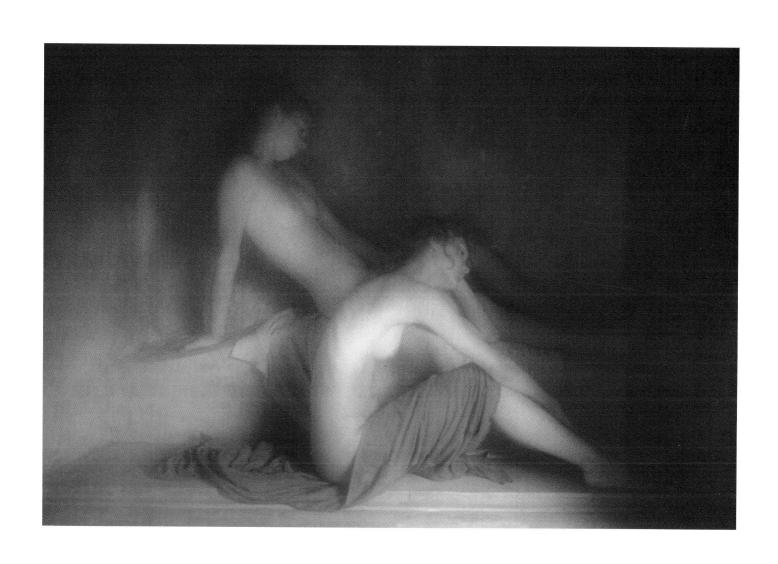

The blue hammam, Saint-Tropez, 1979

223

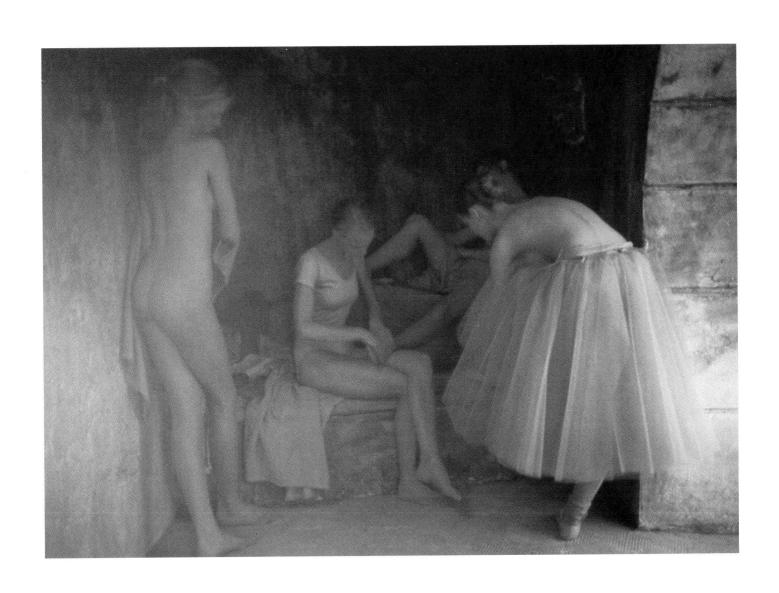

The fresco, Saint-Tropez, 1979

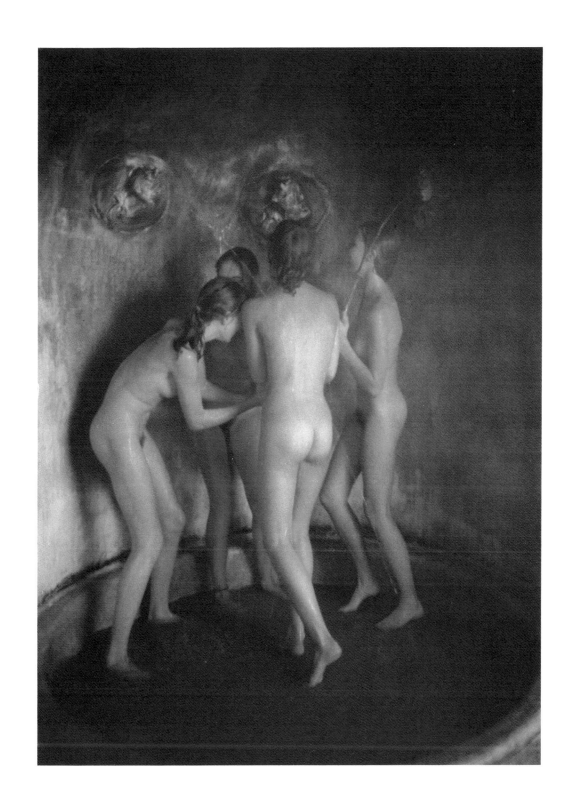

Nymphs playing, Saint-Tropez, 1979

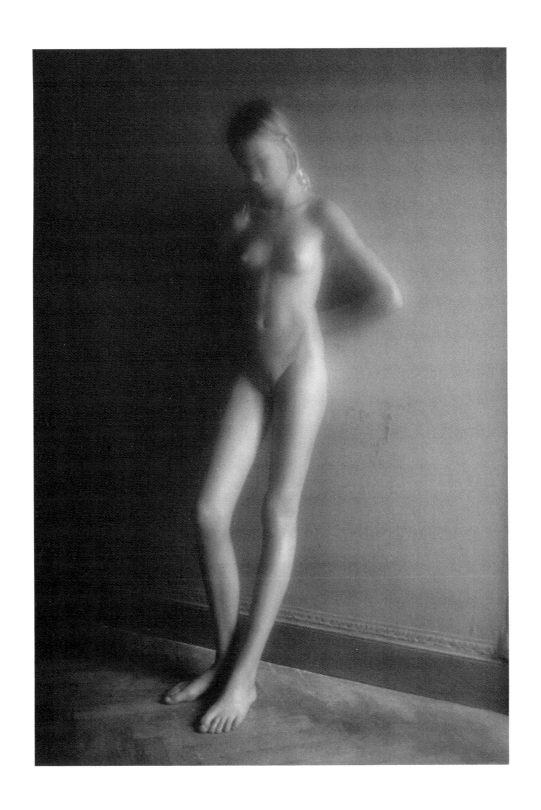

Laura, Saint-Tropez, 1979

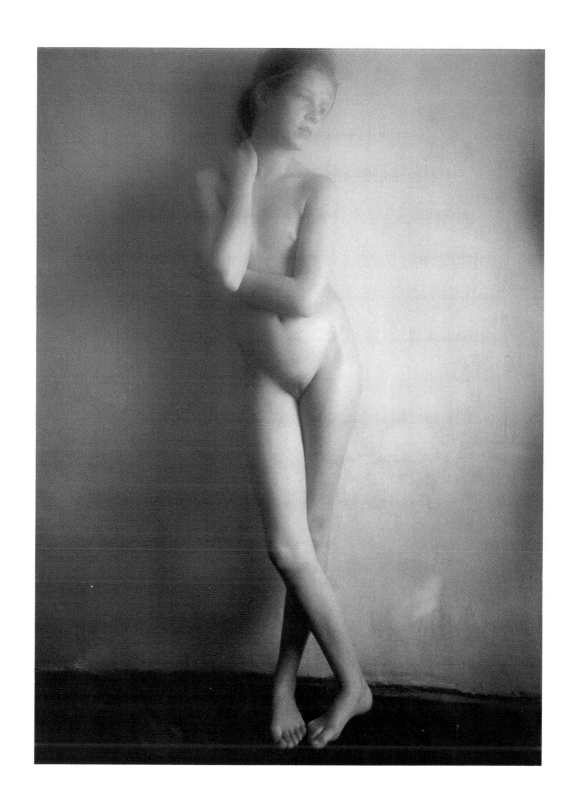

Maggy, Ramatuelle, 1988

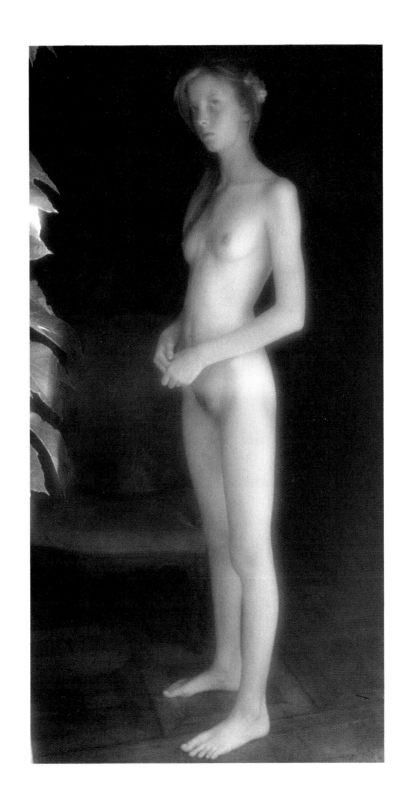

Homage to Cranach, Paris, 1985

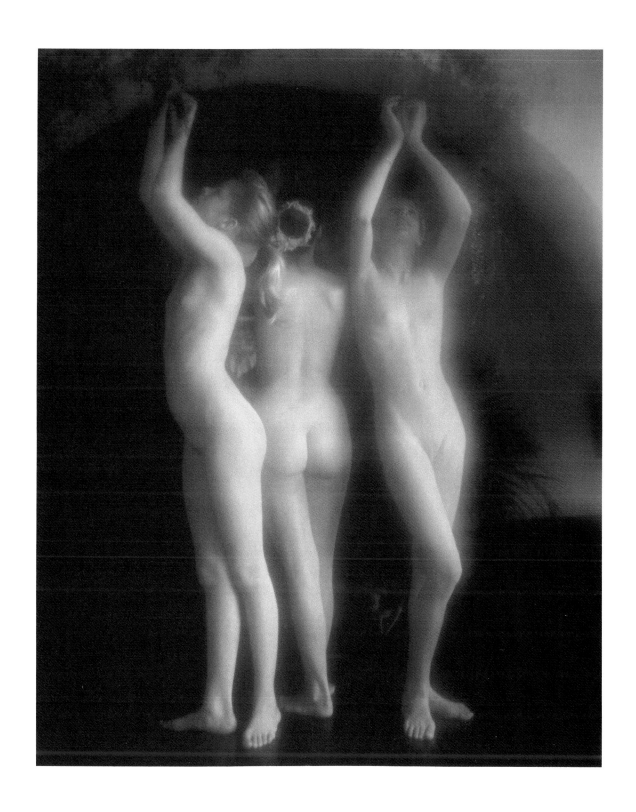

The three nymphs, Ramatuelle, 1988

with David Bailey and several others. I can recall perfectly this photo: a fashion picture of Celia Hammond. She and Jean Shrimpton were the two most beautiful women of that era. My ideas about photography and layout were by now very specific and as he refused to listen to me, I told Stevens that I was leaving immediately. Michel and I packed our bags and returned to Paris.

We were hoping to return to *Elle* but that was not possible. I worked briefly for *Havas*, but found it did not suit me and soon after I was offered a position as art director of Printemps Department Store. Here I was responsible for all the promotional flyers, the publicity which appeared in magazines and the billboards outside the store.

In those days Peter Knapp ran *Elle*, Jean Demachy was at *Marie-Claire*, and there was a very talented Swiss at the Galeries Lafayette. The exceptional quality of the fashion publications at that time was due to the fact that the art directors made the decisions and gave the photographic layout priority over the text. Later, everything changed and those who came after were 'Yes Men'. The words took precedence over the photographs and the general layout, and the quality and prestige of these magazines deteriorated.

It was a golden age for art directors and we would defend our power of decision at any cost. Peter Knapp, for example, had discovered Gene Laurence, an American photographer with a great deal of talent but no money, and bought and published his work. When

I worked at *Queen* I bought photographs from Laurence; he was always hard up and often had barely enough to buy a roll of film or a meal. He had a tremendous talent and I owe my early ventures into photography to him.

Photography interested me increasingly, and it was inevitable that I should begin to indulge in it. I bought a camera, which did not seem to be quite as simple to master as I had thought. My first roll of film, which I had failed to put in correctly, came out completely black ! Eventually, having learned how to load the camera I took some very simple shots: random objects, street scenes. We often used young Swedish models at Printemps for the fashion pages and I started photographing them. I rented a studio in Montparnasse that had once belonged to Petula Clark. I practised this new hobby and experimented with a flash light but found I could never achieve what I wanted with artificial lighting.

My studio became a popular meeting place for models, artists and photographers. Often forty or more people would crowd into the forty square metres and start to queue at the door if it was too packed. Charles Matton, Matti Klawine, Saul Steinberg, Omar Sharif, Sean Flynn (son of Errol) and Coleman Hawkins were just a few of the 'names' who called in. There were parties, too, with different themes. Once I had a 'black' evening based on the idea in Huysman's book *À Rebours*. The walls, the rugs, the furniture were black, even the food: caviar, grapes, mussels, black sausage.

(Cont. page 242)

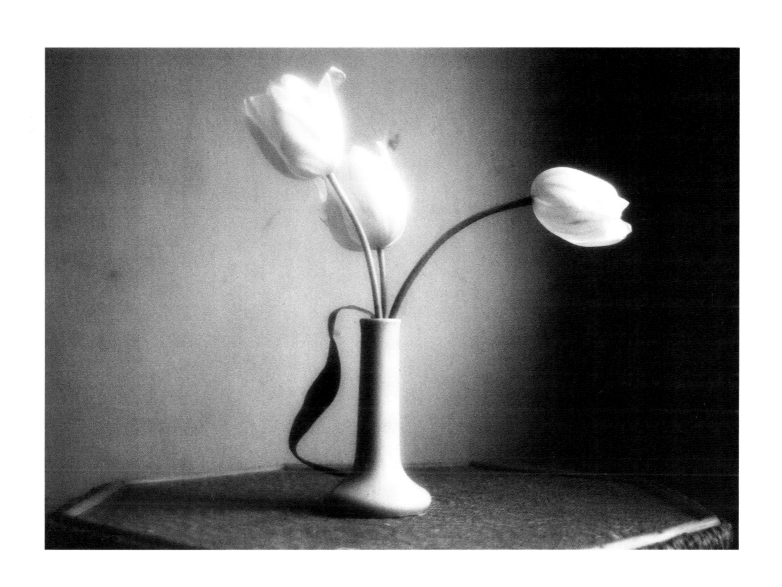

The three tulips, Ramatuelle, 1985

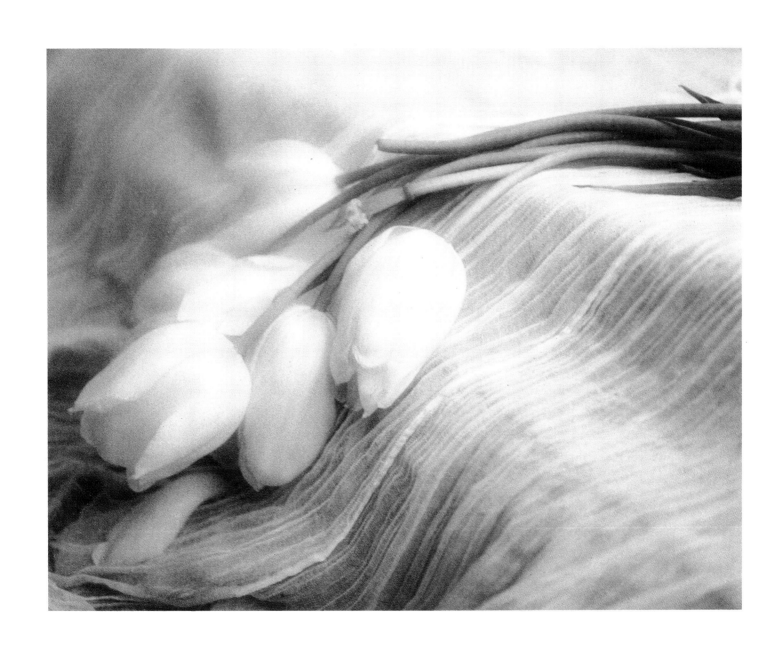

Yesterday's tulips, Ramatuelle, 1985

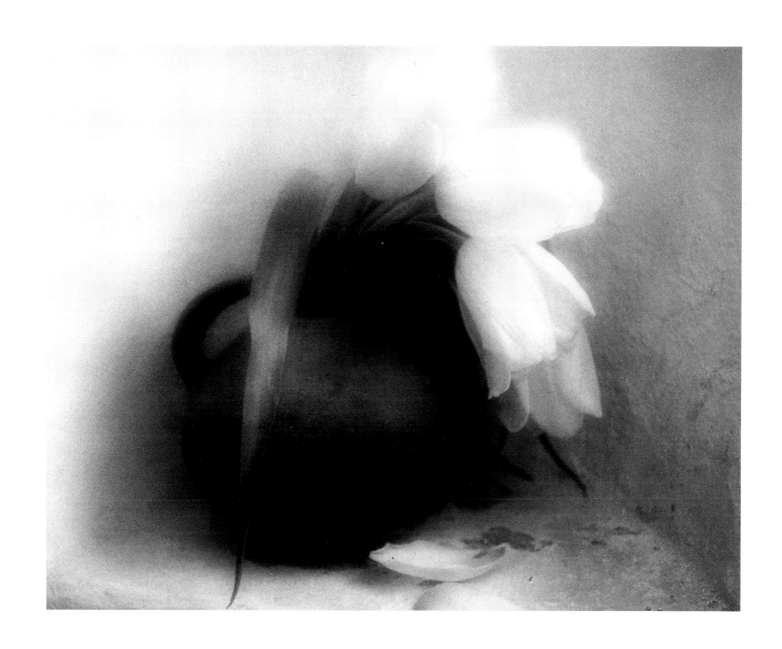

Bouquet in black and white, Ramatuelle, 1983

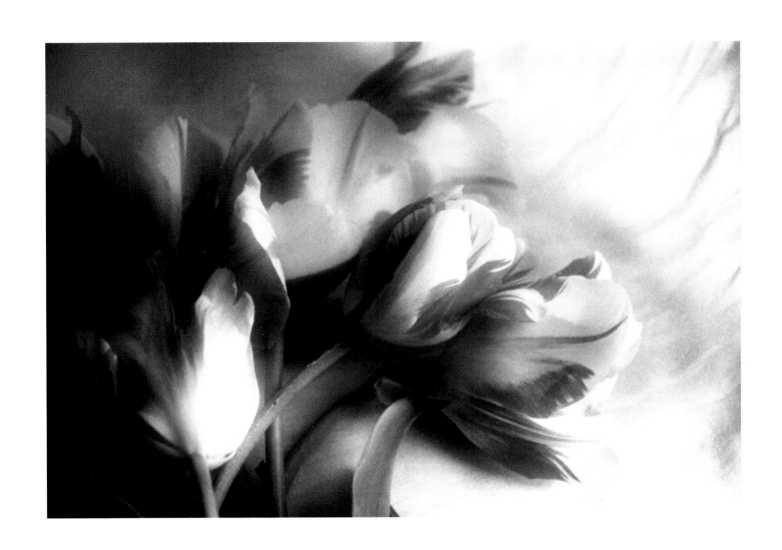

Flamboyant tulips, Ramatuelle, 1990

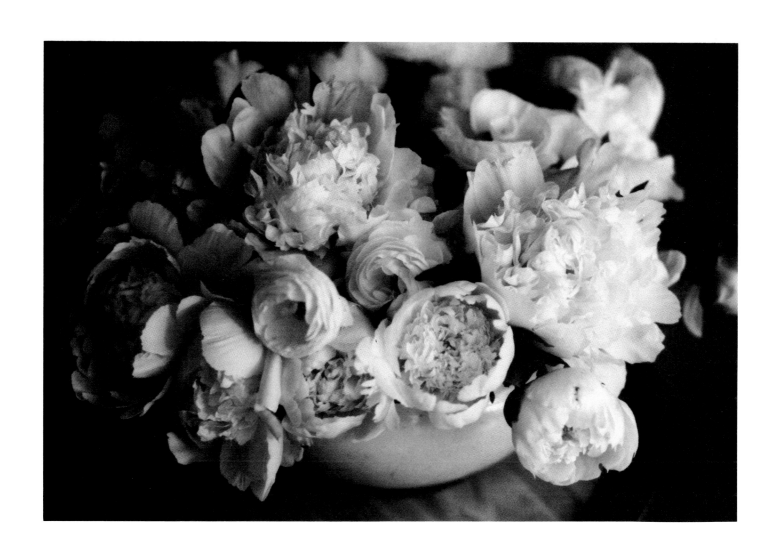

The bouquet, Ramatuelle, 1986

Peonies, Paris, 1988

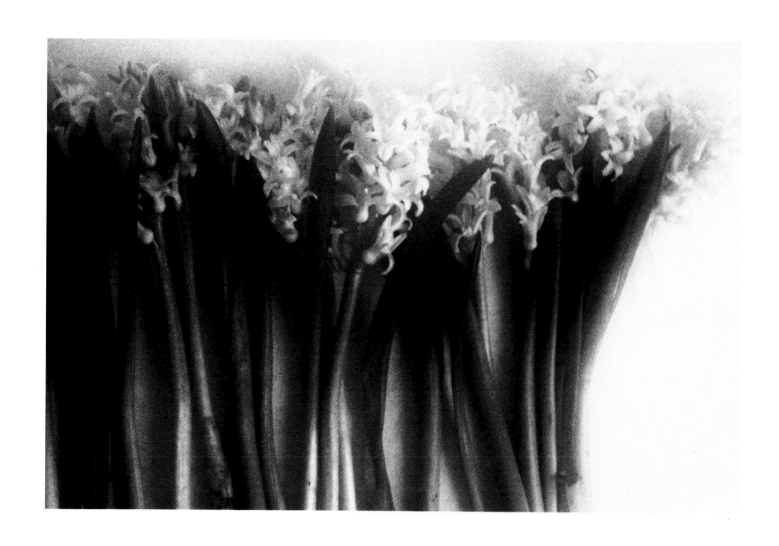

Hyacinths, Ramatuelle, 1988

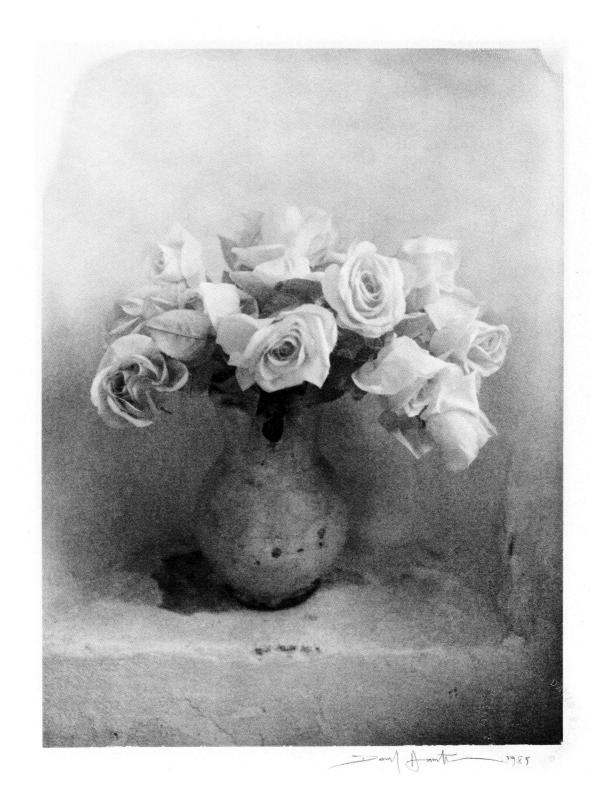

April roses, Ramatuelle, 1981

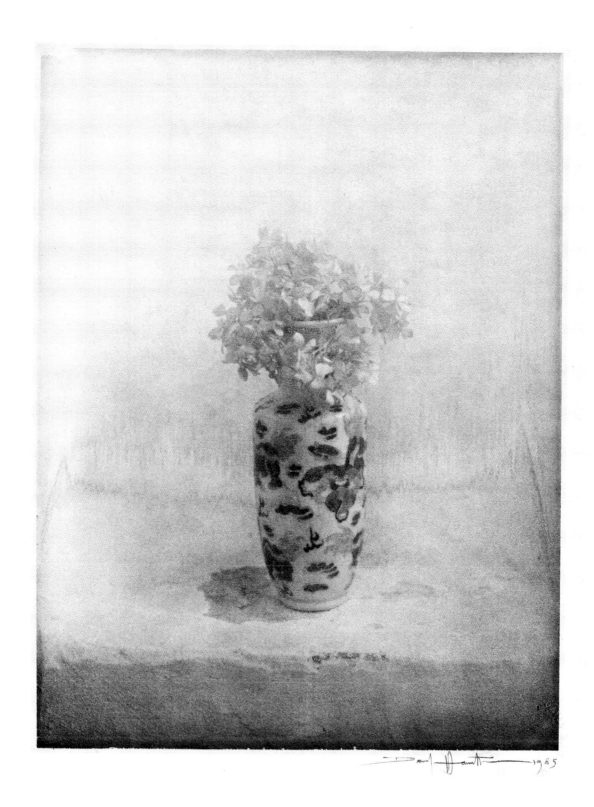

The Chines vase, Ramatuelle, 1981

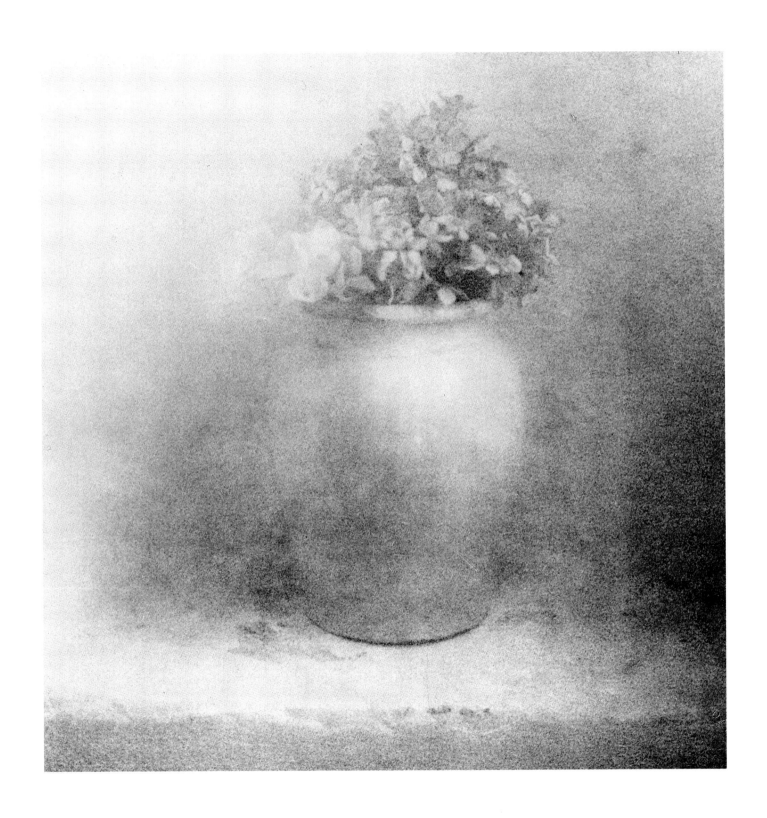

The white bouquet, homage to Charles Matton, Ramatuelle, 1981

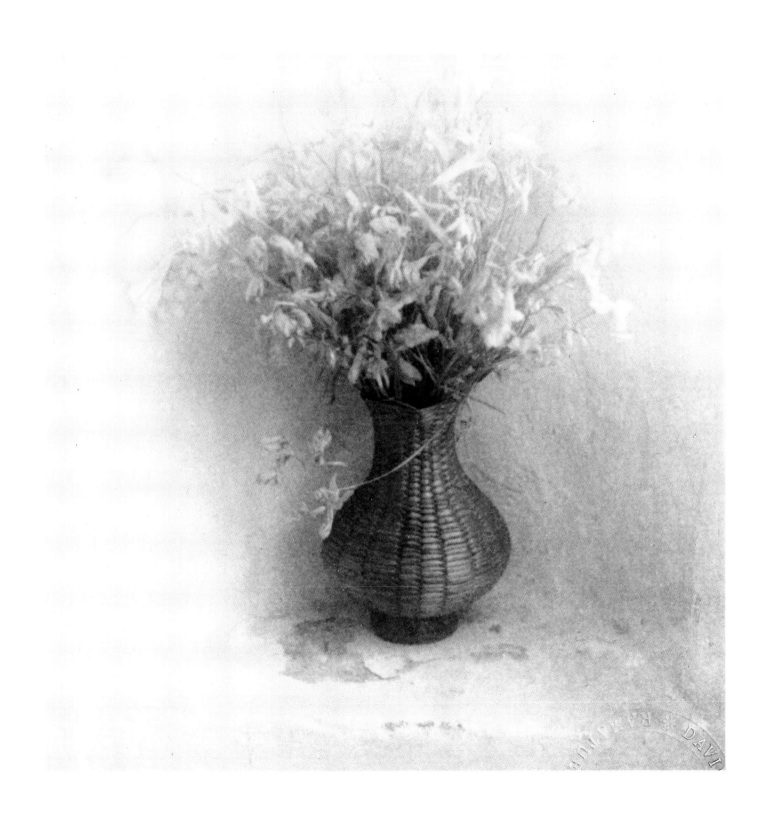

The bouquet of wild flowers, Ramatuelle, 1982

The guests were dressed in black – everything was black – except the blondes !

It was when I was working for Printemps that I discovered St. Tropez, in its sublime setting with beaches where people sun-bathed in the nude. It was a world that was completely new to me, and nothing, during my youth in England, or the life I had led until then, had prepared me for it. I decided to buy a house in nearby Ramatuelle in 1962 and I went there regularly with models, to shoot my first fashion photos. As I was usually escorted by two or three Swedish girls, I soon became well-known in St. Tropez but I socialised very little.

It was in this area that I was able to create my special style of photography. My house became my studio. The village, the surrounding countryside, provided perfect settings, full of softness and charm, and it was, for me, a life so beautiful and new, that I wanted to show, through my work, this earthly paradise. I went there at every opportunity and would catch the night train from the Gare de Lyon on Friday evening at sunset and arrive in St. Raphael at dawn. Later, for 20 000 francs, I bought an Aston Martin DB2, the car which had been used in Alfred Hitchcock's *The Birds*.

My work at Printemps interested me less and less. My stubbornness about certain artistic choices, which might have been taken for arrogance, my Aston Martin, my St. Tropez sun-tan, to say nothing of my beautiful girls, created sufficient resentment to get me dismissed in 1965. I had really begun to enjoy photography by now and my professional status over the preceding years meant that I had established good contacts with publishers and models.

After I left Printemps, I carried on taking photographs for my own pleasure, but I also took on freelance work, including fashion photos, such as a series on bathing costumes that I had done at Agadir for *Elle* magazine with the famous model, Kira.

I had been fascinated for some years by the beauty of two particular young women, whom I have previously mentioned: Jean Shrimpton and Celia Hammond. Both were tall and slender with long legs end exquisite bone structures – the high cheekbones, high brows, *retroussé* noses. For me and many others, these two were the epitome of feminine beauty.

Two years later Twiggy came on the scene; she was quite a character and I liked her very much. She was incredibly skinny but gave hope to all young girls who, like her, had little in the way of a bosom or hips. My preference for tall, slender bones was inspired by these three exquisite women who were on the covers of all the magazines, and whom I saw regularly. It was therefore natural for me to choose similar models for my photographs.

The light in the South of France is so beautiful that artificial lighting is unnecessary. I have always liked pastel colours and soft shades, which is why I never shoot pictures in bright sunlight. I prefer either the end of the day, even though the light lasts only for

(Cont. page 256)

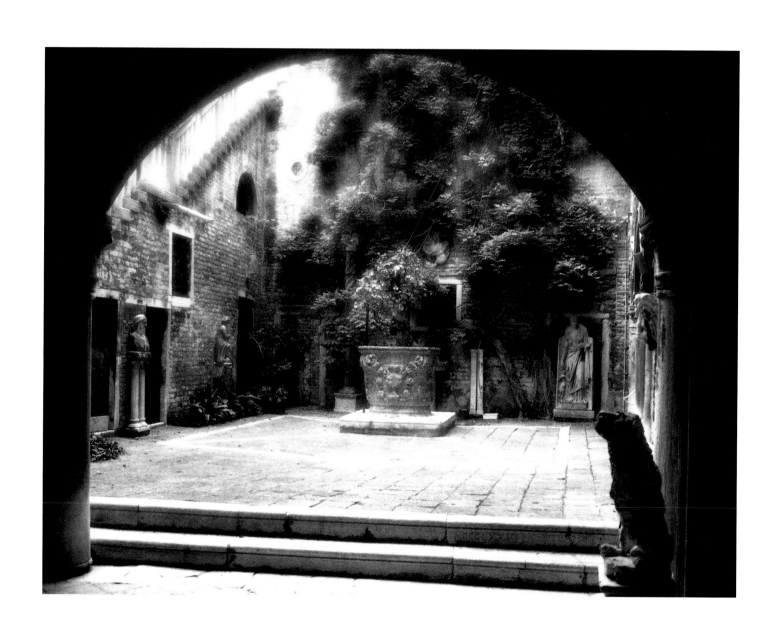

The courtyard of the palazzo Van Axel, Venice, 1991

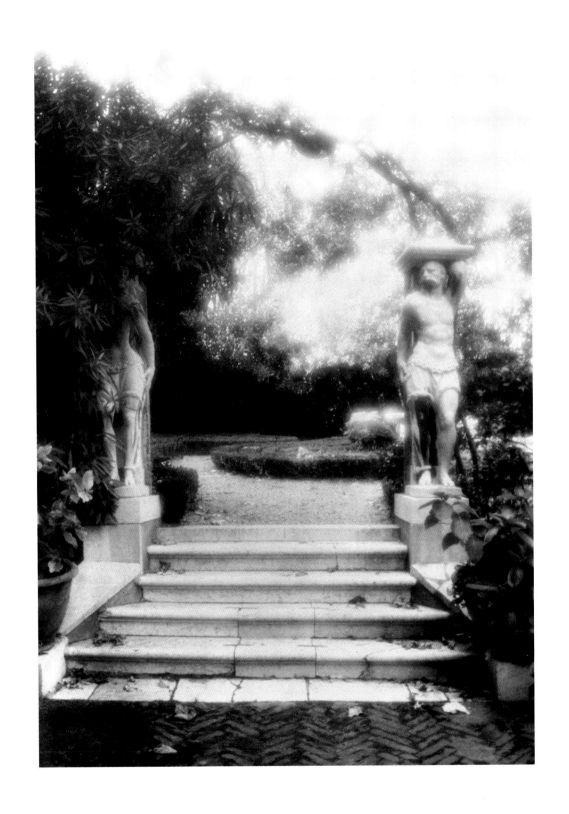

The garden of the palazzo Giustini-Brandolini, Venice, 1986

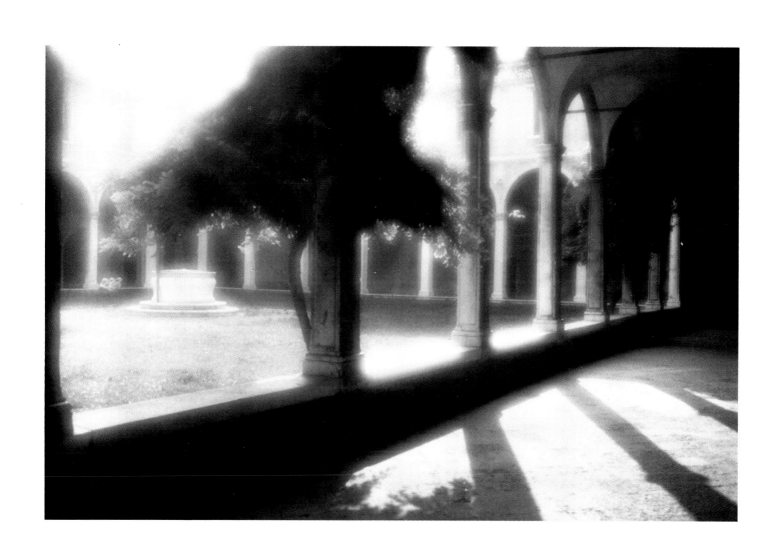

The Carmini cloister, Venice, 1986

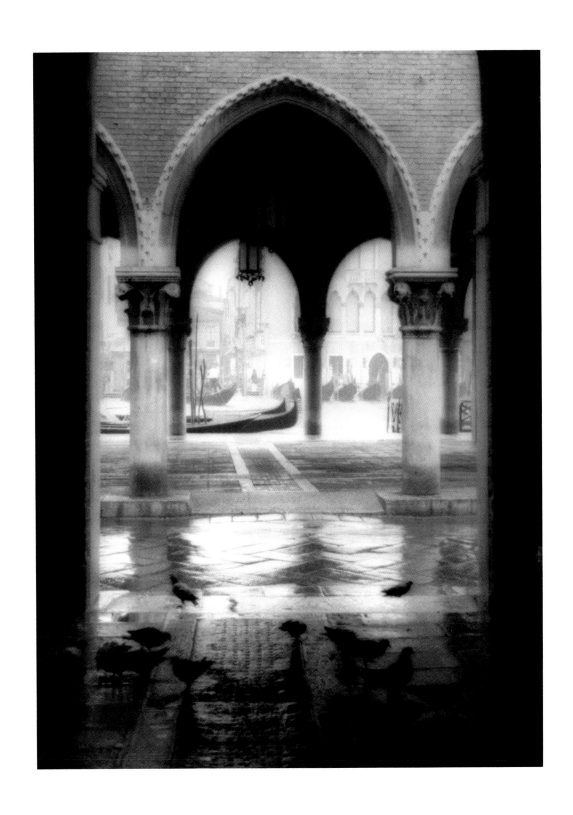

View on the Grand Canal from the fish market, Venice, 1986.

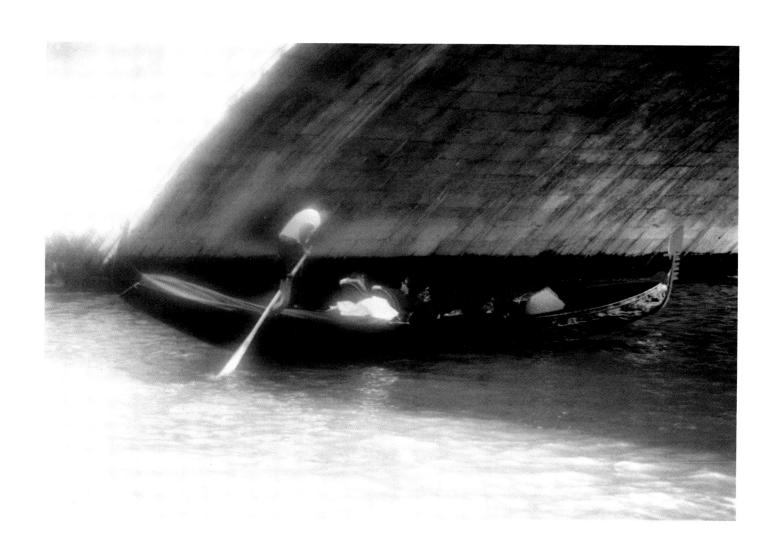

Gondola under the Rialto Bridge, Venice, 1986

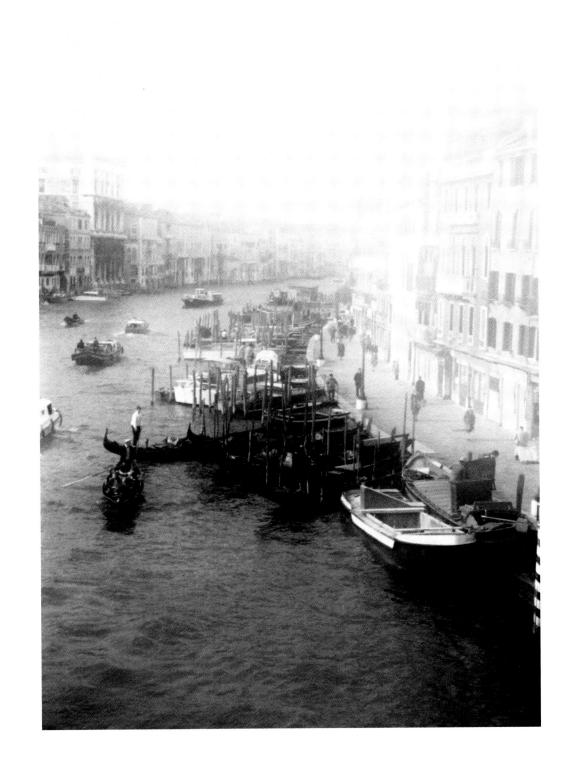

Riva del Carbon, Venice, 1986

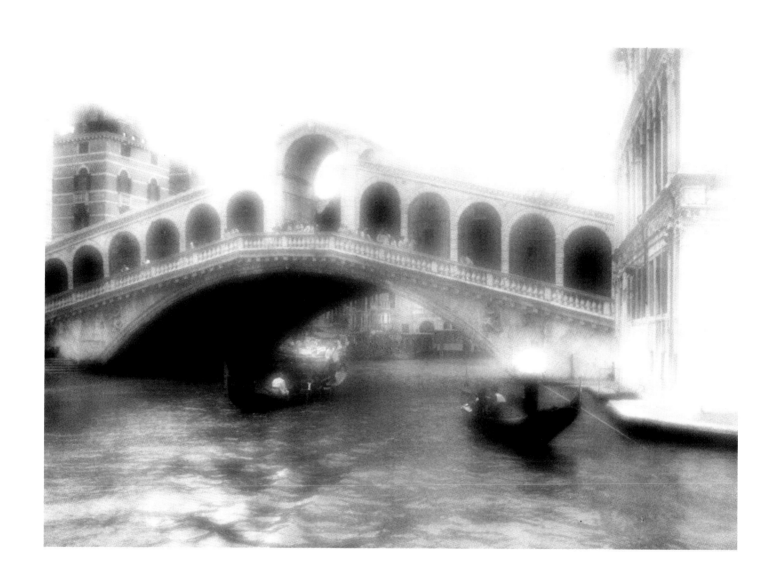

The Rialto Bridge, Venice, 1986

Bricoles, Venice, 1986

The light on the lagoon, Venice, 1986

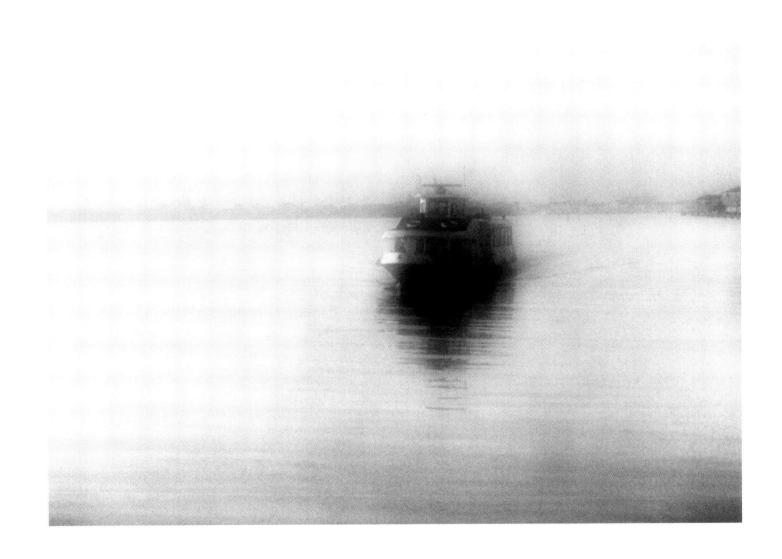

A vaporetto leaving Venice, 1986

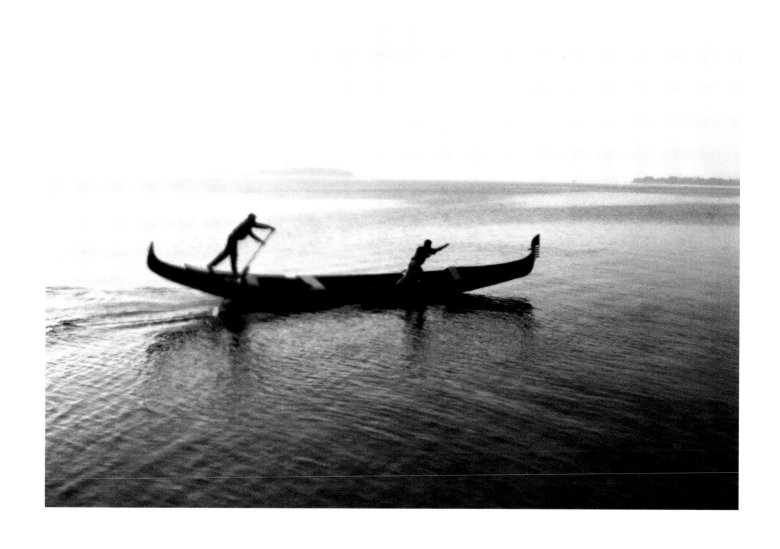

Training for the Regatta, Venice, 1987

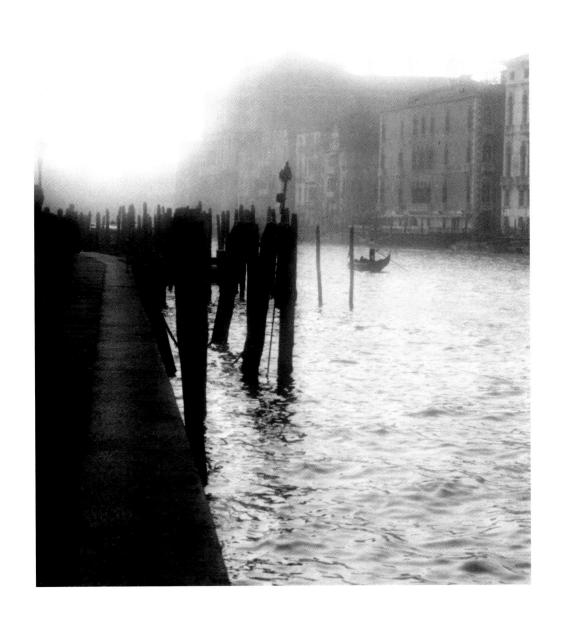

The Grand Canal seen from the customs house, 1988

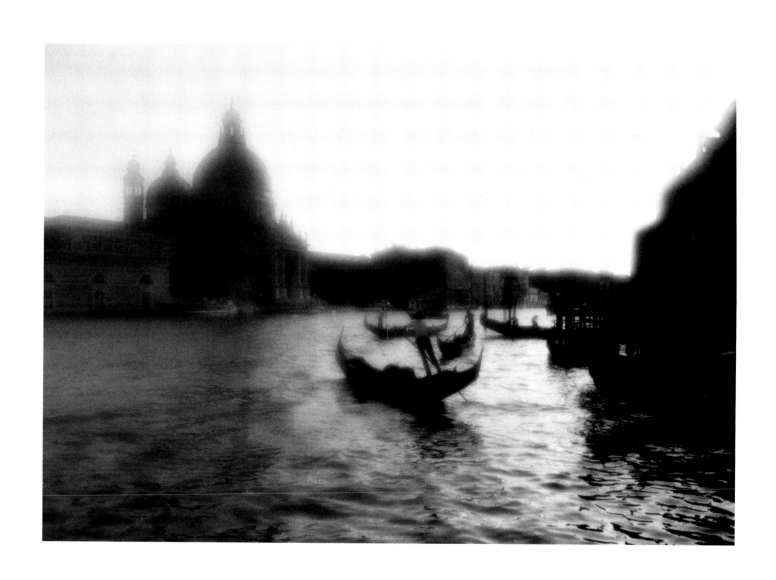

The Grand Canal seen from the hotel Monaco, 1986

a short while, or areas in shadow, beneath a tree or inside a building. Gene Laurence's photos taught me the use of softly diffused light and the way in which it should fall upon the subject. All of my photographs have been taken without artificial light, reflectors or filters. I have used the same film for twenty five years, the Ektachrome 200 ASA, which can be found absolutely anywhere, and have been faithful to the same lab since the very beginning: Pictorial Service, on the Rue Delambre in Montparnasse.

In my search for soft atmospheres and pastel tones, I have found that blondes are best for such settings. What is characteristic in a true blonde, or in a redhead, is the translucency of the skin, the colour of the hair, and the distribution of body hair. I would have found it difficult to photograph naked brunettes, whose hair and pubis would have been in stark contrast to softer shades. The great classical painters never depicted the pubis in their nudes. It was blotted out or discreetly covered by leaves or wisps of gauze, thus maintain-

ing a sense of mystery. The paradox of the erotic is that it reveals and hides simultaneously.

The German magazine *Twen*, managed by Willy Fleckhaus, published my first photographs. The ones that I had taken previously for Printemps were fashion pictures and such shots were rarely signed by the photographer. The photos in *Twen*, and *Réalité* in France, were published under my name, and more of my work appeared in *Photo*. Free of all professional obligations I could now work assiduously and soon found myself with enough material to put together my first album, *Rêve de Jeunes Filles*, which was accompanied by text written by Alain Robbe-Grillet. The composition of this first album was inspired by Leonard Cohen's song, *Suzanne*, the words of which had been translated and used as captions. Collins of London decided to publish this album at the same time as Robert Laffont in France and William Morrow in New York. Its success was immediate and others followed: *Les Demoiselles d'Hamilton, La Danse, Collection Privée, Souvenirs*. The

(Cont. page 268)

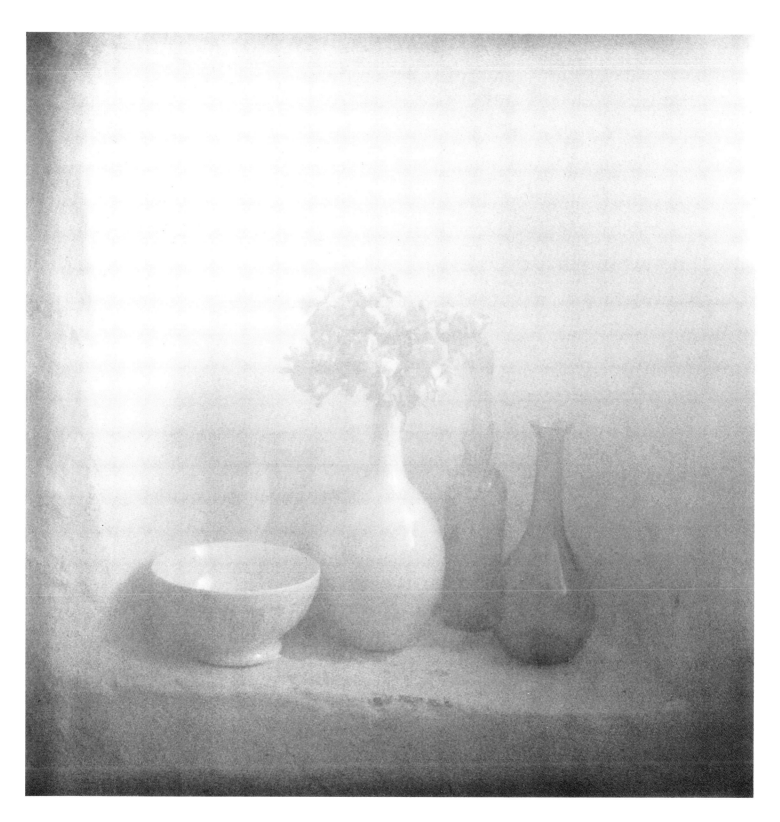

Homage to Giorgio Morandi, Ramatuelle, 1983

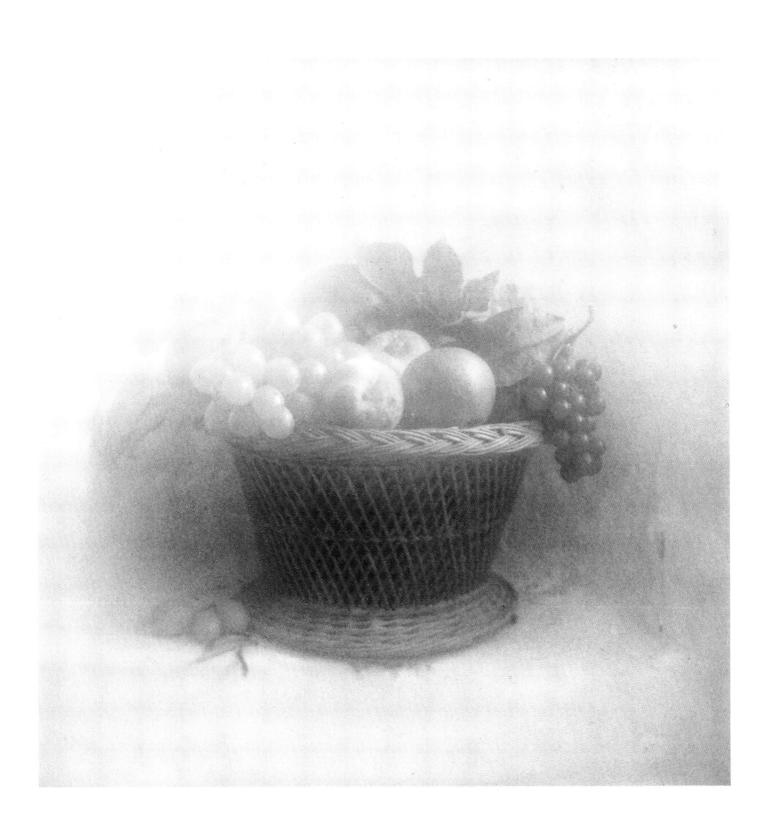

Homage to Caravaggio, Ramatuelle, 1990

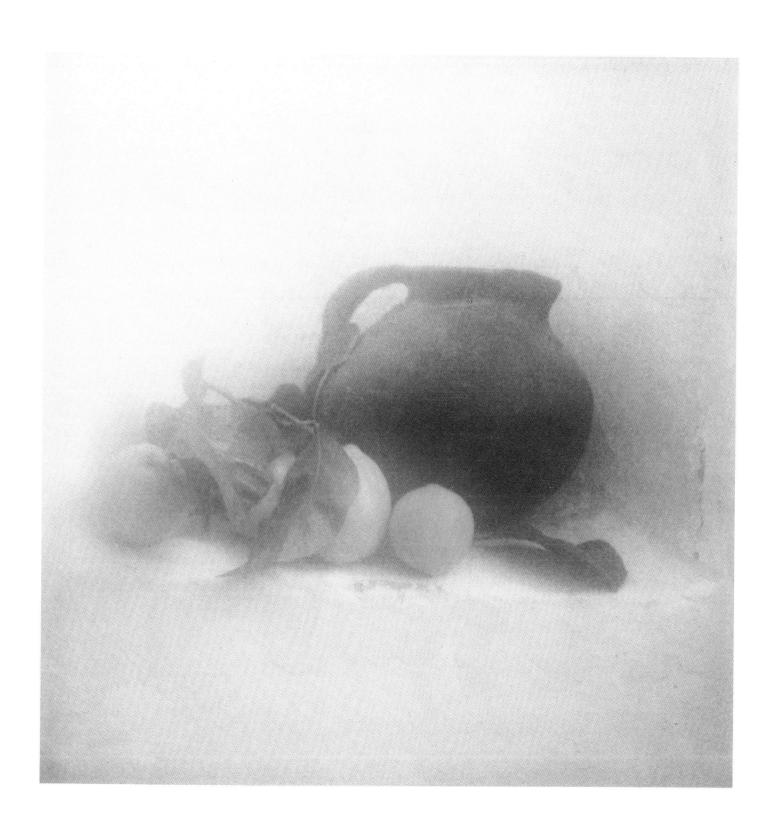

Still life with lemons, Ramatuelle, 1990

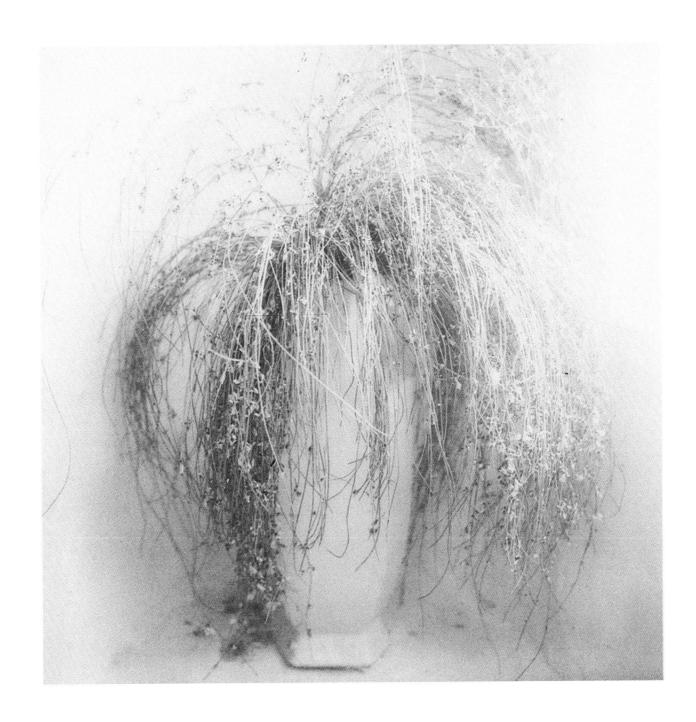

White on white, Ramatuelle, 1979

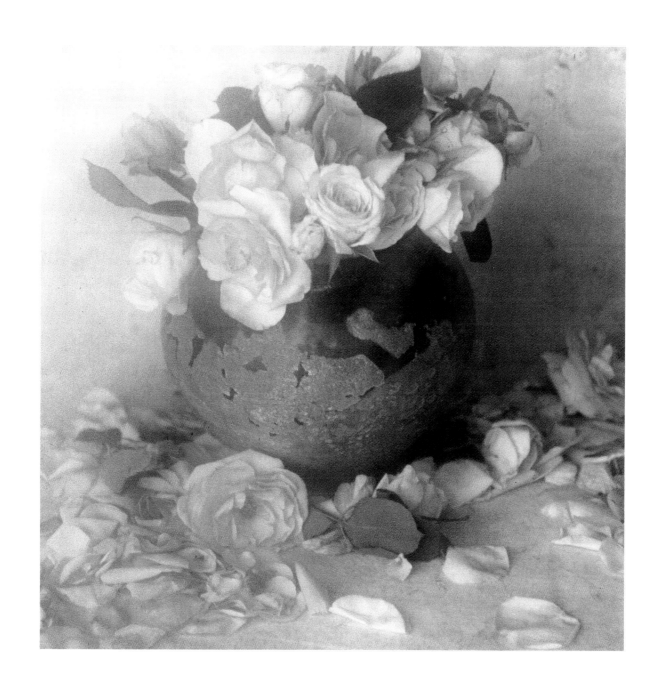

The end of summer, Ramatuelle, 1991

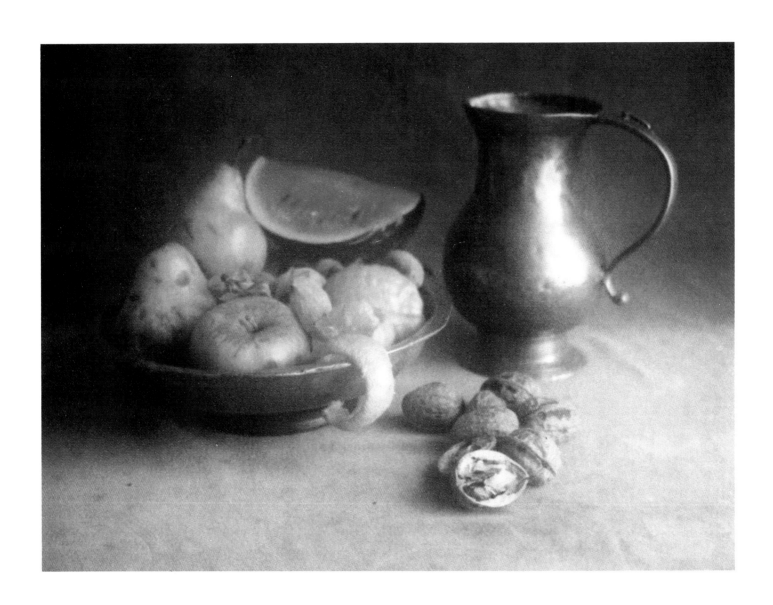

Homage to Chardin, Ramatuelle, 1990

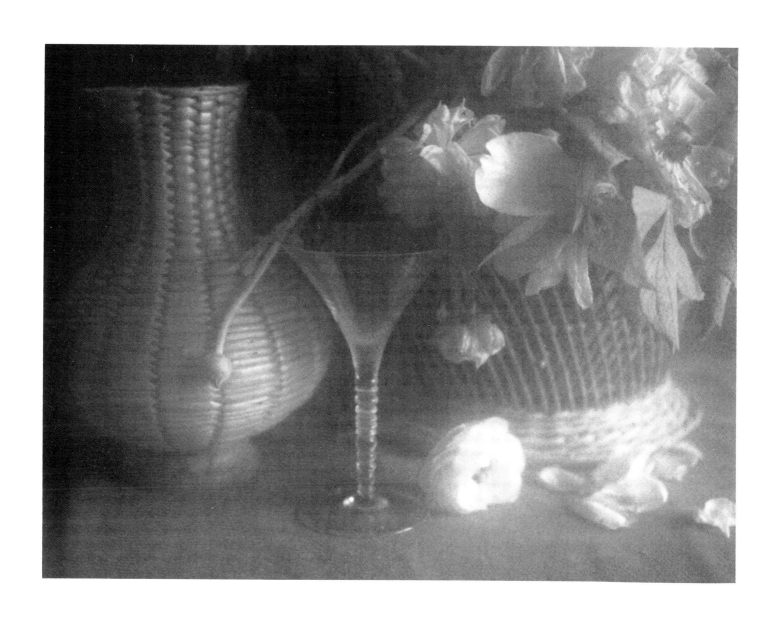

The last peonies, Ramatuelle, 1989

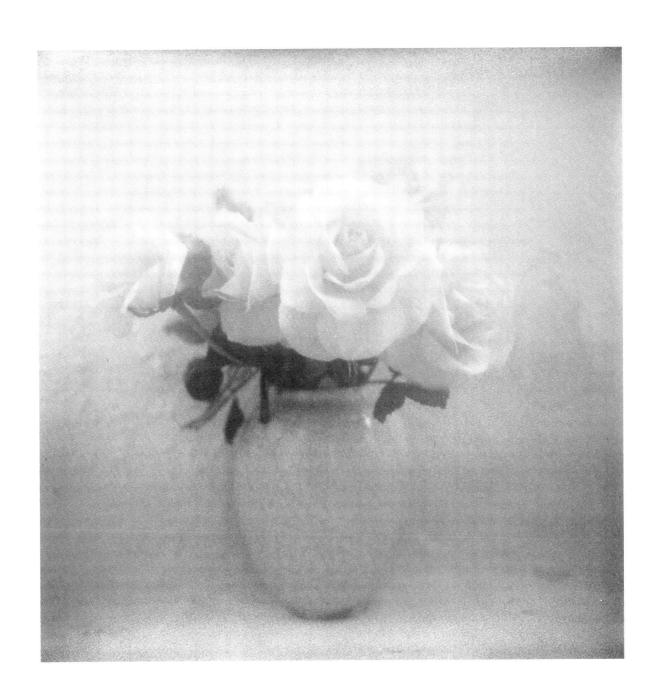

Roses, Ramatuelle, 1979

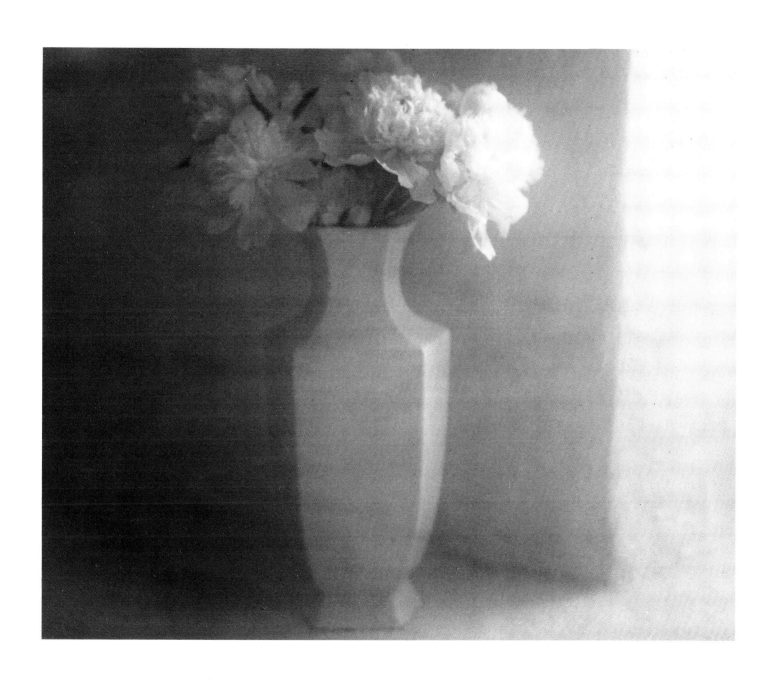

White, pink and beige, Ramatuelle, 1980

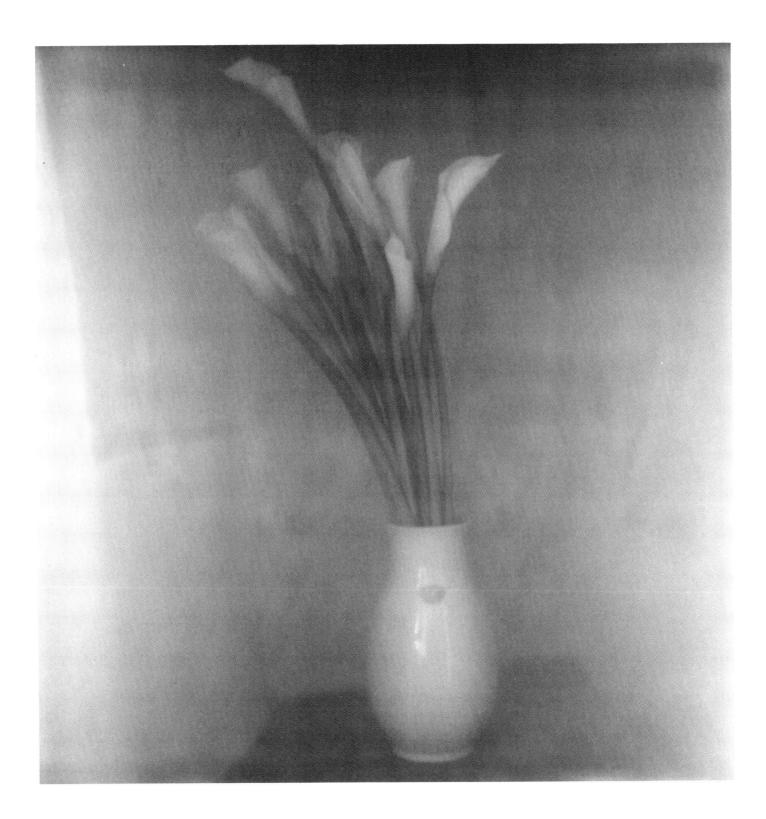

Arum lilies, Ramatuelle, 1989

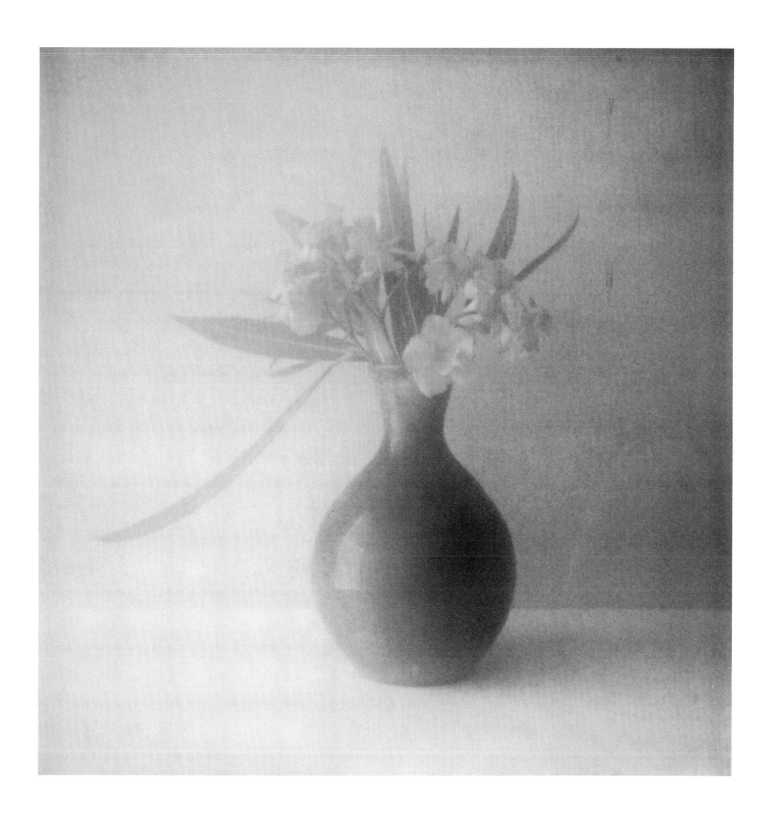

Oleander, South of France, 1991

first editions sold very quickly, then there came copies which were mass-produced and the quality of the prints was not as good as it should have been. About one hundred thousand copies were sold of each of the first albums; a million books, a million fantasies ! This is quite a clear indication of the craving for personal freedom which existed at the time, and which seems to be disappearing today.

Not all the reviews were favourable. Some criticised the erotic aspect and lack of realism. Journalists exclaimed, "It isn't true ! We do not live in a world like this, on a mountain !" But I could prove otherwise. I still live this way, on my own mountain, in Ramatuelle, with the girls, and if my photographs met with such success, it was because they were natural and uncontrived. I am convinced that the public found in these pictures something unaffected and spontaneous, that cannot be found in a studio portrait. My success provoked envy and jealousy because I was realising my dreams and making money at the same time, but the public was so enthusiastic that they ignored the critics.

My photographs started to be sold in Japan, where exhibitions of my work had been organised. I was asked to direct the film *Emmanuelle*, but this wasn't the kind of thing I wanted to do and so I declined. There were many requests for publicity photos but I have always found it difficult to work to order and have never been pleased with the results, with the exception of the work that I did for Nina Ricci perfumes.

Robert Ricci had considerable artistic flair and he left me free to work in my own way. he would choose, from among my pictures, the ones he wanted to use for his advertising campaign, and together we created the sophisticated image of the perfume *L'Air du Temps*.

Although the particular way I use light and colour is of great importance, my work owes its success, and undoubtedly much of its criticism, to my partiality for a theme: the young girl. I would like to explain why I find a particular type of girl so immensely attractive and why she has become the main feature of my work.

There exist among young girls, within a clearly defined age group, some rare beings who are able to exert a powerful erotic attraction upon certain much older men. It is a kind of magic, a fleeting charm which touches such men, of whom I am one, in a secret part of their sensibility. By means of my photographs I make a sincere confession that few men, bewitched as I am by the forbidden desire, will dare to make.

Not all young girls of this particular age have such a rare quality, far from it. But all those who are sensitive to this attraction will recognise them amongst thousands. They are not always pretty, according to the uncertain criterion of beauty. Vulgarity, impertinence or pride never touch them. Basically, there seems to be nothing about them which allows one to distinguish them from their peers. No common trait of character differentiates them, but in observing them closely, one has the impression from their attitude and their gaze, that they sense the particular attraction

(Cont. page 281)

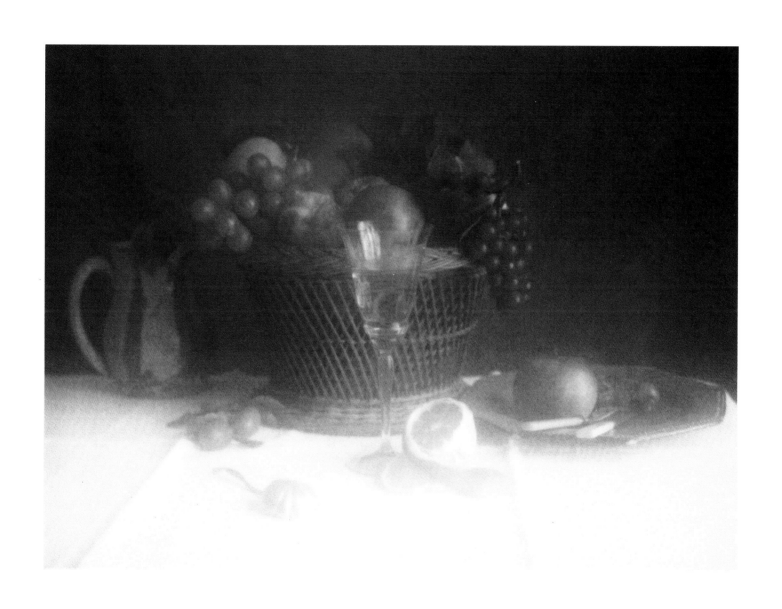

Still life, the Dutch school, Ramatuelle, 1990

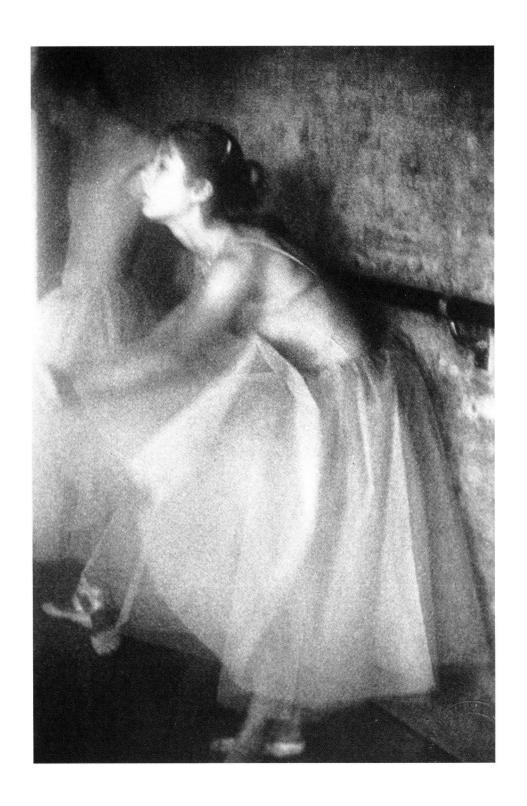

Homage to Degas, Saint-Tropez, 1979

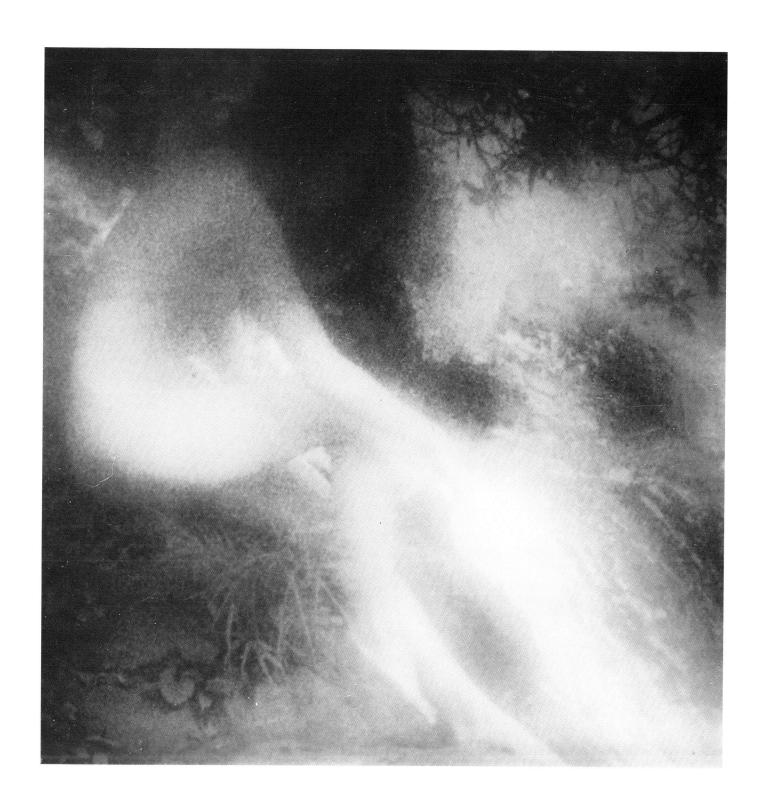

Homage to Levy-Dhurmer, Tokyo, 1976

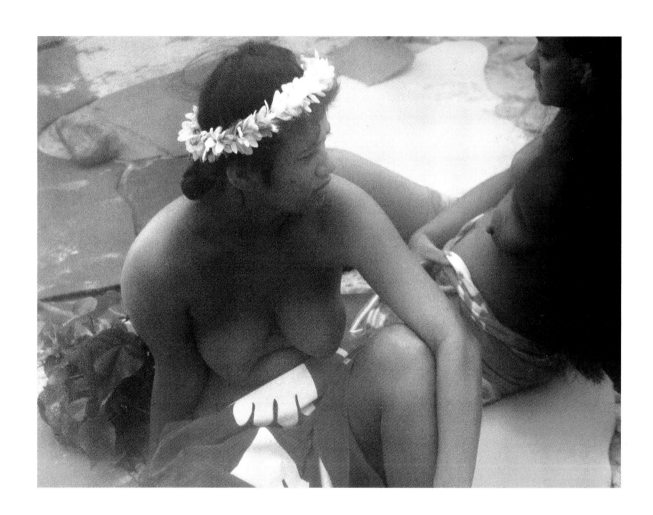

Homage to Gauguin, Tahiti, 1987

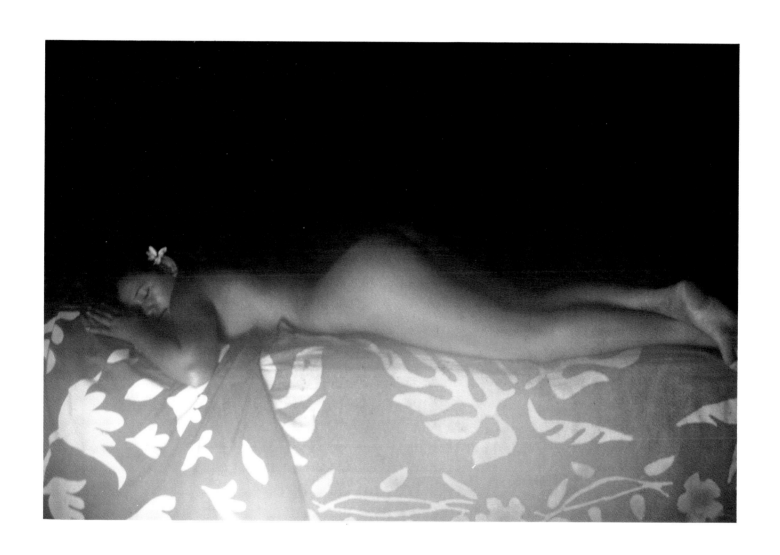

Nevermore, Tahiti, 1987

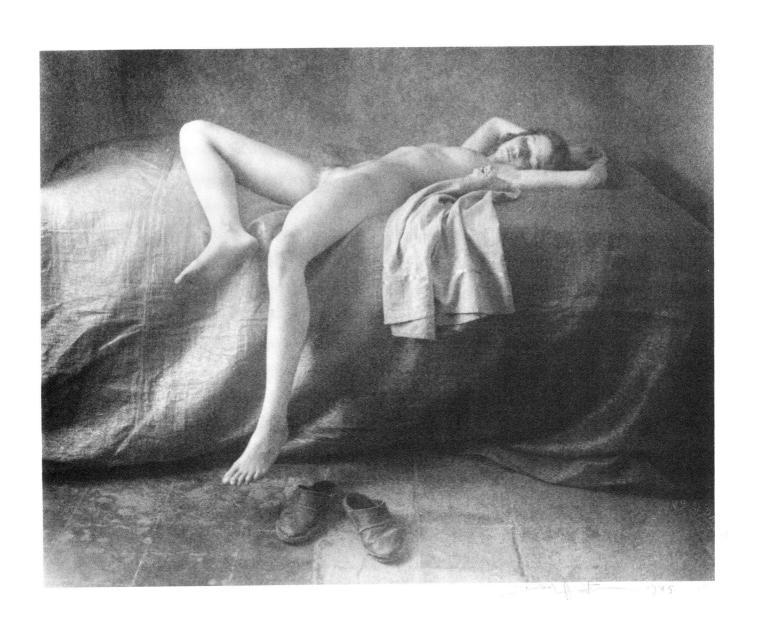

Homage to Balthus, South of France, 1980

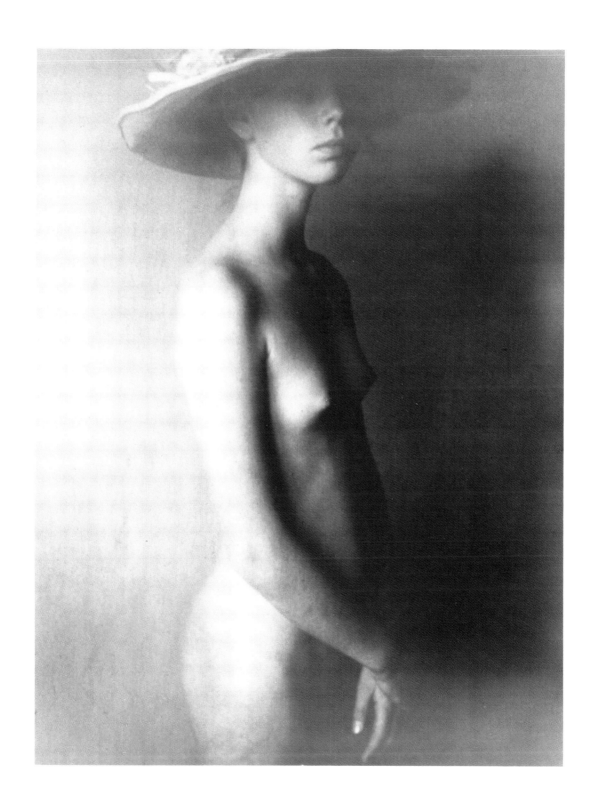

The pastel, Ramatuelle, 1980

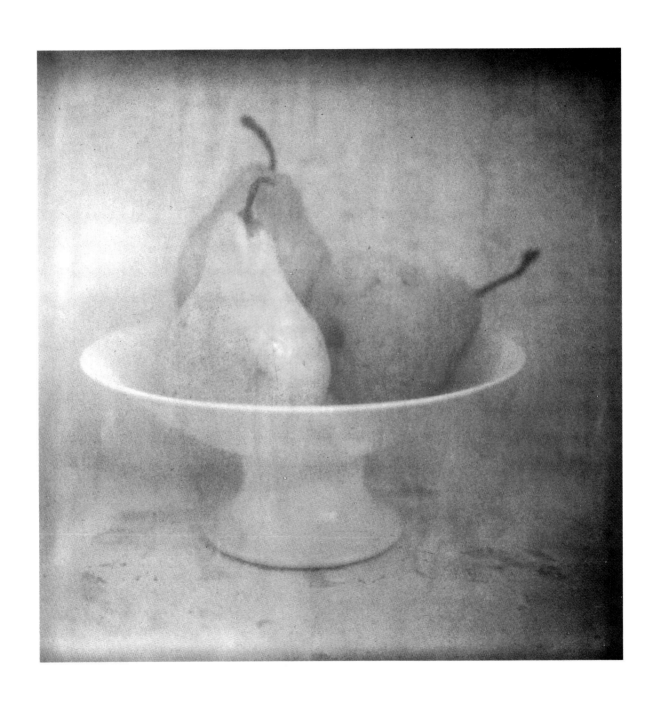

Still life with pears, Ramatuelle, 1982

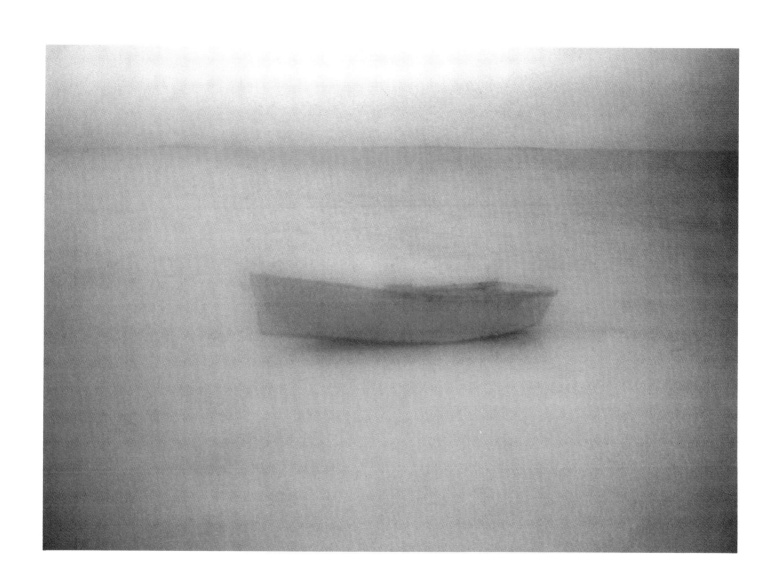

The boat, homage to Lazzaro, Bahamas, 1980

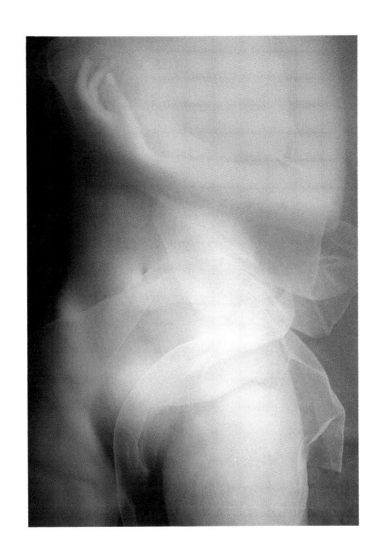

Veiled obsession, Ramatuelle, 1989

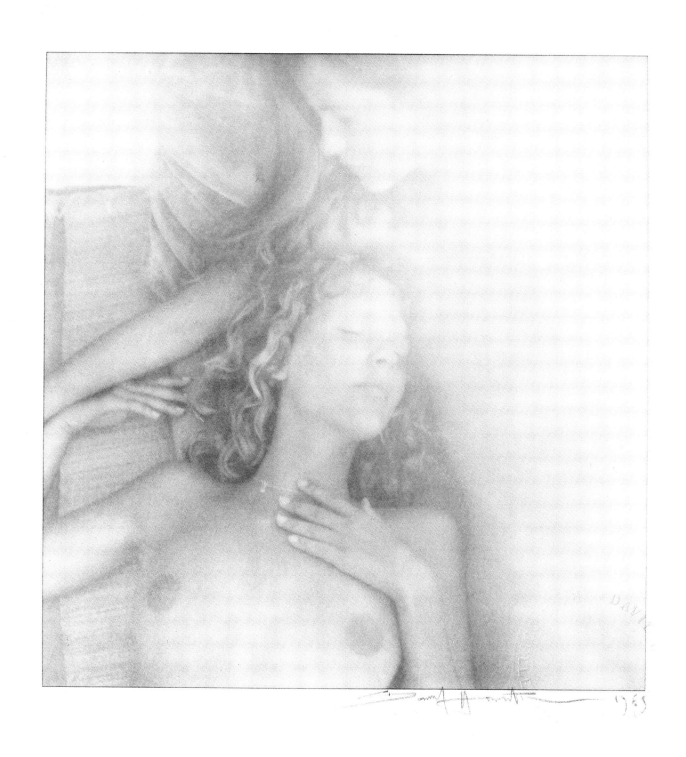

The pencil sketch, South of France, 1981

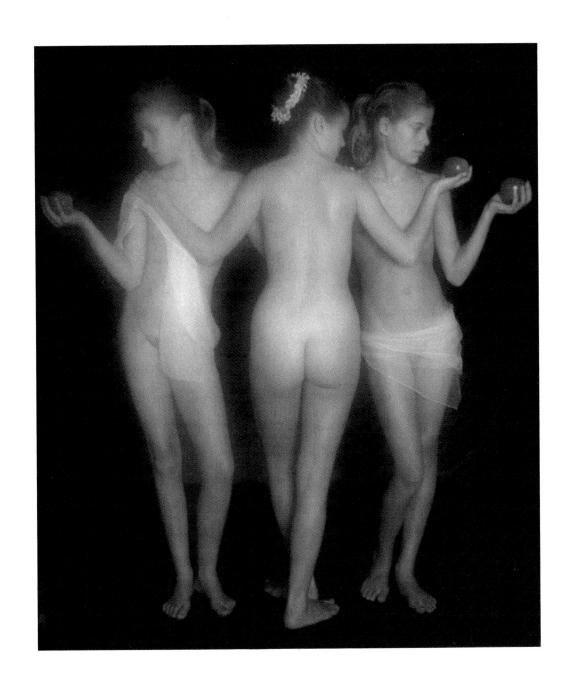

The three graces, homage to Raphaël, Ramatuelle, 1988

they exert around them, thus rendering them different; they are aware of it, and sometimes play on it. It seems to me that their femininity is revealed sooner than that of their contemporaries. A femininity too mature for their age, an animal instinct that they already know to be right for them, even if they decide to hold out against it for as long as possible. This intuition, which they do not understand, tends to make them discreet, shy, and thus mysterious.

These young nymphs who fascinate me, often shun the avid gaze of the public which reflects an awareness of the beauty that they themselves are trying to ignore. However, being able to recognise them, to approach them and to understand them with patience and trust, I have felt their need to express the difficulties they face from having suddenly found a sensuality that took them by surprise. Some of them would give anything to be different; to be 'normal', as they sometimes dare to say. It is true, the rare delicacy of their physical appearance sets them apart, and everyone knows how much it costs to be different in this world. This transparency of the skin and eyes, extreme fineness of hair, excessive fairness which blurs the eyebrows, projecting cheekbones, high forehead and the movement of full lips, and the snub nose, like a tender pink muzzle, earns them, at school, the curious, envious and sometimes jealous thoughts and glances of their classmates. And if, by chance, in the changing rooms, their classmates observe that the sensual moulding of the face is also revealed in more intimate parts of the anatomy, then they have to live with teasing or envy, like symbols of segregation. Thus, often solitary and silent, these young girls take refuge in dreams which they have wished me to bring into reality. The thousands of photos that I have taken over twenty five years have already made them familiar to you.

I later discovered that other artists, and writers had this same passion. Laclos described the type exactly in *Les Liaisons Dangereuses*, written in 1782: "… the heroine of this new romance deserves your fullest attention. She is really pretty: only fifteen years of age, a rose-bud. Gauche, of course, to a degree, and quite without style, but you men are not discouraged by that. What is more, a certain langour in her looks that really promises well."

The great painter Balthus, did not try to hide it in his work. His models possess those physical characteristics, which I have spoken about, and leave no doubt as to their youth. Balthus' paintings are perfect illustrations of how a face, or a body lacking in grace, according to the popular standards for beauty, can hold a powerful erotic attraction. The poses they adopt for him, the situations in which they are depicted, evidence with great clarity the erotic intentions of the artist.

But painting has an advantage over photography in that it allows for interpretation; it is difficult to distinguish the intentions of the artist from the represen-

tation of reality. The photograph offers reality, which I endeavour to soften, with a beautiful setting.

Words too, are powerful tools and a writer with an exceptional talent is needed to expound on such a subject without the risk of alienation. Such is Vladimir Nabokov, author of the uniquely sublime novel which established the name of Lolita as the pseudonym for young girls in possession of that certain fatal charm. In fact, Nabokov wanted this desire for a very young girl to be fatal to his protagonist in much the same manner as he wanted the novel to carry his own condemnation, a moral judgement he had no doubt would

Playing male model with Suzanna York, Paris, 1957

Advertising prototype chair, Paris, 1960 (photo : T. Round)

befall his work. Nabokov has always defended his carnal appetite for those which he calls 'nymphettes' with the fancy that they are of mythical origin; however, the precision of his language, the inspiration which guides his phrases, cause me to doubt this. But how many other men share this same desire for forbidden fruit without ever acknowledging it publicly ?

The first time I clearly perceived in myself the attraction to this particular *beau idéal*, was on the beach at Bournemouth in England in 1966. I had known and photographed many beautiful girls but had never, until

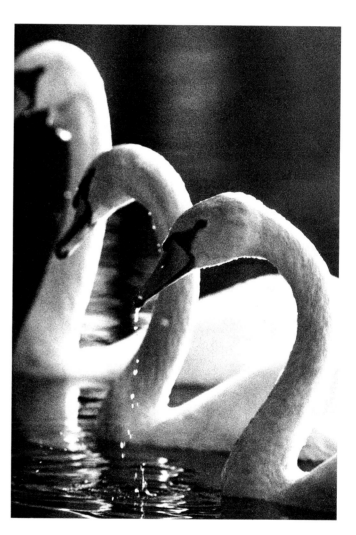

First pictures around Paris

then, experienced what can only be described as a revelation. The girl was playing on the beach with her younger sister, and immediately I noted the long line of her legs, the delicate structure of her body, and most especially, her feline face, the cat-like eyes with the heavy upper lids. Looking at her, I could see the great beauty she would one day become. Her name was Mandy and I asked her where her parents were. I intro-

First exhibition in Paris, Fnac, with Henri Lartigue, 1971

duced myself to her mother and wondered if she would agree to my taking some pictures of her daughter when she was a little older. Surprised and flattered, the mother seemed to like the idea and I promised that I would give her a call in about two years. I couldn't understand why I had made this appointment so far in advance, but it seemed important to me and two years later I did contact her. The picture of Mandy was published in *Rêve de Jeunes Filles*. This first chance encounter was followed by others which were to change my life to a degree that I could never have imagined. In 1969 I went to the Canary Islands to shoot some photographs for Yves St. Laurent, which were published in *Twen*, and it was here I saw Mona for the first time. She was Danish, nineteen years old, and the most beautiful girl I had ever seen. I took some pictures of her for the spread that I had come to do. Mona came to Paris at Christmas 1969 and our long relationship began. Later, I discovered another young girl, Heidi, in a telephone booth in Zurich. She and Mona were like twins and appeared in *Les Demoiselles d'Hamilton*, entitled *Sisters* in the English version.

Male model again, Paris, 1957

"Bilitis"
reception in
La Coupole with
Gunther Sachs,
Mona, Ernst Fuchs, Paris, 1976

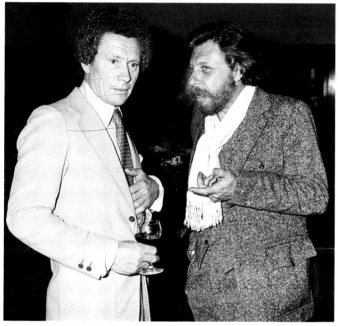

Conversation with Charles Matton, Paris, 1976
(photo : Christian Petit)

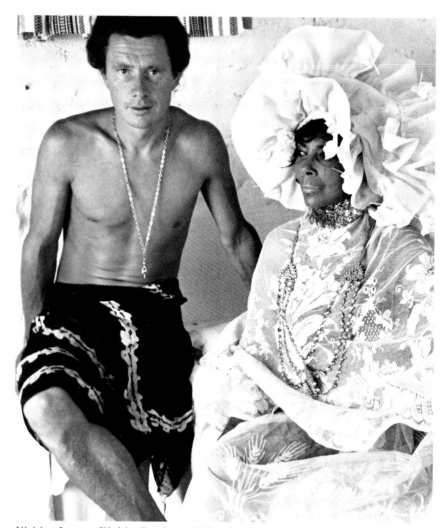

Visiting Leonor Fini in Corsica, 1972

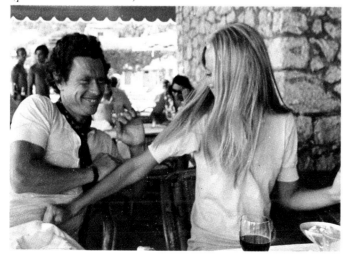

With early model in Capri, 1969

Lunch with Oliver Messel, in Barbados, 1974

Mona and I travelled around the world and discovered other models. Everywhere we went she fascinated people with her beauty and was inundated with invitations. She was at ease with the jet set but I soon began to tire of this worldly existence which had never been of particular interest to me. Eventually, we went our separate ways but she remains a central figure in my work. I have taken more pictures of her than of

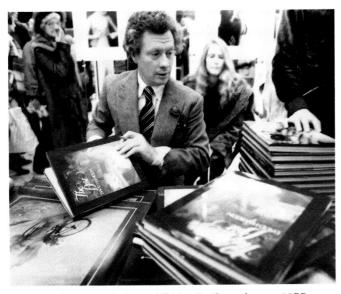

Autograph session during exhibition in Copenhagen, 1977

any other girl including those for Nina Ricci. She also starred in my first film, *Bilitis*.

For many years, film producers had been suggesting that I direct a film in which I could bring my young girls to life. I had repeatedly refused. I knew that cinema was a difficult medium because it brought together various talents, techniques, and personalities. My pictures have always been created spontaneously, and

privately. A beautiful play of light which lasts but a few minutes can be captured by my camera but when you find yourself with a team, with complex machinery, and the need to shoot a scene ten times in order to have one good take, you can be certain that a cloud will have moved or that the sun will have set.

However, Henri Colpi, a director and film producer, and Bernard Daillencourt, a director of photography, had the talent and the experience to make *Bilitis* a charming film in which the audience could find and enjoy the atmosphere of my photographs. The subject and the title come from Pierre Loüys' *Les Chansons de Bilitis*, prose poems, published in 1894. We filmed

Portrait taken by Stan Rumbough

Lunch with Mona at the Plaza Hotel, 1976

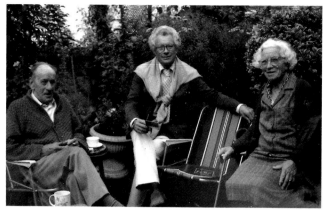

Tea in the garden with my mother and stepfather, London, 1988 (photo : G. Versyp)

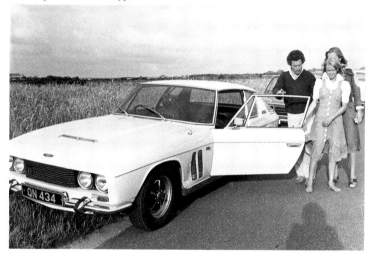

Early days in Sylt with my Jensen FF. (photo : J. Gebhardt)

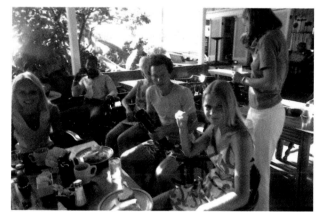

First trip to Hawaii, 1969

Portrait, 1978

in surroundings which were familiar to me: the hills of Ramatuelle, the beaches, the castle of St. Amé above the commune of St. Tropez. This castle, a millionaire's fantasy at the turn of the century, had never been completed, and we were using it as a studio. The arrival of the set-designer, Eric Simon, was essential to *Bilitis*' success. Extremely talented, he has created sets for many films. He and I immediately found we had much in common in our taste for furniture, colours and shapes. The film came out in 1976 and was very successful.

In 1979, after endless battles over the scenario, we finally decided to proceed with the filming of *Laura*,

Exhibition in Rome with Mona, 1977 (photo : J. Bauer)

Leaving the village of Ramatuelle, 1972 (photo : A. Chatelain)

Reception at the Byblos, Saint-Tropez, 1974 (photo: J. Aponte)

(Cont. page 292)

Shooting "Bilitis", Saint-Tropez, 1976 (photo : R. Gordon)

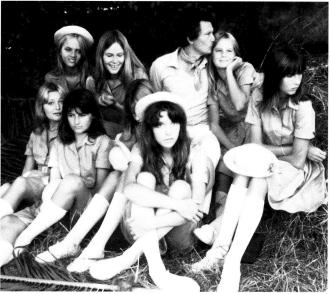

The "Bilitis" family picture, 1976 (photo : R. Gordon)

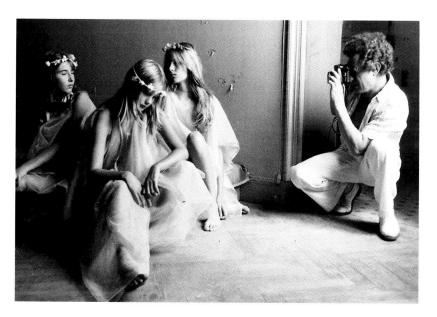

With Bilitis: Patti d'Arbenville (photo : R. Gordon)

The house in Ramatuelle

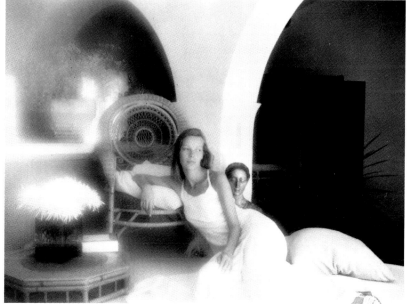

My favorite corners in the house

les ombres de l'été. Much of it was beautifully filmed, but it was not a hit at the box office. This was followed in 1980 by *Tendres Cousines*, which I was not happy with visually but which, surprisingly, was well-received. Most film-makers will agree, that success or failure is totally unpredictable. *Premier Désir*, made in 1983, was a resounding flop, but these experiences with the cinema were not all negative. They made me take stock of my work and my goals. One always returns to one's first love, and mine was painting. As I did not have the necessary technical ability nor the patience to devote myself to it, I began, more than ever before, to make my photography emulate art. My ballet dancers were by Degas, my still-lifes by Cézanne. I know this is a practice that has been debated for decades.

Upon its discovery, in the early part of the nineteenth century, photography was subjected to criticism from those who thought that it could be nothing but a craft and that it would never be recognised as a

Visiting my exhibition in Tokyo with the British ambassador and his wife, 1985

Joint exhibition with Ernst Fuchs in Austria, 1978

true art form. Baudelaire said "As a Narcissus, our pitiful society rushes to stare at its trivial image captured on a piece of metal", yet he himself was one of the first to have his likeness captured by the new process. When the French artist Paul Delaroche saw a daguerrotype image he exclaimed, "From today, painting is dead!" The inventors of photography were men of varied talents. Nicéphore Niepce, who took the very first photograph in 1827, *A view from the Window at Grasse*, was fascinated by lithography and searched for a method of capturing permanently, the fleeting images of reality produced by the *camera obscura*. He was, incidentally, one of the first men to build a bicycle. Daguerre was a theatre-set painter and William Henri Fox Talbot invented the negative/positive process and produced the first book to be illustrated with original photographs.

VENISE · DAVID HAMILTON

FENICE ARTS GALLERY
VENEZIA · CAMPO LA FENICE 1895
DAL 20 FEBBRAIO AL 1 MARZO 90
ORARIO 10.30 / 12.30 – 15.30 / 19.30

AMERICAN EXPRESS

Poster promoting the Venice exhibition, 1990

Me in Venice, Carnaval, 1988

*Visiting Count Targhetta's palazzo, 1990
(photo : P. Portalier)*

Leaving Venice by Orient Express, 1990 (photo : P. Portalier)

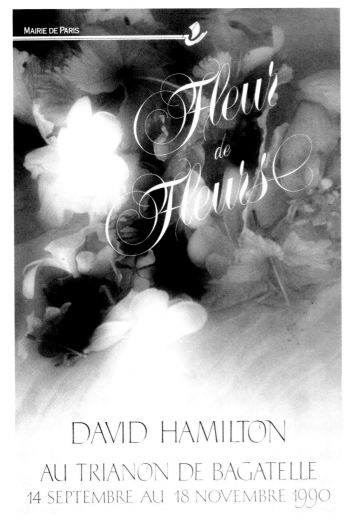

Poster promoting the Flower exhibition, 1990

Courbet, Ingres, Delacroix and Millet were all interested in photography and it is thought that Courbet and Ingres even painted from photographs. Many artists, such as Gustave Le Gray, abandoned painting altogether, in order to pursue what they saw as a new exciting art form.

Le Gray, Robert Demachy, Heinrich Kühne, these are photographers who have had an impact on me.

They shared one thing in common: all three created images which elicit an emotion very similar to the one experienced when looking at a painting. It is this ultimate goal with which I am preoccupied. My landscapes are inspired by those of Le Gray: desolate and barren, and one need only see a Demachy nude to understand, in an instant, the influence that he has had on my work. He was a friend of many of the Impressionists and in order to produce similar effects in his photographs, he used a special process to soften their tones and shadows. He maintained that there could be no art without the direct intervention of the artist on the image.

Jacques-Henri Lartigue and Leslie Hamilton Wilson perfected the difficult art of the snap-shot, pictures taken on impulse. Although becoming great masters, they were able to maintain the freshness of amateurs. But what amateurs! They were lucky enough to live at a time when cars, clothing and architecture had elegance and style. I endeavour to find, in today's world, vestiges of that lost era, but they are rare. Venice is probably the most beautiful example and we all know the dangers she faces. In some ways, I feel that I too belong to a bygone age.

Among my contemporaries I admire Robert Mapplethorpe, even though his style is radically different from mine. The images he creates are unexpected. I am surprised that there are so few young photographers of today who have followed in the footsteps of the pictorialists. I would have been amongst the

Exhibition at the Bagatelle with Paul-Loup Sulitzer, 1990 (photo : G. Manens)

Exhibition in Auckland, New Zealand, with Rachel Hunter (Ms Rod Stewart), 1986

Exhibition at the Bagatelle with Gilles Fuchs and Ms Jacqueline Nebout, 1990 (photo : G. Manens)

Exhibition in Punta del Este, Uruguay, 1991

first to encourage them and buy their work but perhaps they need to learn something of the history of photography and the great principles which had to be defended immediately following its invention.

I try to work with a fully open lens aperture in order to obtain a characteristic flatness, without perspective, similar to the frescoes at the beginning of

With Alexia in Guam, 1987

the Renaissance. I believe that it is a mistake to think that photography can offer an accurate representation of reality. There is always interpretation, even in photographs taken for the purpose of reporting. The technical aspects of photography are something in which I have little interest, a fact which sometimes disappoints many students. At a lecture in a Texan university some years ago, I presented a series of

my slides to an audience of five or six hundred. Afterwards, the lights came on, and dozens of students raised their hands, eager to ask questions. Before opening the discussion, I took my camera, and holding it out, said "Here, one camera, 35 mm, single lens, one type of film, and all with natural light." All hands dropped. Not a single question. Not one person wanted to ask me about the composition of the pictures, the choice of models, the settings, no. The only matters which were of interest to them were technical ones; my methods were too simple. I found this attitude very sad.

In many respects I have remained an amateur. I feel that because photography today is associated with so

Photo session in Tahiti, 1987 (photo : C. Durocher)

296

Portrait (photo Breinbauer)

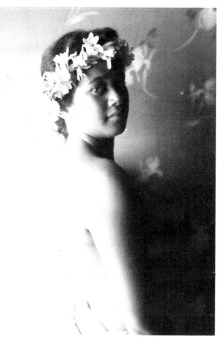

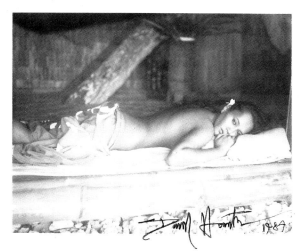

Homage to Gauguin, Tahiti, 1987

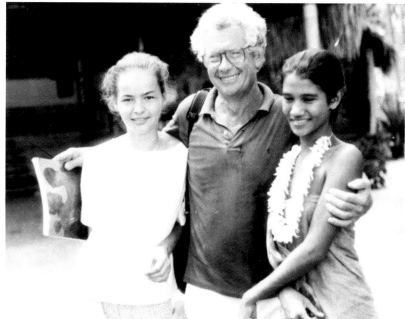

With Alexia and Tahitian model, 1987 (photo C. Durocher)

...Diamond head, Hawaii, 1982... paradise

Sailing in Punta del Este, Uruguay, 1991 (photo : G. Versyp)

With Monica at the Kahala Hilton,...

many technicalities and tricks, its spontaneity, freshness and beauty have been lost. The lessons I have learned over the years are how better to master the art of colour and of form, how to explore the medium and develop a style. Style comes from deep within; it reveals itself in one's art, and depends on tastes, fantasies and sensibilities. The use of light to enhance a subject and the perfection of composition are all-important; such artistry has to come from the spirit. Either it is there, or it is not and artists have debated this for centuries.

Thus, to find my influences, it is necessary to look amongst the painters. My perception of painting is neither that of a critic nor of an historian. It is a very personal view guided by what concerns me as a photographer. Those paintings which move me most are those which exploit the fact of the painting itself, as

(Cont. page 302)

The Breakers Hotel, Palm Beach, Florida, 1982

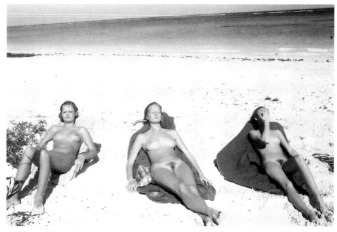

A day off, Bahamas, 1978

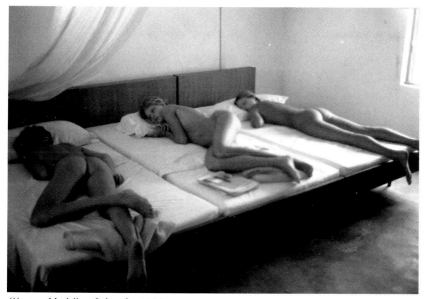

Siesta, Maldive Islands, 1977

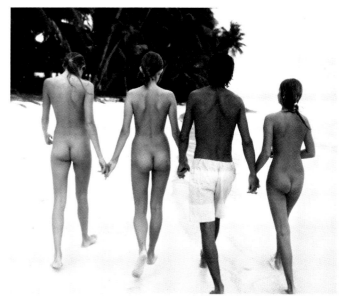

Promenade, Maldive Islands, 1977

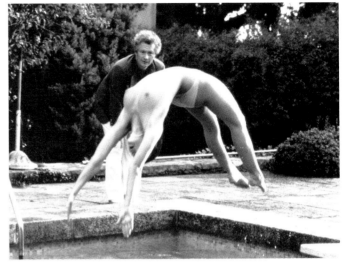

Working in Saint-Tropez, 1983 (photo : R. Lemorvan)

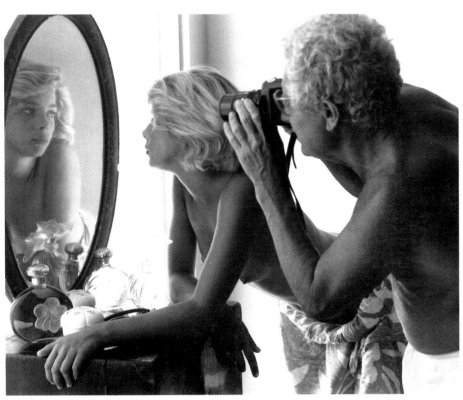

Testing for the new "Bilitis" film, 1990 (photo : G. Versyp)

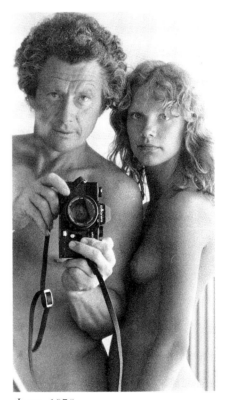

Joan, 1978

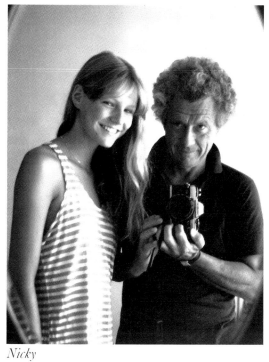

Nicky

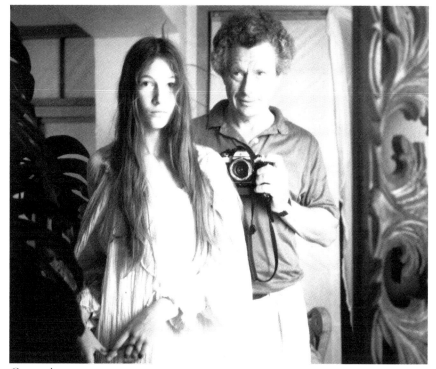

Gertrude

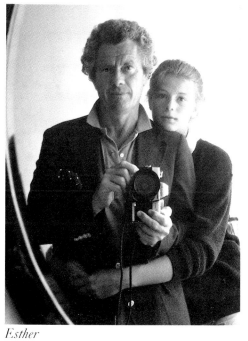

Esther

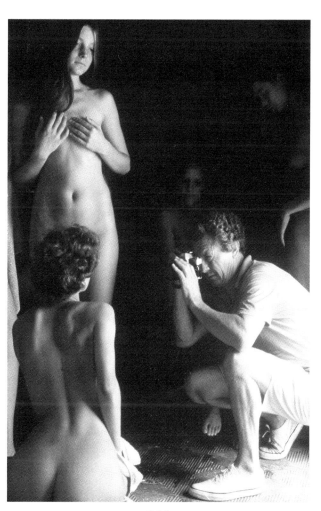

Anémone

Working on the filmset "Summer in Saint-Tropez", 1982 (photo : P. Gauthier)

With Monica filming "Premiers désirs", 1983 (photo : Sveva)

conceived in a single dimension, on a flat plane, such as Giotto's frescoes where perspective has purposefully been ignored. The simplicity and even naivety which I feel with Giotto, I also recognise in Uccello. These great masters were able to achieve the precision of line and the fresh, bold treatment of the whole, simultaneously. Although they painted religious subjects, they were able to detach themselves from this sanctity and allow a sensuality to emerge. Cranach the Elder painted some nudes in which I can discern the criteria for sensuality that I look for today: very pale, translucent skin, light eyes, high forehead, breasts set apart, long legs. The errors of proportion here and there create a feeling of innocence.

After the Renaissance, my tastes in painting make a joyful leap in time to Gauguin. I find in his use of a broken, patched texture, more forcefulness in the lines and colours, and Matisse works in a similar way. Look at the progress made by Gauguin from his Pont-Aven period to his period in Tahiti. He has found his colours and his power is spellbinding. All are beautiful; it is impossible not to like the red, or the green, their density and texture.

I admire the great draughtsmen too: Michelangelo, Leonardo da Vinci, Raphaël. Drawing is, perhaps, the

With Dawn promoting the film "Laura", 1979 (photo : R. Gordon)

(Cont. page 310)

With Dawn in New York, 1979

With Joan filming "Laura", 1979 (photo : R. Gordon)

With Anja preparing "Tender Cousins," 1980

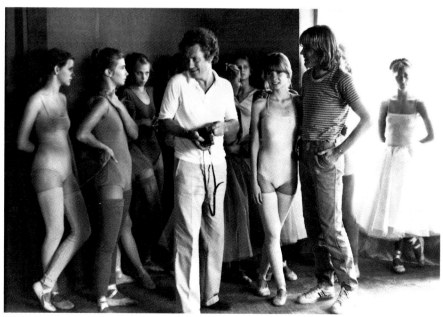

With the girls and Patrick Juvet, Saint-Tropez, 1979 (photo : R. Gordon)

50th anniversary with Monica at Maxim's, 1983 (photo : M. Boutefeu)

Lunch in Munich with Leni Riefenstahl, 1974

Exhibition promoting the Venice book with Frederico Mayer Zaragoza, Unesco, Paris, 1989

Felix and Diana during reception of the film "Laura," 1979 (photo : J. Aponte)

Sam Spiegel… a member of the club, Saint-Tropez, 1974 (photo : S. Doussot)

Tea with the governor, Mauritius, 1989 (photo : G. Manens)

With Freddy Cushing at my exhibition in the Bistro, Trump Tower, New York, 1980

In the garden of Prince Dado Ruspoli, Vignanello, 1980

Film festival of Cabourg with Esther Williams, 1987 (photo : L. Duval)

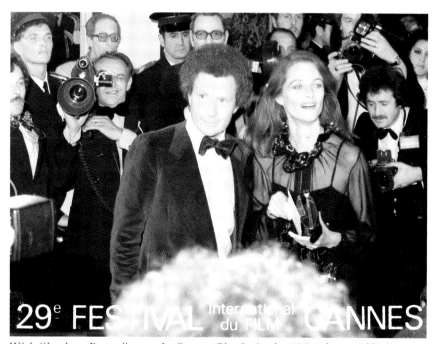

With Charlotte Rampling at the Cannes film festival, 1977 (photo : Alfieri)

With Douglas Fairbanks, Newport, 1980

Freddy Cushing on his estate in Newport, 1980

Croquet at Claus von Bulow, Newport, 1980

With friends at the Bath and Tennis Club, Palm Beach, 1980

With Monica watching the polo game, Palm Beach, 1979 (photo : L. Capehart)

Watching the Sultan of Brunei play polo, Manila, Philippines, 1981

With César at the launching of the perfume Ricci Club, 1989

Geneviève and Mona, Club 55, Saint-Tropez, 1972
(photo : A. Chatelain)

With friends at the Villa Medicis near Florence, 1983

Party at the Orloff's with Philippe Bigar, Joan, Esther and Monica, Saint-Tropez, 1982 (photo : J. Aponte)

Fooling around with Prince Charles-Antoine de Ligne, Antoing, Belgium, 1989

After having lunch at the Dôme with Mina,
Paris, 1985

With the girls in Knokke, Belgium, 1985
(photo : AG)

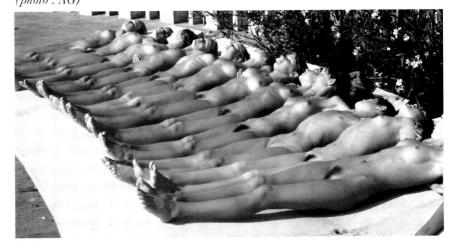

The winter stock

Esther and I posing for Philippe Bigar, 1983

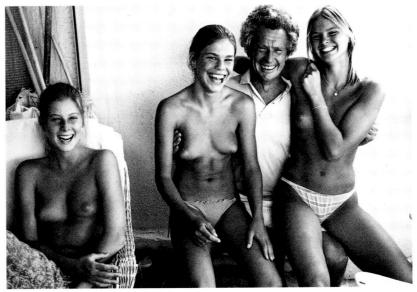

Holidays, South of France, 1983

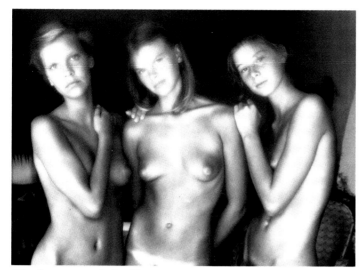

The three graces, Saint-Tropez, 1982

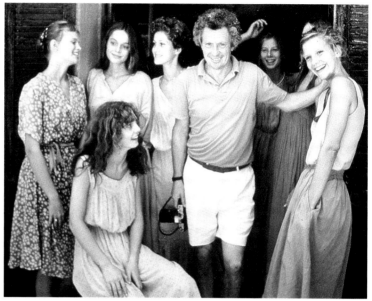

Summer souvenir, Saint-Tropez, 1982 (photo : R. Bac-Hoffner)

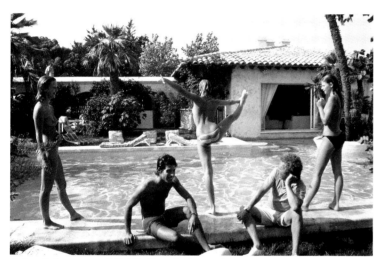

*A hard day around Eddie Barclay's pool, 1982
(photo : R. Bac-Hoffner)*

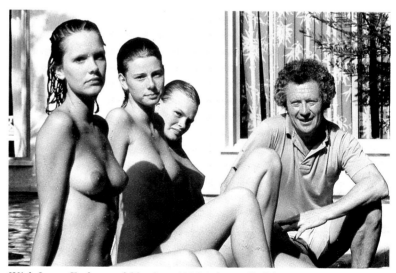

With Joan, Esther and Monica, 1982 (photo : P. Bigar)

Alexia watching herself on television, Mauritius, 1989

most abstract of art mediums, perhaps the least illusionistic. And so , with my photography, I have made a humble attempt to move closer to this purity. I have photographed, in black and white, simple bouquets, where the photographic impression is lost to the more important lines and blots. Later, attracted by this method, I tried my hand at some drawings and found

Opening at the Marlborough Gallery, New York, 1982 (photo : B. Cunningham)

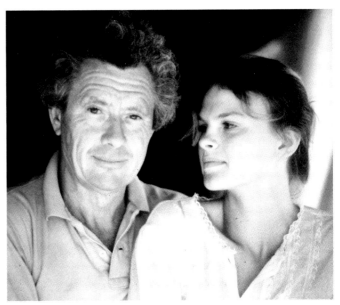

With Monica, Saint-Tropez, 1983 (photo : Sveva)

yet another means through which to depict a nude with the delicacy that it inspires within me. Where lies the boundary between desire and inspiration ? In 1915, Freud added a note to his *Three Essays on the Theory of Sexuality*, where I find a subtle answer to this question: "It would seem irrefutable to me that the concept of the 'beautiful' has its origins in the domain of sexual excitement and that it points to the origin of what is sexually stimulating." Could my obsession be the source of inspiration ? If that is the case, I can do no more than hope that the latter will do justice to the former.

Immersed in these thoughts, far removed from worldly matters, I move naturally towards an existence which is becoming ever more simple and harmonious. It seems to me that an accomplishment, no matter what it might be, is not an attempt to build, to amass,

Alexia, South of France, 1987 (photo : H. Rhensius)

Gertrude, Mauritius, 1989 (photo : G. Manens)

Monica, Saint-Tropez, 1983 (photo : Sveva)

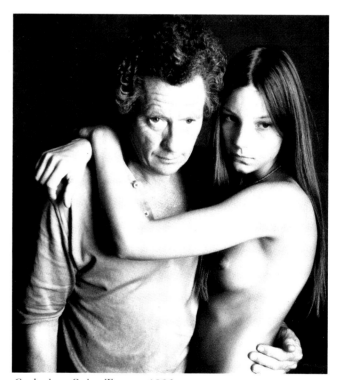

Catherina, Saint-Tropez, 1982

Lisette, Ramatuelle, 1980

as one might imagine, but to depict, to clear away an imaginary landscape. A photograph is capable of changing attitudes. There is more beauty in the perception than there is in the subject. It is a question of the attention that one brings to the things around one: a face, a hand, a cloud, a tree. Should you, while in a taxi, pass a tree which, at that precise hour of the day, in that particular light, seems beautiful to you, you must stop the car. Immediately. You must take the picture immediately. Do not tell yourself "I'll come back tomorrow, at the same time…" No. Everything will be different. The light will no longer be

Prince Dado Ruspoli and Deborah, Rome, 1980

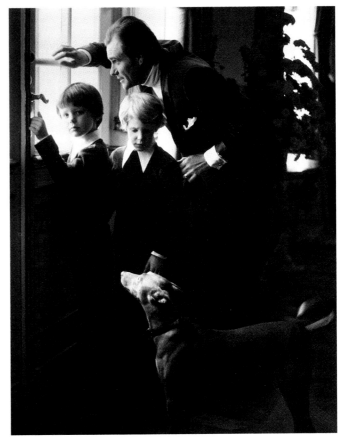

The Danish Royal Family, Denmark

there, or a crane will have been hoisted on a neighbouring construction site, or simply your perception will have changed, and what you had momentarily seen will have gone. If you are on a beach and you notice a face, or a body, that stands out from the crowd, the sight of which makes your heart leap in your breast, then stop. If your feeling is honest and sincere, it will help you find the right words. Who knows what could then come from such a meeting?

Several years ago, on a Mediterranean beach, where I have returned repeatedly for long walks during the

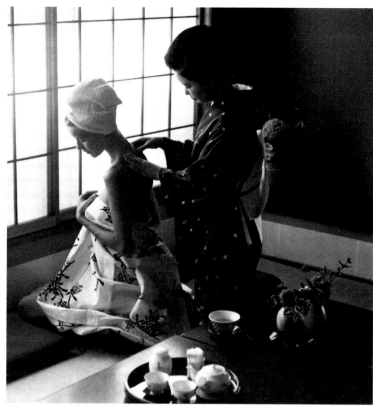

Mona in Kyoto, Japan, 1972

Mariano de Tour de Montèse in his palazzo, Ibiza, 1973

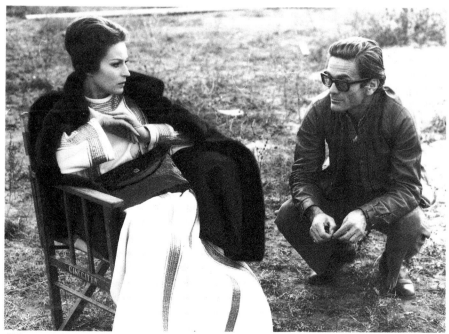

Silvana Mangano and Pier Paolo Pasolini on the set of the Decamerone

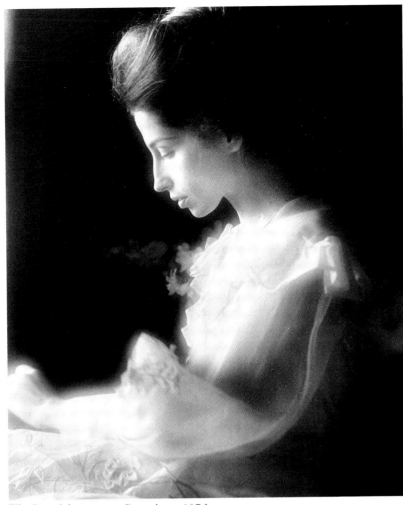

The Spanish contessa, Barcelone, 1970

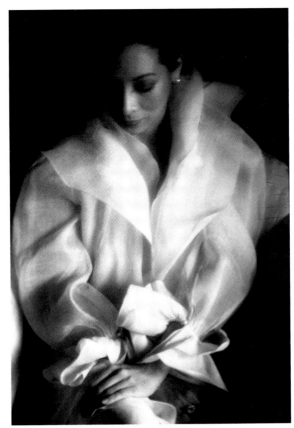

Ting-Ting Aquino, Manila, Philippines, 1980

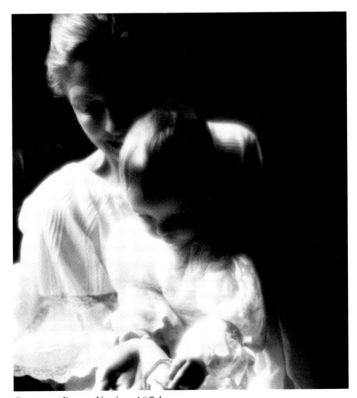

Contessa Boza, Venice, 1974

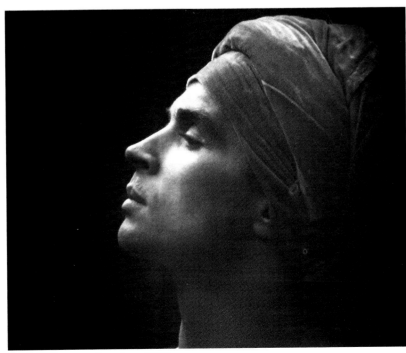

Rudolf Nureïev, London, 1972

past twenty-five years, I noticed a young girl, and I stopped. She has now become a young woman, and today, it is with her I share my life. This meeting, which was so precious to me, did it not begin with a glance ?

I think that we often ignore the extent to which one's visual perception affects one's life. The first daguerrotype fascinated the public: mirrors able to freeze time. A true miracle. The rediscovery of a glance. Photography has been made commonplace by its omnipresence and has lost some of its magic. Publicists know that the experience of perception is a voyage of no return, that a billboard, a fifteen second advertisement, will make a lasting impression on the retina and thence on the brain, although we may not be conscious of it. I would therefore urge you to persevere in the education of your perception by re-discovering the works of great painters and photographers. The great artists have received, completed, and transmitted the visual heritage of man from time immemorial. The principles of composition, of colour, have found their basis in the course of history and remain valid whatever the style. There are those who conform rigorously to life, and those who fight conformity and have attempted to break free. There are no rules but there are sensibilities and emotions. That is why it is essential that we explore, in every way, the universe which surrounds us. We may not always like what we see but we will learn to evaluate it. For one should never forget that the moment of discovery is unique, and that once you have caressed an object with a glance, you can never be free of that image.

Original French text by Philippe Gautier.
English Adaptation by Lilian James.
4th June 1992, Geostudies (U.K.).

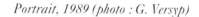
Portrait, 1989 (photo : G. Versyp)

The text in this book was set in Caslon 540 Roman 12/17,08

Realisation PAO Octavo, Paris

The photographs were treated by Pictorial Service Paris

The photo-engraving was made by Daiichi Process Pte Ltd

The book was printed and bound by Arti Grafiche Amilcare Pizzi Spa Milano

under the supervision for the Publisher by Robert Gordon.

Philippe Winckler prepared the pages for the printer.

Back cover :
With Gertrude, South of France, 1989 (photo Brice Toul).